Margaret Shepherd

Calligraphy NOW

Other books by Margaret Shepherd

Learning Calligraphy
A Book of Lettering, Design, and History

Using Calligraphy
A Workbook of Alphabets, Projects, and Techniques

Borders for Calligraphy
How to Design a Decorated Page

Capitals for Calligraphy
A Sourcebook of Decorated Letters

Calligraphy Made Easy
A Beginner's Workbook

Calligraphy Projects
for Pleasure and Profit

Margaret Shepherd

Calligraphy NOW

New Light on Traditional Letters

G. P. PUTNAM'S SONS • NEW YORK

For David

Copyright © 1984 by Margaret Shepherd
All rights reserved. This book, or parts thereof,
may not be reproduced in any form without permission.
Published on the same day in Canada by
General Publishing Co. Limited, Toronto.

Acknowledgment is made here of permission to use the
following copyright material:

Quotation by C. S. Lewis from *The Silver Chair,* by per-
mission of Macmillan Publishing Company, New York,
and Collins Publishing, London. Copyright reserved.

Quotation by Vladimir Nabokov from *Speak, Memory,*
by permission of Mrs. Vera Nabokov. Copyright © 1966
by Vladimir Nabokov. Published by G. P. Putnam's Sons.

Quotation by E. B. White from *Charlotte's Web,* by per-
mission of Harper & Row, Publishers, Inc. Text
copyright 1952 by E. B. White; renewed 1980 by E. B.
White.

Quotation by Don Marquis from "the stuff of literature"
in *Archy's Life of Mehitibel,* by permission of Doubleday
& Company, Inc. Copyright 1933 by Doubleday & Com-
pany, Inc.

The work of Suhas Tavkar appeared in a 1983 article in
U & lc magazine, New York.

Library of Congress Cataloging in Publication Data

Shepherd, Margaret.
 Calligraphy now.

 Bibliography: p.
 Includes index.
 1. Calligraphy. 2. Alphabets. I. Title.
Z43.S5429 1984 745.6'1 84-6908
ISBN 0-399-12975-8
ISBN 0-399-51148-2, Perigee edition

Printed in the United States of America

Contents

Foreword

We do not know what the art of the future will look like. No one particular style is art's final climax. Every style is but one valid way of looking at the world, one view of the holy mountain, which offers a different image from every place but can be seen as the same everywhere.

Rudolf Arnheim
Art and Visual Perception

THIS BOOK BRINGS TOGETHER the influences that have shaped today's handwritten word and defined the field of contemporary calligraphy. It is organized to be read straight through as a narrative as well as dipped into as a resource. In addition, its twenty-nine chapters form the outline for an introductory course in graphic communication.

In twenty years of practicing calligraphy, I have learned that its greatest strength comes from its readiness to combine. Calligraphy can get something from and contribute something to just about any field. While it overlaps the arts of typography, type design, illumination, and computer graphics, it also touches architecture, drawing, tapestry, painting, sculpture, costume design, graphics, and music. Whenever possible, I have included insights from these disciplines and from recent discoveries in biology, metallurgy, psychology, and archaeology that clarify the process of seeing, reading, and writing.

Calligraphy's kinship with other arts is founded not only on long-established traditional usage, but also on common concerns about basic issues. The issues that calligraphers grapple with today—permanence of media, intelligibility of subject matter, originality of design, uniqueness of copy, purity of means, legality of process, social function, relation to other arts, and accreditation of practitioners—are the same concerns that preoccupy artists in other fields. Conclusions that calligraphers in the past and musicians, photographers, painters, and writers today have reached on these subjects can serve as useful guidelines. I owe much to my acquaintances in other artistic fields who have generously shared their experiences.

An overview of modern calligraphy must of necessity compress some of the landscape in order to fit all of it into the picture. I have also, no doubt, unconsciously added distortions of perspective that originate in my personal prefer-

ences and skills. Calligraphers who have a favorite area may find their entire field of specialization treated in one chapter or described in terms dissimilar to their own. I have had to borrow words from one field to describe innovations in another, or to choose among terms from several systems that describe the same thing. I hope that the forbearing reader will understand that such provisional labels and temporary maps are necessary if people in different fields are to learn from each other. ("Leading," for instance, which describes the space added between lines of letters, may seem an archaic term to borrow from the world of typesetting, where a touch of the phototypesetter's button now accomplishes what was formerly done with strips of metal, but no other convenient term has yet emerged. Words like "pen width" and "page," in the same way have been given sometimes specific and sometimes general meanings.)

Borrowing ideology and terminology from other fields has meant borrowing technology, too, and here the question has not been just one of whether the tool fit the task but whether it was readily available. Although every chapter includes a list of suggested materials, only those that are easy to find, afford, purchase, make, fix, and use are recommended. The lists include brand names, not so much to limit the reader as to help him or her ask for a tool by its trade name in a store. Not all potential materials are listed: the reader is assumed to have on hand pencils, paper, and a soft eraser. In addition, the text sometimes suggests exploring other unlisted items that are usually available in hardware, stationery, grocery, or art stores. Whenever I had the choice, I favored the standardized over the esoteric. Every technique is described in terms simple enough to give any reader an introductory, hands-on experience. Readers who develop or already have expertise in a particular chapter's lesson can follow up the visual lessons with advanced work from the suggested reading lists.

While I am aware of the various needs that the inquisitive reader may find only partly satisfied in this introductory book, I have great faith in its basic premise, to see as a whole the many facets of contemporary letter art. *Calligraphy Now* has been a long time in the making, and even longer in the seeing. For years I felt like first one and then another of the eight blind men who each touched a different part of the elephant and mistook it for the whole. Seen in its entirety, calligraphy today is both simpler and richer than any one of its parts would suggest. I trust that the letters in this book will create for the reader the same sense of fragments united and a vision complete.

Margaret Shepherd

Using This Book

Calligraphy Now broadens and deepens the art of the hand-lettered word. Here the calligrapher who has wondered what to try next, as well as the beginner who wonders where to start first, will find clear, easy lessons about the most avant-garde topics in calligraphy today.

Although the modern resurgence of interest in calligraphy relies on letters formed by the broad-edged pen, the history of the Western letter offers the scribe today many other kinds of letters to choose from. Letters shaped by the turned broad pen, the flexible quill or brush, the monoline pen, the digital screen, and the airbrush are presented here not as minor eccentricities or revolutionary departures but as important and vital parts of the calligraphic mainstream. Section I of this book, "New Pens and Pen Strokes," suggests how to see and understand these letters, shows where they fit into historical tradition, explains how to use each pen and brush, and provides dozens of clear and detailed model alphabet styles to copy.

The alphabet is not the only outlet for calligraphy. Section II, "New Visual Purposes," offers techniques for applying the new pens and pen strokes of Section I to the shaping of spaces, the construction of serifs, and the calligraphy strokes of abstract flourishing and pen-stroke drawing.

Section III, "New Human Intentions," looks at who is writing, and how, and why. Calligraphy today not only draws on new materials and modern art forms, but also serves new functions in society—new, that is, in relation to the medieval and Renaissance tradition of book copying and document production. Many of these twentieth-century needs, however, have already been recognized and answered in other times and places by very different, very characteristic adaptations of the alphabet. These find expression in the lettering of the amateur, the rebel, the handicapped writer, the antiquarian, and the child, whose needs straddle the boundaries of the alphabet's fine-arts tradition.

Calligraphy teaches as much about seeing as about doing. It is a science of the eye almost more than it is a craft of the hand. Section IV, "New Perceptions," opens a window on what the many letter styles of the past show about how the eye sees and what the discoveries of twentieth-century science reveal about why the alphabet now looks the way it does. Letters that calligraphers have written for centuries have fooled the eye, both blatantly and subtly. This section analyzes familiar alphabet styles from startling new perspectives and offers additional easy alphabets of optical illusions for exploration.

Calligraphy has been a two-dimensional art of the page for so long that its other dimensions have been neglected. Its origins in, and continued association with, graven images are so many, so varied, and so intriguing to eye and brain, that Section V, "New Dimensions," is devoted to the three-dimensional letter and to the other dimensions of the alphabet—time and color.

Making letters, in all its variety, is still only one aspect of the calligrapher's art. The most important part is how those letters are arranged. Section VI, "New Configurations," outlines the many kinds of layout the calligrapher can experiment with.

Calligraphy is an appealing and fertile field of interest, and the many people who have discovered it by themselves, for themselves, in the last few decades are now beginning to discover each other. Artists from many backgrounds, whose common ground is their interest in working with letters, are sharing new ideas about tools, techniques, materials, and visual principles. This has made calligraphy richer and more interesting. It has also begun to enlarge the borders of the field itself. *Calligraphy Now* maps the landscape of this new kingdom.

I.

NEW PENS
AND PEN STROKES

Dancing in all its forms cannot be excluded from the curriculum of a noble education: dancing with the feet, with ideas, with words, and need I add that one must also be able to dance with the pen?

Friedrich Nietzsche

CALLIGRAPHERS, like other artists, are inventors. They experiment with new tools, borrow from other fields, rediscover forgotten historical techniques, find new uses for old pens, and even write with things with which no one else would have thought of making letters. Each tool shapes a particular kind of letter stroke and gives it distinct flavor. After the calligrapher has written with a new tool, he or she will begin to recognize many formerly unfamiliar letters as old friends and understand that they lie within the expanded borders of the field of calligraphy. The materials, techniques, and letter strokes introduced in this section will be used throughout the book.

the TURN of the PEN

The Weighted Line

E pur si muove.
(It moves nevertheless.)

Attributed to Galileo Galilei after church authorities forced him to recant his published theory that the earth revolved around the sun.

Pen angle is made by an imaginary line running across the flat end of the nib.

TODAY MANY CALLIGRAPHERS begin their acquaintance with letterforms by employing a broad-nibbed pen and holding it at a fixed angle. This pen position then stays set during the execution of the letter stroke so that any variation between thick and thin is determined solely by the direction of the stroke. The angle of the pen in twentieth-century calligraphy, like the assumed position of the earth in seventeenth-century astronomy, does not move; everything around it— rules, concepts, persons, historical realities—bends to preserve its immobility.

At first, calligraphy with a set-pen angle seems too easy to be true. The beautifully flowing thicks and thins are all accomplished by geometry: if a beginning calligrapher holds the pen steady at a certain angle while moving it along a certain path, the pen will "automatically" put the thicks and thins where they belong. The kind of letter produced by this technique has come to dominate the visual thinkng of the mid-twentieth-century calligraphy revival, to the neglect and near exclusion of many other lettering systems.

The idea behind set-pen lettering seems simple enough: According to this approach, each of the half dozen or so most familiar traditional alphabet styles has its own prescribed pen angle that, when combined with the appropriate pen weight and stroke path, produces the distinctive visual characteristics of that style. Although there may be some latitude for personal preference in the choice of this pen angle, once it has been chosen it must be kept constant for the whole alphabet. One letter, stroke, or serif done at a different pen angle will strike an unwelcome, discordant note.

While these principles of the set pen seem reasonable in theory,

Learning to recognize the pen angle at various degrees.

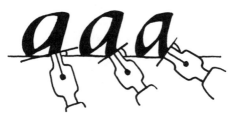

Three variations of pen angle and the resulting Italic letters.

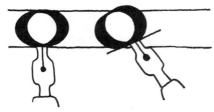

Two variations of pen angle and the resulting letters.

10

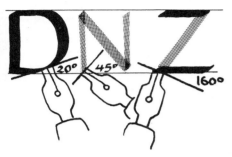

Characteristic Roman pen angles.

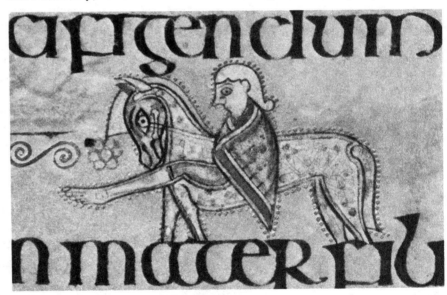

Eighth-century Celtic letters show a variety of pen angles within the same letter style, word, and letter. (From the Book of Kells, with permission of the Board of Trinity College, Dublin.)

Fourteenth-century Gothic letters show different angles at top and bottom of letter. (Detail from the Luttrell Psalter, with permission of The British Library.)

they are so frequently modified in practice that they have begun to assume the proportions of a myth that will not bear scrutiny. Even the basic Roman alphabet style, for example, simply cannot be lettered in its classic form by using a single set-pen angle. A second set-pen angle is demanded to accommodate the diagonal letters. Characters like Z, borrowed from Greek and added to the alphabet after the foundation of the classical Roman style, can be translated into its idiom only by introducing yet another specialized angle of the pen. In addition, since the original Roman letter was fundamentally carved and now has become predominantly phototypeset, many subtle refinements and adjustments appear in the ideal models that can be approximated with the pen only if the rules of the set-pen angle are freely modified. Research and letter design by Arthur Baker in the twentieth century have reestablished the fundamental importance of pen manipulation in interpreting any historical broad-pen style and creating contemporary ones.

Similarly, Celtic letters in the Book of Kells show evidence, on close scrutiny, of stroke widths and endings that could only have been accomplished with several different pen angles. The constant angle of the pen was clearly not the sacred cow in the eighth century that it was to become by the nineteenth.

In their overemphasis on the set-pen angle, many calligraphers of the twentieth century resemble the Victorians, who believed that rules and systems could codify images and guarantee visual results. They, like the scholars of the Renaissance-revival Roman capitals, seemed to place ultimate faith in complicated and thorough analytical description as the best way to interpret the letters they saw. Twentieth-century calligraphers have tended to copy the copiers rather than to go back to original sources and really look at them.

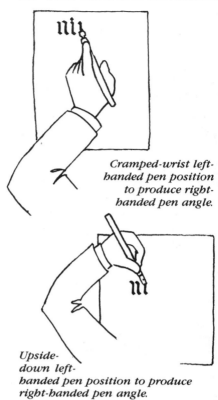

Cramped-wrist left-handed pen position to produce right-handed pen angle.

Upside-down left-handed pen position to produce right-handed pen angle.

Turned-paper left-handed position to produce right-handed pen angle.

Natural left-handed writing position for specially designed Roman, Italic, and Gothic.

The traditional set-pen letters of the modern calligraphy revival have, furthermore, created an intolerable dilemma for the 10 percent of the writing population that is left-handed. Virtually all of the traditional alphabet styles' pen angles are tailored to the natural writing position of the right hand; left-handers must compensate by cramping their wrists into unnatural positions, curling their arms 180 degrees to produce the correct angle upside-down, or rotating the paper to an odd and disorienting perspective. Pen nibs that slant at a negative angle can compensate a little for this awkwardness, but not enough to make left-handers really feel welcome in the world of broad-pen calligraphy.

Left-handers can feel free to question the hegemony of the right-hand set-pen angle and to demand alphabet styles designed around the 135- and 160-degree pen angles that mirror the right-handers' familiar 45- and 20-degree angles. The four simple alphabet styles offered later in this chapter represent a step toward providing left-handers with some basic, well-designed, broad-pen letters that derive from the mainstream of calligraphic tradition and at the same time work with, not against, the physical realities of the natural left-hand pen position. Many of the other letterforms in this book further expand and map the territory open to the left-hander.

Venturing away from the set-pen angle will expand the right-hander's world as well. While the set-pen alphabet styles may seem like an easy place to *begin* to learn calligraphy, they are not the best place to *stop*. Beginners often find it all too easy to take the shortcut of letting a few rules from one book or the pronouncements of a busy teacher do the work that their eyes should be doing in learning how to see and shape letters.

Pen turning is best regarded as one ingredient in the daily diet, not as a miracle drug. Not all alphabet styles benefit equally from a dose of the variable pen angle. Those that do can introduce the beginning scribe to a valuable calligraphic skill. The most important part of pen manipulation, however, is not the dexterity of the hand but the

GOTHIC

Bodoni

SQUARE SERIF

Caslon f

Mid-twentieth-century showcard lettering techniques use chiseled-pencil turning to evoke the look of familiar type styles. (From Practical Lettering *by Robert Shaw, New York: Wm. Penn, 1955.)*

clarity of the eye. Look at the letter; look hard and objectively. How was it made? What path did the pen follow? What kind of pen was used, and how was it held? A beginning calligrapher's first step in studying any alphabet style should not be to learn the rules, but to learn how to see.

MATERIALS
rigid broad-edged pen such as:
> Coit pen
> Box pen
> chisel-tipped marker
> Mitchell Witch pen

India ink or fountain pen ink

any paper except newsprint

TECHNIQUE
The basic premise of the turned-pen stroke is that the calligrapher can control the incidence of thick and thin strokes whose weight otherwise would be controlled by the geometries of the constant pen angle. To change some of the familiar set-pen forms into turned-pen forms, no change in the path the pen follows on the surface is necessary, just a change in the angle of the pen. This angle may be altered by changing the position of the body, the arm, the hand, the fingers, or the pen itself, depending on the scale of the letter being made and the frequency of the change. The thicks and thins will occur where you decide to put them, as the pen's angle is changed between letters, between strokes, or during execution of the stroke.

Neuland
This alphabet style, derived from a typeface named Neuland and designed by calligrapher Rudolf Koch, is a good style to ease the traditionally trained scribe away from dependence on the attitudes and techniques of the set-angle, broad-pen letter. The pen angle may be changed between strokes but is held constant for the duration of each stroke to eliminate the preordained contrast between thick and thin that characterizes the classical Roman letter.

Sharp, heavy, overlapping corners give the letter a routed-out quality that echoes not just the pen but the stylus, the graver, and the cuneiform tool. Contemporary calligraphers find it a flexible, highly personal letter that adapts to a multitude of uses. Its heavy weight contrasts with the more delicate textures of traditional hands, but enough broad-pen flavor remains to keep the styles harmonious. It can tolerate a relatively heavy width of pen without sacrificing legibility, thus lending itself readily to such visually vigorous media as woodcut or papercut, where it is easy to produce and integrate into other parts of the design. It suits the left or right hand equally well. In addition, facility with the changes of pen angle it entails will enable you to feel

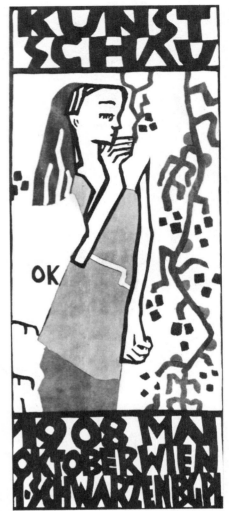

Early twentieth-century letters echo the Neuland type style. (1908 poster by Oskar Kokoschka for the Kunstschau, Vienna, with permission of the Victoria and Albert Museum, Crown copyright.)

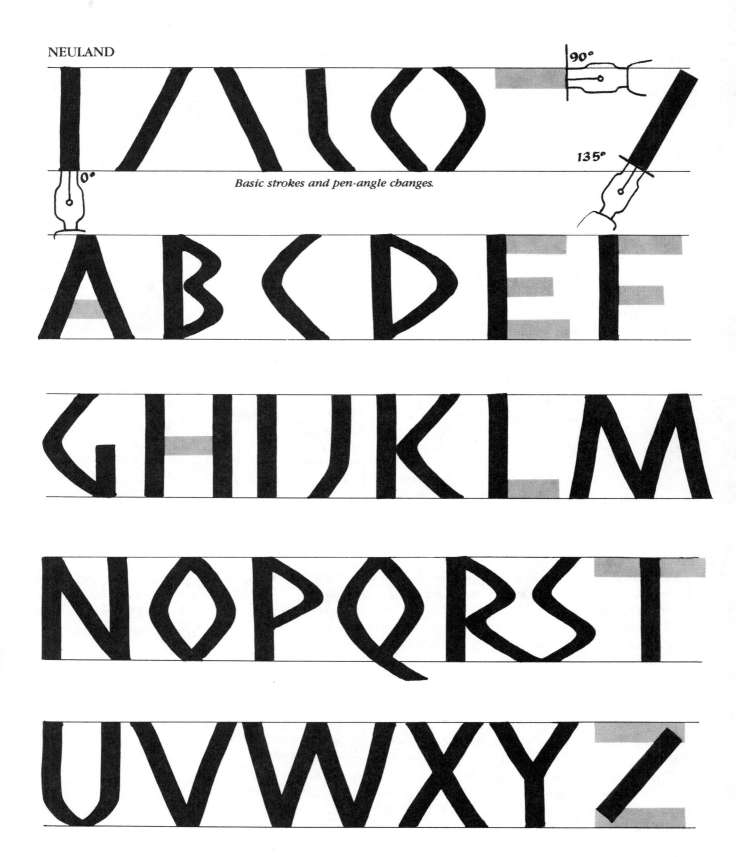

NEULAND

90°

135°

0°

Basic strokes and pen-angle changes.

ABCDEF

GHIJKLM

NOPQRST

UVWXYZ

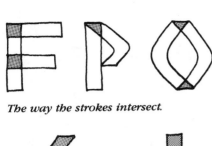

The way the strokes intersect.

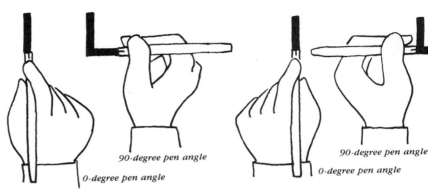

The way the curves compare to sharp corners and straight lines.

90-degree pen angle

0-degree pen angle

Right-hand pen position for Neuland.

90-degree pen angle

0-degree pen angle

Left-hand pen position for Neuland.

comfortable moving the pen around and to experiment confidently later with other turned letters.

Left-Handed Italic

For some calligraphy teachers and left-handed scribes, maintaining the purity of the traditional right-handed set-pen broad-edged models is not always worth the price paid in awkwardness of execution. Special styles specifically for left-handed calligraphers offer many advantages. Left-handers can practice more comfortably and learn many of the same principles of these alphabets in almost perfect mirror image to right-handers; teachers have a resource to offer those left-handers who have felt shut out by the exclusively right-handed exemplars; some of the left-handed styles are genuinely new and exciting; and both right-handers and left-handers can learn fascinating visual lessons about symmetry and rotation by comparing the two versions. Right-handed teachers of the occasional left-hander, particularly, are urged to spend a few minutes with this alphabet style, attempting to reproduce its left-handed pen angles while holding the pen in their right hands, in order to get a firsthand feel for how the right-hand letter feels to the left-hander.

Left-handed Italic letters follow the same rules for understanding and practice as right-handed ones. Letters are composed of a limited number of basic strokes and can be divided into categories of letter families according to what general shape they have in common with each other. The 135-degree left-hand angle makes a letter that has much in common with the 45-degree right-hand one, but with more that is unique. It is familiar at first but prompts a double take when its "handedness" sinks in. To maintain the visual logic, some of the usual serifs and joins may be reversed.

The alphabet of basic left-handed Italic lowercase letters shown here may suggest other experiments to left-handers who want to develop further a writing style that is truly their own.

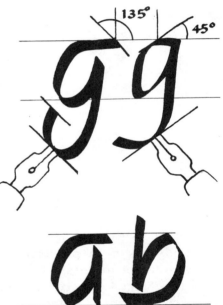

135° 45°

In left-handed Italic, A-body letters and B-body letters are rotated versions of each other.

Leave white space here to compensate for extra stroke weight here.

These strokes just touch.

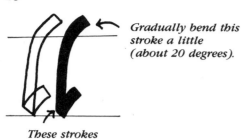

Gradually bend this stroke a little (about 20 degrees).

These strokes overlap.

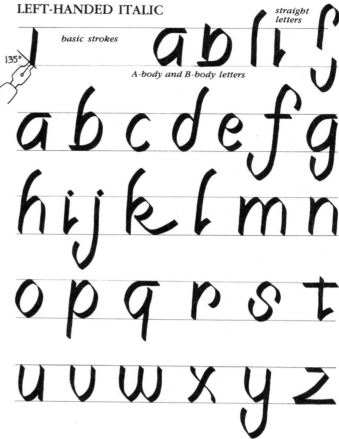

basic strokes

straight letters

A-body and B-body letters

135°

a b l i f

a b c d e f g

h i j k l m n

o p q r s t

u v w x y z

Swash is optional on most letters, necessary on f and g, helpful on y and j.

Right-Handed Roman

Calligraphers who study the right-handed classical Roman alphabet style know that one key to interpreting its architectural dignity and exquisite sense of proportion is to start with not one pen angle but two: one for the straight and round letters and one for the diagonal letters. Some letters require combinations of both, and a few demand special odd angles of their own. Changing the pen angle—sometimes by only a few degrees—helps you add weight on the thick strokes and shave it off the thin strokes exactly where your eyes and classic exemplars suggest it will look best. In writing the detailed Roman alphabet shown here, you will always be aware of the pen angle and thereby will always be in control of the weight of the stroke, no matter in what direction the stroke goes. The rules are tailored to the visual results you want to create; the letters are not tailored to what the rules will permit.

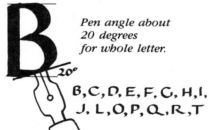

Pen angle about 45 degrees for whole letter.

45°

N, V, X

Pen angle about 20 degrees for whole letter.

20°

B, C, D, E, F, G, H, I, J, L, O, P, Q, R, T

Left-Handed Roman

The classical Roman letters are so familiar that the left-handed calligrapher is wise to learn from them before trying to update them. They are not sacrosanct, however; over the centuries they have provided the touchstone for many useful innovations. A left-handed Ro-

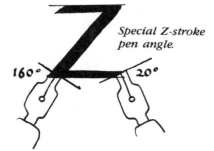

Special Z-stroke pen angle.

160° 20°

IO ⎯ VI *45°* *20°* *160°*

IO ⎯ VI *160°* *Basic strokes and pen-angle changes.* *135°* *20°*

A B C D E F A B C D E F

G H I J K L M G H I J K L M

Some alternate treatments of K, Q, and R necessitate a "backward," or right-handed, 20-degree angle.

N O P Q R S T N O P Q R S

U V W X Y Z T U V W X Y Z

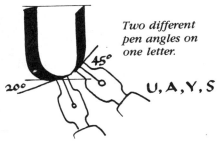

Two different pen angles on one letter.

45° 20° U, A, Y, S

30° 20° *Pen angle to make this stroke not too thin, not too thick.*

Four slightly different pen angles to compensate for none of the strokes being quite parallel. W, M

man alphabet is shown here in detail and with suggestions for adapting it to various needs. Some of these left-handed letters and strokes already appear in the right-handed Roman alphabet; half of the letters are virtually unaltered by being done left-angled; most of the remainder emerge as a mirror image of themselves; less than half a dozen put up any resistance to fitting into the Roman style.

The trade-off seems worth the trouble. The left-hander who must make one backward-angled stroke—for the N—out of the sixty-seven it takes to produce an otherwise comfortable and visually almost correct left-handed Roman alphabet is no worse off than the right-hander who must also make one backward stroke out of sixty-seven—for the Z—and considerably better off than the left-hander who must make sixty-six awkward strokes out of sixty-seven to do the traditional right-handed Roman alphabet. The left-hander who is willing to go to a little extra trouble to make five backward-angled strokes out of sixty-seven will have a useful and almost irreproachable counterpart to the classical Roman alphabet.

PEN TURNING

Freely changing the angle of the pen between letters and between strokes gives the calligrapher great control over the balance of thick

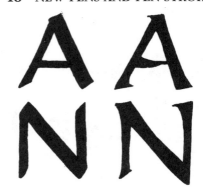

A comparison of turned and unturned Roman letters.

Contemporary lettering puts calligraphic opinion on a bumper sticker. (Courtesy of Larry Neises, Spokane, Washington.)

This twentieth-century logo design shows how letterforms derived from pen turning can produce a monoline—with a final twist. (Courtesy of the Trustees of the Philadelphia Orchestra.)

and thin strokes in each letter. There is, however, much more to pen turning than that. You can actually change the angle of the pen while you are doing the stroke, as is already necessary to dovetail the central stroke of the S with its top and bottom. This subtle control of pen angle can be applied either with restrained moderation to refine some traditional styles or with great vigor to invent new ones. It also applies without prejudice to either right- or left-hand positions.

The best pen to begin with is a large chisel-tipped marker pen or metal folded pen, held so that it points straight down on the page. The pen is turned by rotating it between fingers and thumb. After you have learned to turn this pen in this position, you can progress easily to smaller pens held in other positions.

The basic ingredient of pen turning can be described most simply as a change in pen angle between a vertical angle (90 degrees) and a horizontal angle (0 degrees). This does not refer to the angle that the shaft of the pen makes relative to the surface of the paper, but to the angle that the flat end of the stroke makes relative to a horizontal line on the paper. The pen either starts in the vertical position and rotates during the stroke to end in the horizontal position or it rotates from the horizontal to the vertical. This rotation can be even and gradual or uneven and abrupt. The rotation can stop before the pen actually reaches the full vertical or horizontal position. The two edges of the pen do not necessarily have to move in mirror image to make a symmetrical stroke.

After this fundamental ingredient of the basic turn has been thoroughly understood and practiced, the next step is to put two strokes together in various arrays to make useful complete straight strokes and letters.

Curves involve the question of whether the pen is to be turned clockwise or counterclockwise in relation to the direction of the curve. Four different characteristic curved strokes result from turning, which follow some of the same principles that apply to the straight strokes: the pen can turn suddenly or gradually; the turn does not necessarily have to end at right angles to where it began; the stroke also need not be symmetrical. These curves are put together with the straight strokes and with each other to form an immense repertoire of letters. The examples that follow start with some slightly modified traditional styles and lead to some original innovations, with suggestions for further inventions.

To begin, visually compare the unturned capitals with the turned ones. The first step is to relearn how to see the Roman letters. This is not just a process of learning enough rules to repeat exactly, by whatever method possible, the letters that appear in the inscription on Trajan's Column. It means first knowing what repertoire of tools, movements, and techniques are available to the calligrapher, and then applying them intelligently to many exemplars. Today, the challenge of lettering in this classic style is to try to evolve not just fluency in

executing Roman letters but intelligence in grasping what the essence of the Roman letter is.

Pen turning elegantly solves some of the essential problems posed for centuries by the Roman letter and opens new areas of inquiry for the future. The smooth and balanced serif of the carved letter is gracefully integrated into the lettered stroke, instead of being added on; awkward pen angles and inaccurate overlaps are eliminated; and the calligrapher can include many subtle visual compensations that are entirely within the spirit of the similar adjustments to be observed in Roman architecture.

Turned Celtic

Pen turning can be applied to other traditional alphabet styles, in the spirit of inquiry into how it can facilitate both expression of their historic form and experimentation with their innate potential. A careful examination of the insular Celtic uncial and half-uncial of the Book of Kells has taught many calligraphers to resort to pen turning whether they approve of it or not, since without turning the pen it is impossible to make the characteristic Celtic stroke that is slanted at one end and square at the other.

Gothic

Pen turning will also greatly enlarge your repertoire of Gothic variations. It can heighten and refine the angularity of this style, suggest radical new variations, and refresh the execution of the myriad pen ornaments that embellish the capitals.

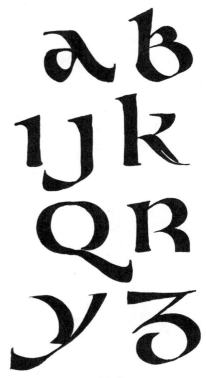

TURNED CELTIC

A small selection from many variant letters.

TURNED GOTHIC

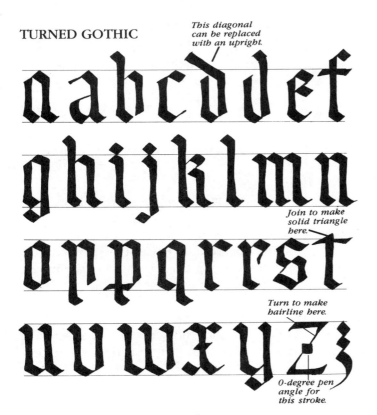

This diagonal can be replaced with an upright.

Join to make solid triangle here.

Turn to make hairline here.

0-degree pen angle for this stroke.

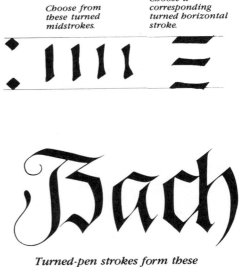

Choose from these turned midstrokes.

Choose a corresponding turned horizontal stroke.

Turned-pen strokes form these Gothic letters. (From Inversions *by Scott Kim, with permission of the McGraw-Hill Book Company. Copyright © 1981 by Scott Kim.)*

Versal

Pen turning puts many of the time-consuming symmetries of the drawn Versal capital within reach of a single stroke of the broad-edged pen.

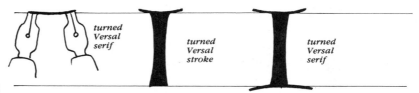

Constructing a turned Versal straight stroke.

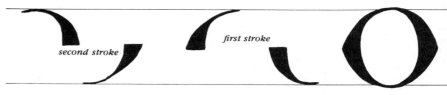

Constructing a turned Versal curved stroke.

Lowercase Roman

Pen turning, applied in a few obvious ways to the pen path of the ubiquitous lowercase Roman letter, can radically change its identity. This utilitarian traditional style can be turned into a softened and

gracefully serifed Bookhand, stripped down to a very bare Futura, refined into a near-monoline Helvetica, or rippled into a ribbon-like Banner, and it contains the seeds of many other new personalities.

Turned and Skated Italic

Turning the pen between thumb and fingers while holding it slanted, not straight up and down, over the writing surface, will leave only a corner of the nib actually touching the page. Skating along the corner of the nib allows you to pull ink out from an existing pen stroke and move it around on the page without using the full width of the nib. It offers yet another technique to help you express with the pen what you see with your eyes.

Remember that the letters you read today are the product of a long transmutation from original carved Greek letters to brush letters

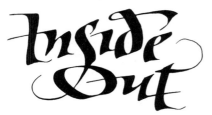

at the *Ames gallery*
2661 Cedar at La Loma · Berkeley

31 October – 1 December 1979
Reception: Thursday · 1 November · 7 to 9 pm

Inside Out

Self · Portraits by Bay Area Artists

Ann Bernauer · Lynn Bostick
Michael Bradley · Jerome Carlin · Laura Cornet
Georgianna Greenwood · Michael Grossman
Leo Hobaica, Jr. · Daria Niebling
Stan Washburn · Dale Wilhite
Marika Wolfe · and You!

Open Wed–Sat, 2 to 6 pm or by appt: 845-4949

Contemporary lettering uses pen turning to dramatize poster graphics for a self-portrait exhibition at Ames Gallery, Berkeley. (Courtesy of Georgianna Greenwood.)

on stone to carved letters on stone to quill letters on parchment to cast type in metal to printed letters on paper. The examples you copy can come from any point in that process and still have something valuable to teach you if you know how to see them for what they are and manipulate the pen to write your vision.

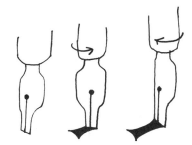

Turned-pen stroke with pen held vertical while rotating.

SUGGESTED READING
The Calligraphic Art of Arthur Baker by Arthur Baker (New York: Charles
 Scribner's Sons, 1983).
Foundational Calligraphy Manual by Arthur Baker (New York: Charles
 Scribner's Sons, 1983).

The same stroke, with pen held at an angle and lifted while rotating and, left, a skated stroke.

TURNED AND SKATED ITALIC

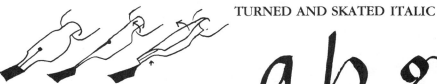

Short skated strokes up and down.

A skated stroke can pull into a spiral or a ball.

Pressure-Sensitive

The Pulsing Vein

Between 1500 and 1800, lettering evolved from forms based on the broad-edged pen to forms based on the thin flexible pen.

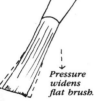

Pressure widens pen nib.

Pressure widens flat brush.

Pressure widens a flexible broad-edged pen as well as a flat-ended brush.

Press: more ink, wider stroke.

Let up: less ink, narrower stroke.

Press: more ink, wider stroke.

CALLIGRAPHERS WHO WRITE traditional broad-pen letters can let the pen dictate the width of the letter stroke or can intervene to control the width themselves. One way to control width is to push down on the pen to make the nib wider than normal. The natural flexibility of the pen shows in many historical examples of broad-pen letters, softening their contours and expanding the range of the pen's expressive qualities. The elasticity of the broad-edged brush, too, infuses the granite forms of the carved Roman capitals with life. The ebb and flow of added pressure gives letters a vivacity that the rigid pen cannot imitate.

This pressure-sensitive line is not news; it's just old news. Twentieth-century calligraphy, heavily influenced by the broad-pen Gothic Revival letters of the late-nineteenth-century Arts and Crafts movement, is, in some ways, still overreacting against the dominance of the exaggeratedly pressure-sensitive letter styles of the eighteenth century. Early-twentieth-century graphic designers championed the forms of the broad-pen letters as an antidote to the spidery handwriting, ornate display letters, and visually weak typography they saw around them. The popularity of relatively inflexible metal dip pens in the late eighteenth century, rigid fountain pens in the late nineteenth, and chisel-tipped markers today did much to root out flexibility from the visual vocabulary of the calligraphy revival and has artificially polarized the gray area between calligraphy done with an inflexible broad-edged pen and calligraphy done with a flexible sharp-pointed pen. The pendulum has swung away from the flexible pen and is only now beginning to swing back.

Today's calligraphers, most of whom have begun their study of traditional letters with broad-edged pen forms, can learn flexible-pen calligraphy without having to shelve their broad-edged pens and start again from scratch. All that they need is a broad-edged brush or one of the more flexible versions of the broad-edged pen.

Some modifications similar to those pen turning introduces into the broad-edged pen line can be achieved instead with pressure on a flexible broad-edged pen or a brush. This not only saves the constant turning for very small letters, but is also useful with large letters; the subtleties of the Roman capitals, in particular, thrive on this treatment

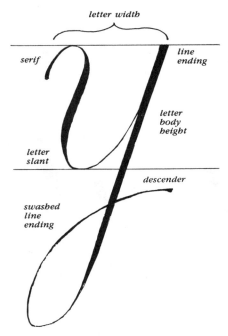

Pressure-sensitive letters share some characteristics and terms with broad-pen letters.

to such a degree that it seems likely that some pressure shaped the Romans' letter strokes and serifs in the first place.

Widening of a stroke by pressure makes it visually more interesting. By the rules of force, if a tool presses harder into a three-dimensional substance, it digs deeper; the surface of the paper, however, pushes back enough to spread the stroke. This graphic record of the flow of the pen point highlights the strength of the paper surface and the impermeability of the plane of vision.

Notice that pressure not only narrows or widens the stroke but also lightens or darkens the tone of the ink. This happens partly because the spread nib lets more ink gush on the wider parts of the letter and also because when the pressure is light, friction is reduced. The pen travels faster in the unpressured middle of the stroke, and since ink flows at a constant speed, it can't quite keep up. The lighter ink tone looks to the eye much like narrower line width. Lightened ink tone in the midsection of the pressed letter visually intensifies the inward curve that has already been introduced by pen pressure.

Variation in ink tone gives depth and sparkle to the page. It is, incidentally, highly esteemed in Chinese calligraphy. Furthermore, subtle graying in the letter stroke is unique to letters done in calligraphy. The effect does not exist in inked type and survives the photo-offset process only with the most complicated precautions.

Pressure can be applied, however, not just to refine the geometry of the broad-edged stroke but to create a different kind of thick line with a sharp-pointed pen or brush. Although this completely pressure-sensitive line in its most distinctive and familiar historical style is the basis of the Copperplate letter, many other alphabets can be designed with this pen and this technique.

Between the completely rigid broad-edged pen and the completely flexible sharp-pointed pen stretches a spectrum of styles shaped partly by the edge of the nib and partly by pressure on the nib. These give the calligrapher a wide variety of letters to choose from. Some characteristics of these letters can be described in the familiar vocabulary of broad-pen letters: letter slant, letter width, letter shape, and line ending. Other characteristics are unique to pressed letters. They can be described in terms of pen weight, stroke weight, weight frequency, pressure speed, weight number, and point position.

Pen weight means the width of the thinnest line the pen can

Progressively greater pressure, using the same pen or brush, is applied to the same stroke at beginning and end. Initial and final pressure is applied to the same stroke at beginning and end.

Initial and final pressure is applied to wider and wider strokes; each is widened by the same amount, but it becomes less and less noticeable.

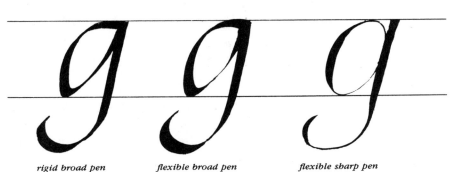

rigid broad pen flexible broad pen flexible sharp pen

pen weight → *stroke weight* →

Letters of increasing pen weight but identical stroke weight; as the pen weight approaches the stroke weight, the letter approaches a monoline of uniform width.

Letters of increasing stroke weight but identical pen weight.

Three kinds of weight frequency.

nomin

Weight added to each stroke.

nomin

Weight added to some letter strokes.

nomin

Weight added irregularly at scribe's discretion.

make. Most pressed alphabet styles use this width for the letter's thinnest stroke, so that pressure between the weighted strokes is at a uniform, easily controllable minimum.

Stroke weight refers to the width of the line when the writer pushes down on the pen. In some alphabet styles this weight is the same for all wide strokes; in others it varies from letter to letter and from stroke to stroke.

Weight frequency describes how many strokes in the alphabet are weighted and how many are thin. In many alphabet styles weight frequency does not have to be mechanically repetitive; one of the beauties of pressure-sensitive letters is that the calligrapher can control this visual rhythm rather than abandoning responsibility to the mechanics of the broad pen.

Pressure speed determines the gradualness of the change in pressure. Slow pressure makes a bulging line, slow letup a tapering one, and sudden pressure a rectangular line.

Weight number refers to the number of changes in pressure during the execution of one pen stroke.

Changes of pressure during stroke.

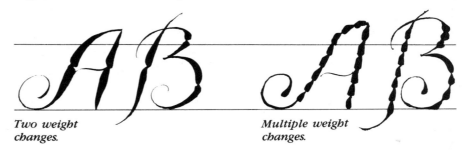

Two weight changes.

Multiple weight changes.

The *point position* is said to be either "exposed" or "reserved," depending on whether the pen is parallel or perpendicular to the stroke angle. The more exposed the point, the greater pressure will be needed to achieve a weighted line but the easier it is to maintain a

hairline of no pen weight. A pointed brush, on the other hand, makes a wide line more easily if it is exposed, but the line will be jagged on one side and harder to control. If you want a smooth line, the brush point position should be reserved; that is, the point of the brush should travel down the center of the stroke, not along one of its edges.

The pressure-sensitive line does not necessarily have to re-create the traditional strokes of formal Copperplate printing. Just because it can make the swelled curves of traditional alphabet styles so fluently doesn't mean it has to. A stroke can express multiple weight changes, irregular pressure, imaginative line endings, or a split-pen double line.

By putting responsibility for the thicks and thins with the writer

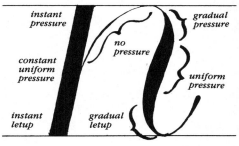

Pressure speed of a typical pressed letter.

*A suite
of eleven moments
that together
form a stillness
at the center
present with all
it contains
which is
a flowering out
beyond
what we know*

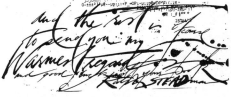

Irregular pressure and pen speed create a strong and inimitable style. (Courtesy of Ralph Steadman.)

Variable line weight adds subtle overall texture to these fluidly handwritten brush letters. (From Moments, *Beacon Press, courtesy of Corita Kent.)*

rather than with the pen, the pressed line offers unlimited flexibility and expressiveness in getting across fresh and unconventional messages. Cartoons, posters, fine art, graffiti, and type designs suggest ways to put vigor into the moving line. And the result does not have to be conventionally pretty; the line can be ragged, strange, and powerful.

Correct pen position for sharp flexible pen. This position will work only for a pointed brush, not a pointed pen.

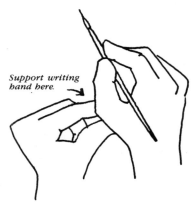

Support writing hand here.

For very precise lines, brace the hand that holds the pen or brush.

broad-edged pen pointed pen

press let up

let up press

press let up

Ink tone darkens as pen presses more heavily.

MATERIALS

flexible broad-edged pen or brush such as:
 Mitchell Roundhand pen, 00 to 4 nib
 flat, wide brush
 feather quill cut to a broad nib

flexible sharp-pointed pen or brush such as:
 metal crow quill
 watercolor brush
 Pentel Color Brush
 feather quill cut to a sharp point
 Mitchell Roundhand pen, 6 nib

India ink or fountain pen ink

hot-press paper or bristol board

TECHNIQUE

Bearing down on some of the familiar broad-edged calligraphy pens will introduce the traditionally trained scribe to pen pressure. Hand-cut feather quills, metal dip pens, and wide brushes are particularly cooperative, *if* you remember to pull each stroke toward you. Pressure on a pushed stroke will usually drive the nib into the paper or cram the brush bristles outward in an ugly mess. Don't spend time trying to lean on fountain pens, whose nibs are designed for strength, consistent width, and long wear rather than flexible responsiveness. Avoid also—obviously—rigid markers and poster pens.

You will find that pen pressure simply accentuates some of the motions intrinsic to the broad pen. Each stroke needs a little extra pressure at the beginning to get the ink flowing and at the end to make a sharp exit. To bear down on a broad-edged letter, use a flexible, wide dip pen on hard-surfaced paper or a flat brush on just about any paper. Press the pen down at the beginning of a stroke to spread the two halves of the nib, ease off toward the middle of the stroke, and then gradually bear down again.

Pressure makes more ink flow from the pen, so that the ends of the stroke are more heavily inked than the middle. In addition, the pen or brush is usually accelerated smoothly from a standing start, speeded up in the middle of the stroke, and slowed down again near the end to approach the base line accurately, leaving more ink at slow speed than at fast. The normal slight contrast in tone caused by these gradual changes in speed can be accentuated by increasing the speed even more in the middle of the stroke and by using thinned, transparent, or water-based ink. Or the contrast of tone can be played down by keeping the speed more even and using heavier, opaque ink. Graying of the ink caused by changes in speed alone can give the illusion of a tapered stroke without any pressure change.

Ink that varies in tone reveals the color and texture of the paper behind it. Paper of rougher texture or greater absorbency heightens these effects. The lighter pressure of the brush stroke can reveal paper

PRESSED ROMAN

A B C D E
F G H I J K
L M N O P
Q R S T U
V W X Y Z

PRESSED RONDE CAPITALS

A B C D E
F G H I J K
L M N O P
Q R S T U
V W X Y Z

COPPERPLATE

a b c d e
f g h i j k
l m n o p
q r s t u
v w x y z

*Some split letters are included to suggest
experiments with this effect.*

COPPERPLATE CAPITALS

A B C D E
F G H I J K
L M N O P
Q R S T U
V W X Y Z

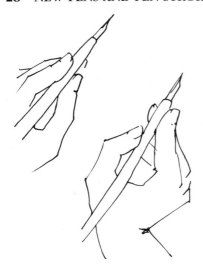

Left- and right-hand positions for lettering with a sharp flexible pen.

Pressed letterforms can be outlined and filled in when greater precision is needed than tools or scribe can provide.

texture that the heavier pressure of the pen stroke would hide.

Pressure solves many practical problems of the Roman capital alphabet style, dovetailing awkward joins, highlighting beautiful ones, compensating for optical illusions, correcting curves, and facilitating countless small shifts in letter weight, as well as tapering the basic straight stroke. Many of the visual effects of pen turning can be created instead with pen pressure.

Try pressing other broad-pen alphabet styles with pens of various widths. Practicing with the narrowest of the broad-edged pens will prepare you not only for the technical feel of sharp pens, but for some of the visual problems as well. Approaching sharp pens this way, through a series of gradually narrowing broad points, helps highlight the gray no-man's-land that extends from the completely rigid broad-pen styles to the completely flexible sharp-pen ones. A hand-cut feather quill is especially instructive at this point. You can cut the same quill down gradually from broad to sharp.

Once achieved, this facility with the pressure-sensitive broad pen can ease the transition to the pressure-sensitive sharp pen. A sharp pen works best with thick India ink on very smooth, hard paper such as bristol board. A textured surface may interfere with the smooth workings of the sharp point by snagging it, creating uneven line width, absorbing the ink unevenly, and letting small paper fibers stick to it, while adding relatively little to the appearance of many of the formal styles. If rough paper is used, its unevenness should appear to be an integral part of the visual effect and not a mistake.

Because Copperplate and many of its related brush-letter styles first evolved to fit the demands of the etched metal printing plate on which the image was written in reverse, the handwriting that derived from it needs some adjustments to suit the physical realities of the modern calligrapher. Some right-handed scribes frequently find it easier to approach the Copperplate letter and other slanted styles with an intervening angle-changing device that allows them to write left-handed with the right hand. The scribe can maintain a comfortable writing position and still keep the pen point reserved. This also helps prevent snagging if the paper is soft.

What makes this style somewhat awkward for right-handers, however, makes it supremely suited to left-handers, who can compensate with the satisfactions of this pen position for the difficulties they have encountered with the other alphabet styles of the right-handed world.

There are other ways to adapt Copperplate to the underprivileged right-hander. A serviceable imitation Copperplate, perhaps truer to its traditional origins, can be fudged with a narrow broadedged pen. Finally, though perhaps least elegantly, many working calligraphers, when requested to do just a few large Copperplate letters, simply draw each letter and fill it in.

Other letterforms, whose curves cannot be expressed with a broad-edged pen—even with skilled pen turning—can be evoked

PRESSED RONDE

abcdefghijklm
nopqrstuvwxyz

PRESSED GOTHIC

aabcddefghijkkl
mnopqrstuvwxyz

PRESSED BOOKHAND

abcdefghijklm
nopqrstuvwxyz

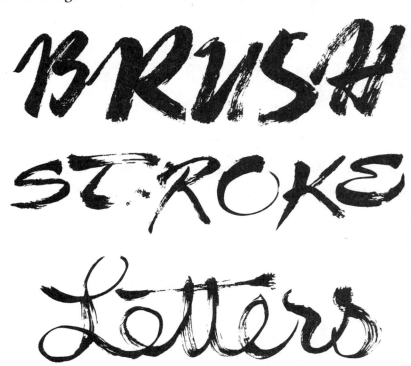

Memories & Portraits
Ivan Bunin

Pressure-sensitive brush techniques can produce the effect of pen turning. (Courtesy of Ronald Clyne.)

with the pressed line. An eighteenth-century Bodoni alphabet can be approximated with the same crow-quill pen that writes Copperplate, and will harmonize visually and historically with that style.

Ideas for new kinds of pressed lines can come from cultures that write with pressed lines routinely. Classical Roman and Chinese scripts show how varying degrees of flexibility give brush letters an expressive advantage over rigid letters. Modern calligraphers may also find unexpected rewards in exploring new tools and forms; the progress of the Western alphabet has been fueled for centuries by the creative willingness of its scribes to invent or borrow better pens and letters whenever they could. The pressure-sensitive letter seems to be ripe for serious rebirth. It is a style whose time has come, and gone, and come again.

Brush letters can be done in a great range of expressive styles.

Art

Brush calligraphy, because of its relatively lighter pressure, can reveal paper texture more clearly than pen writing. (Courtesy of Art New England.*)*

SUGGESTED READING
Brush Calligraphy by Arthur Baker (New York: Dover Publications, 1983).
Chinese Calligraphy by Chiang Yee (Cambridge, Mass.: Harvard University Press, 1973).
Copperplate by Richard Jackson (New York: Macmillan, 1979).
Lettering as Drawing by Nicolete Gray (Oxford: Oxford University Press, 1970).
Reed, Pen and Brush Alphabets for Writing and Lettering by Edward M. Catich (New York: Hastings House, 1980).
The Script Letter by Tommy Thompson (New York: Dover Publications, 1965).

THE MOVING THREAD

The Monofilament

When far off we see the four-square towers of a city, they often appear to be round.

Lucretius

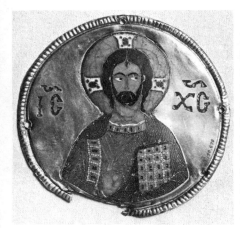

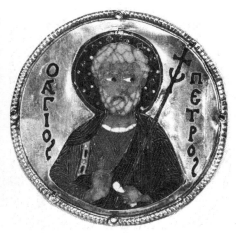

Enameled letters form a monoline. (Two medallions from a set that was on an icon of St. Gabriel in an old church at Monastery at Jumati in Georgia. Gift of J. Pierpont Morgan; reproduced with permission of The Metropolitan Museum of Art, all rights reserved.)

MANY LETTERS ARE made of monoline strokes, whose width never fluctuates, no matter what direction the pen moves in or what pressure is brought to bear on it. Words coil through our lives on an endless thread. We learn to letter in first grade, clutching a monoline pencil, meet script in third grade with monoline pens, follow the teacher's notes off a chalk-monoline blackboard, carry home faint purple dittoed monoline announcements, advance in high school to a typewriter with monoline type, fill out forms with a ballpoint pen to produce the myriad carbon copies that document our existence, order cups of coffee in a neon-designated diner, operate machinery whose buttons are labeled with Leroy-template names, read calculator numbers made from tiny tubes of light-emitting gas, take the subway to the tune of Futura type and—if we are lucky—Art Deco letters, and eat a monoline hot dog in the baseball park, while overhead an airplane slowly spells out monoline messages in the blue and cloudless sky.

The modern reader may at first glance seem surrounded by text, most of it, like this book, set in the familiar lowercase Roman of the Renaissance, the best visual device the world has seen for efficiently conveying large chunks of information. But for thousands of other kinds of reading, contemporary writing reaches outside the confines of broad-pen lettering and type. The ballpoint pen, the thin-line marker, and the technical fountain pen have shaped written letters into a monoline form so different from Roman and so ubiquitous in the visual landscape that people today seem to have two sides to their personalities—one that reads thick and thin, and one that writes monoline, with only minimal connection between them.

Because today's monoline contrasts with medieval and Renaissance broad-pen forms, it has earned a reputation among calligraphers for being fashionably, perhaps dangerously, avant garde. This is undeserved; monolines appear everywhere in the art of the Western letter, and have shaped the alphabet's development as much as the edged line of the broad pen. Egyptian hieroglyphics, Greek and early Roman inscriptions, Celtic runes, Byzantine enamels, and medieval tapestry capitals all display the visual language of the monoline.

Nevertheless, one conspicuous feature of the current calligraphic revival, indeed to some calligraphers its most definitive characteristic,

is its reliance on the thick and thin strokes of the broad-pen letter. For many scribes, the broad-edged is synonymous with calligraphy. The revived letterforms of five hundred and a thousand years ago recall a distant golden age when letters, miniatures, illumination, stained glass, architecture, costume, and religious thought were united by common visual and philosophical principles. Only Gothic letters seem to recapture this nostalgic air of unity. Yet today's monolines relate just as vigorously to each other, making a genuine twentieth-century style at least as unified as Gothic is, while still remaining well within the mainstream of calligraphic tradition.

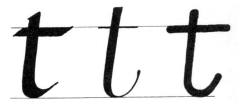

Twentieth-century logo design relies on a futuristic monoline to echo the firm's name and intent. (With the permission of Robots s.p.a., Milan.)

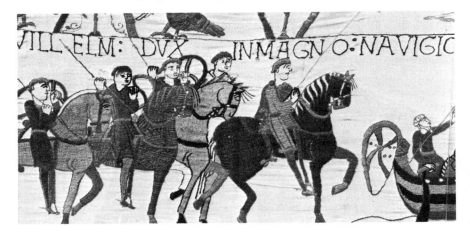

Eleventh-century monoline embroidery forms letters in this narrative panel. (From the Bayeux Tapestry, panel 37, with permission of the Ville de Bayeux.)

Monolines are not necessarily antithetical to the broad pen. Even the scribes of the Middle Ages produced with their broad-edged pens a letter whose line width does not deviate from a monoline. The type designers of the nineteenth century acknowledged this in naming their heavy monoline typefaces "Gothic," since a proper black-letter Gothic letter theoretically contains no thin strokes—only the illusion of them. An equally interesting category is the so-called Egyptian family of typefaces, which designates a Gothic (heavy monoline) letter with a slab serif of equal weight to the letter line.

Experiments in applying the monoline to traditional frameworks of letter design continued into the twentieth century. One of the most notable is the famous London Underground type design by Edward Johnston, the founder of the modern calligraphy revival. His familiarity with and championing of the broad-pen letter facilitated rather than interfered with his success in monoline type design. This letter is roughly equivalent to a monoline rendition of his broad-pen Foundational hand.

Letters written with a broad-edged metal pen, a pressure-sensitive pointed brush, and a monoline pen.

medieval monoline Gothic letter

nineteenth-century "Gothic" typestyle

nineteenth-century "Egyptian" typestyle

twentieth-century monoline typestyle

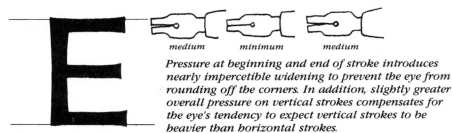

Main Course

Entrées include the house salad & selected vegetables

*Paupiettes of Sole — rolled & filled with spinach — 950
mushroom duxelle; chardonnay cream sauce*

*Catch of the Day — today's selection grilled & daily
served with saffron tomato beurre blanc*

Twentieth-century informal Italic menu lettering contrasts monoline with broad-edged pen letters. (Courtesy of Kim Victoria Kettler and Aesop's Tables, Cape Cod.)

In the twentieth century, monoline Roman capitals and small letters of every description have been tried, with varying success, for the tasks at hand. Futura type of the thirties and Avant Garde of the seventies show the range of expressiveness the monoline can convey. A contemporary monoline Italic type has recently made its appearance, a harbinger of the thousand Italic monolines that emanate from the handwriting of calligraphers coping daily with the exigencies of the ballpoint pen.

Pen turning has made other near-monoline letters accessible to the traditional calligrapher. Turning and pressing the broad pen allows the scribe minute control over nearly every aspect of monoline letters.

Some monoline letters, particularly the heavier display-type styles, are slightly weighted, so that the uprights are a little thicker or thinner than the horizontals. This subtle adjustment anticipates the

A Review for the Arts of the Book
Volume 7, Number 2, April 1981

Fine Print

Raw Materials
for Papermaking

The Types
of Jan van Krimpen

This contemporary typeface builds an Italic shape with a monoline. (With permission of Fine Print *magazine and the type designer, Gerard Unger.)*

Turning between strokes and pressing during strokes compensates for two optical distortions.

medium minimum medium

Pressure at beginning and end of stroke introduces nearly imperceptible widening to prevent the eye from rounding off the corners. In addition, slightly greater overall pressure on vertical strokes compensates for the eye's tendency to expect vertical strokes to be heavier than horizontal strokes.

A monoline stroke must be slightly broadened at the ends to appear of uniform weight. A line of strokes of truly uniform weight will appear slightly tapered.

Turning pen without changing pressure.

Turning pen while changing pressure.

Gradually turn and press the flexible broad-edged pen to control width of the stroke.

Broad-edged pen letters in historical alphabet styles can be rendered in a variety of monoline weights.

heavy monoline letters

medium monoline letters

light monoline letters

eye's tendency to see a horizontal stroke as heavier than a vertical stroke of identical weight. A slightly thick and thin letter appears to the eye to be of uniform line weight. In production of a similarly refined letter whose strokes all appear to be of equal weight, this optical illusion can be provided for by thickening the upright strokes of monoline letters. A calligrapher who is visually familiar with such subtleties can judge where to include them and where the letter will work without them.

As with broad-pen styles, monoline lettering shows a wide range of formality, from the separated, highly geometric Bauhaus letters, all the way to the imitation-handwritten logo design suitable for neon and the skeleton writing of the continuous trail of decorative cake frosting.

Monolines have fat and thin physiques and can be superimposed on the skeleton of most of the "calligraphic" hands that traditionally appear in the thick and thin broad-pen rendering; Roman, Bookhand, and Italic work particularly willingly. Greek does not even need this visual translation, as it is originally a monoline style; so are Celtic runes. Other traditional styles rendered in various monolines yield surprising results: the coils of Celtic uncial are enhanced, but its distinctive serif must be outlined or omitted; Copperplate without thick

Monolines can express letters originally based on strokes of other kinds of pen.

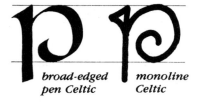

broad-edged pen Celtic / *monoline Celtic*

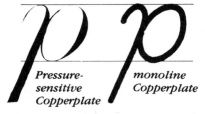

Pressure-sensitive Copperplate / *monoline Copperplate*

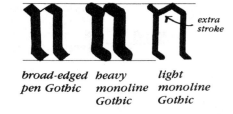

broad-edged pen Gothic / *heavy monoline Gothic* / *light monoline Gothic*

extra stroke

Monolines reveal basic letter structure.

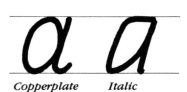

Copperplate / *Italic*

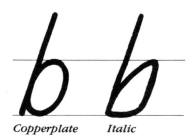

Copperplate / *Italic*

Some letters have identical structure and differ only in their pen strokes.

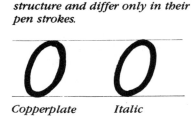

Copperplate / *Italic*

and thin subsides into garden-variety Palmer-method script; and Gothic can dissolve into a mystifying something else altogether unless a very heavy pen is used or extra strokes are added to compensate for the hairline's lack of real width.

Extra hairlines are customary in Gothic letters.

Gothic letters without hairlines become true monolines.

MATERIALS
Speedball pen, A, B, or D point
Rapidograph pen or other technical fountain pen
ballpoint pen
Flair marker
Uni Paint Marker
pencil

India ink or fountain pen ink

any paper except newsprint

TECHNIQUE
Some alphabet styles, like Gothic, are intrinsically monoline and can simply be lettered with the broad pen if all the thin lines that have crept in are ruthlessly wiped out. A determined scribe can render other monoline styles with the broad pen by turning it during the curves and between the straight strokes. For sustained monoline writing, however, you should use pens that are designed especially to give a monoline without additional effort.

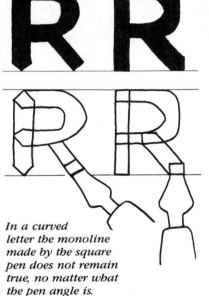

In a curved letter the monoline made by the square pen does not remain true, no matter what the pen angle is.

All three monolines contain real or optical distortion.

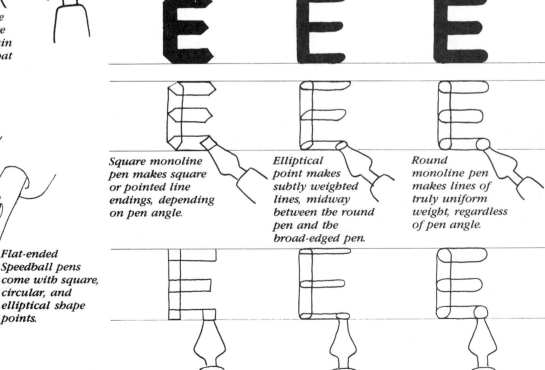

Square monoline pen makes square or pointed line endings, depending on pen angle.

Elliptical point makes subtly weighted lines, midway between the round pen and the broad-edged pen.

Round monoline pen makes lines of truly uniform weight, regardless of pen angle.

flat square monoline pen

Flat-ended Speedball pens come with square, circular, and elliptical shape points.

ABCDEFGHIJKLMN
OPQRSTUVWXYZ

ABCDEFGHIJKLMN
OPQRSTUVWXYZ

ABCDEFGHIJKLMN
OPQRSTUVWXYZ

ABCDEFGHIJKLMN
OPQRSTUVWXYZ

ABCDEFGHIJKLMN
OPQRSTUVWXYZ

Monolines express popular letter contours from different decades of the twentieth century.

A B C D E F G H I J K L M N
O P Q R S T U V W X Y Z

monoline alphabet modernized from Greek

A B C D E F G H I J K L M N
O P Q R S T U V W X Y Z

monoline runes

Bear in mind that all monoline pen points actually yield only some kind of near monoline: the subtly edged geometry of the square point, the barely perceptible weight variation of the oval point, or the technically perfect but optically distorted weight perception of the round point. Each point, moreover, shapes a characteristic square, oval, or round line ending.

Shown here are most of the traditional broad-pen styles in monoline.

Since many of the monolines in the modern visual environment are uninterrupted, the calligrapher will often imitate with pen and ink the demands of other such media as chain-stitch embroidery, cake decoration, or neon tubing. The unbroken line is particularly characteristic of thread embroidery and of neon tubing, which must be sealed off, painted black, or brought behind a backdrop to control its continuity.

All pen writing is done with a continuous line of motion, which manifests itself in inked lines whenever the pen touches the paper; other motions made in the air leave no record on the paper. Forcing the pen to remain in continuous contact with the paper will show you the pen's entire path and will give the pen monoline extra stylistic unity with other continuous-line media.

Pen letters that are meant either to imitate other media, such as neon and chain stitch, or ultimately to be rendered in other media should be designed with the constraints of those media in mind. A continuous line looks better—that is, more real—if it loops around itself in comfortable curves that lie flat than if it piles up in sharp turns that topple over.

SUGGESTED READING
Let There Be Neon by Rudi Stern (New York: Harry Abrams, 1979).
The Letter Forms and Type Designs of Eric Gill, with Notes by Robert Harling (Boston: David Godine, 1977).
The Mystic Art of Written Forms by Friedrich Neugebauer (Natick, Mass.: Picture Book Studio USA, 1980), Lessons 1–4.

Some traditional alphabets originated as monolines.

Italic letters fit inside half a slanted rectangle.

Most of the letters are A-body letters (a, c, d, e, f, g, q, u, y) or B-body letters (b, h, k, m, n, p, r).

Some Italic letters connect points on the rectangle (o, s, v, w, x, z).

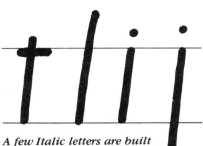

A few Italic letters are built around a straight stroke.

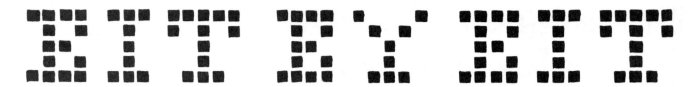

BIT BY BIT

The Mosaic Image

E pluribus unum.

motto of the
United States of America

THE EARLIEST, most fundamental kind of letterform is the answer to a simple on-off test: where the viewer expects something, is an object there or not? And if this question is posed and answered more than once, the objects that are present can be connected to each other to convey additional meaning. The presence or absence of a mark at a predetermined location conveys information quite apart from any other attributes of that mark. A boot print in the woods suggests that a person walked there in the recent past; the image is clear, but the walker's intent is not. That print could be interpreted in a number of ways. It might mean that the person was lost, was following a shortcut, or was avoiding the trail. A cairn of stones, on the other hand, carries a clear message by its presence: a person passed this way, no matter how long ago, and marked it with the intention of guiding others. This cairn does not resemble or portray anything; it is not the image of anything. Its presence or absence means something.

Cairns—and all letters made from separate bits of material—can be any shape or size. They can be as evanescent as Hansel and Gretel's breadcrumbs or as immutable as Stonehenge. They can range in dignity from the pile of stones that means "fallen hero buried below" to the pile of coats that means "cocktail party happening above." But they all share certain characteristics that lay the groundwork for a variety of complex visual information.

(Courtesy of the Goodyear Tire & Rubber Company.)

To begin with, the cairn is distinct from its background. A cairn of round stones on a field of round stones can mark an invisible path through the stones if the arrangement of the pile could not possibly have happened by accident. Even a single object can mean something if its position clearly could not occur in the natural course of things. In the same way, an object is "present," for informational purposes, if it is different enough from the local materials to show that it was brought to the location with the intent of contrasting with the background.

In addition, a collection of objects can be descriptive if, while conveying a message by its mere presence, it also communicates other information by its shape or orientation. A cairn of stones means "you are still on the path; look for the next cairn within a reasonable radius

of this cairn in some direction." The same stones arranged in a row add the extra information "Head that direction." A heap of beer cans implies a party in progress or in the recent past; the same cans arranged to resemble a Greek letter adds the information that this is or was a fraternity party.

Finally, any image made from bits of material reflects a number of visual choices made by the designer, which combine to convey an artistic message. These choices can be analyzed and applied to all kinds of built-up symbols from many media and for many purposes.

Mosaic letters fit the human eye in a particularly comfortable way; the human retina is made up of more than three hundred million photoreceptors that receive images bit by bit and to a great extent connect the dots before transmitting the image to the brain for further processing. The eye and brain are powerful pattern-recognition devices; given a fragmented image, they will strive to establish connections by trying out visually similar shapes from prior experience and by using clues from the context to smooth over gaps.

Because the eye is so willing to link bits of information to make a continuous image, the built-up letter offers a wide range of expression. All aggregate images, from ancient Greek mosaics to marching bands, can be understood and described according to nine visual characteristics: resolution, scale, density, topology, orientation, array, bit shape, color, and style.

Resolution depends first on how coarse or fine the mosaic is—the relative sizes of the letter and the bits of materials of which it is made. The letters of the alphabet, because of their limited number, individual distinctiveness, cultural familiarity, and use in context, can be rendered in extremely coarse grain and still be read. Although a grid of 5 × 5 units per letter seems to define the lower limits for representing all twenty-six letters without ambiguity, an even coarser grid can convey some of the letters quite clearly. A progessively finer grid allows for clearer readability, serifs and swashes, smoothed curves, and other niceties.

Addressability is involved when clues are given to show the viewer that some groups of bits are being treated as a unit. A very fine grid can still deliver a letter of coarse definition if each bit of information is not *addressed* individually.

The grid itself can swell to encompass the letter and still make its presence felt. The classic Roman capital lived for centuries in an invisible box, and typesetters, typewriters, and designers have continued this contained visual approach that echoes the mosaic nature of the letter.

The encompassing grid permeates our lives even at play, in chess, Scrabble, Bingo, alphabet blocks, Rubik's Cube, and the crossword puzzle. Symbols contained in squares shape a four-thousand-year-old game from ancient Egypt.

In addition to the relative size of the letter and the bits it is made

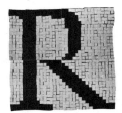

32 × 32

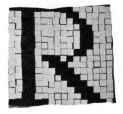

16 × 16

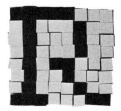

8 × 8

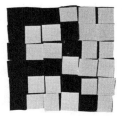

6 × 6

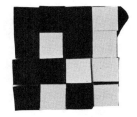

4 × 4

2 × 2

Grids of increasing coarseness define the letter R.

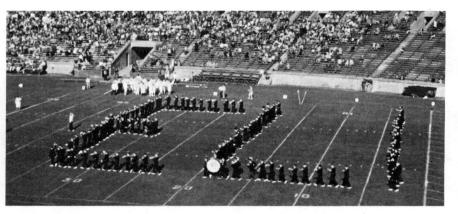

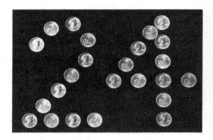

Twenty-four silver dollars spell out an award that symbolizes the original purchase price of Manhattan Island. (With permission of The Museum of the City of New York.)

Musicians line up to form moving, sound-emitting letters. (Courtesy of Jack Brandt.)

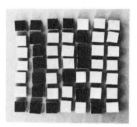

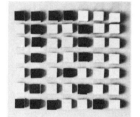

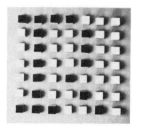

A decreasingly dense grid.

up of, the eye deals with absolute scale relative to the human eye. Since the eye itself sees in mosaic fashion, the real size of the grid, as well as its size relative to the image, can make it seem coarser or finer. The eye tolerates at small size things it can't ignore at large dimensions. Thus the insignificantly jagged contours of a dot-matrix letter ¼ inch high become glaring and unbearable when that letter is enlarged to four inches. Similarly, an image seems larger and less smooth as it gets nearer.

Mosaic letters can also vary in their density, the distance of each bit of material from the next. The space between the bits is commonly filled with grout, lead, sand, mortar, or other supporting material that both physically and visually fills the interstices of the grid. The eye, surprisingly, seems to prefer sparse to dense fill, and can visually fill in gaps and draw connecting lines in a low-density letter almost more readily than it can smooth away the extra bulk of rough solid corners in a dense one.

Grids, in fact, are seldom completely filled, usually allowing for grout to be added in each square for uniform background tone and permanence. Sometimes this filling is uniform; other times it can convey information.

Grids of all kinds are subject to the laws of topology, the science of surfaces. A grid can appear to be distorted, squeezed, stretched, or viewed from unusual perspectives, all without any other change of configuration, to yield a letter that catches and intrigues the eye.

Grids do not have to be filled by small anonymous bits of material. Almost any object of any shape can make up a letter—beans, nuts, coins, stitches, musicians, light bulbs, or flowers. The identity of the individual units that make up a letter can either reinforce the meaning of the built-up letter or entertain the viewer with the discrepancy.

Color increases design potential. Material can vary from light to dark and be of any hue in the color wheel. Colors can make letters and their background appear to advance or recede in relation to each

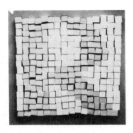

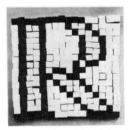

Mosaic letters can be expressed with high or low contrast.

other. Mosaic letters can be made of just two tones that contrast sharply with each other, so there are only two possible choices for each bit in the grid, or they can be composed of selections from an extensive range of shades and colors.

This breadth of choice is a particularly important option for the designer who has no way to increase the fineness of a grid and yet wants to increase the apparent resolution of the letters and smooth out the jagged edges of curves. The eye can, to a certain extent, be led to believe that a square is divided into half black and half white if it is fifty percent gray all over.

The square grid has been used so far to illustrate the range of expression that is available by manipulation of mosaic letters. Letter

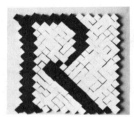 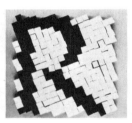

Mosaic letters can be oriented to their backgrounds at a number of angles.

shapes, however, can be superimposed on grids of many kinds. The simplest change is a change of orientation. Many traditional mosaics and tapestries incorporate letters that tilt, wander, or follow the circumference of a circle, so that the orientation of the grid is slightly different for each letter. This kind of layout may necessitate a relatively finer grid to keep the demands of the changing orientation from overpowering the style of the alphabet.

Array can be visualized as a network of imaginary lines that con-

To see effect, hold page at arm's length and squint at the illustration on far right. Its intermediate gray tones fool the eye into perceiving greater resolution and reducing jaggedness. (Courtesy of Bitstream, Inc. Photographer, Dawn Smith. © Bitstream, Inc.)

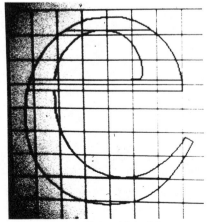

Character outline with grid.

One level of color (black).

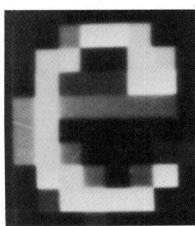

Several levels of color.

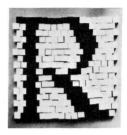

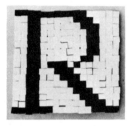

Identical pieces can be arrayed differently.

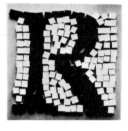

The grid of the mosaic bits can dominate the letter, or the letter can dominate the arrangement.

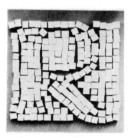

This all-white mosaic can still be read by following the edges of the subservient array.

nect the centers of the mosaic bits. It is not concerned with what happens at the bits' edges; the pieces may almost fit, with only slightly nonuniform spaces, or they may produce awkward gaps that fight with the letter's contours. Mosaic pieces can line up in regular geometric arrays, random distribution, or follow the contours of the letter they form.

The array can be dominant or subservient. A dominant array does not change to express different letters. A subservient array is different for each letter and follows, to the degree allowed by the edges of the pieces, the contours of the letter shape. A subservient array can be read "blind."

Letters can be mosaic in nature but lack a background. Either dominant or subservient arrays can stand alone, or the background can stand alone.

Any object of any shape can occupy the mosaic grid. Nonsquare and irregular objects can be lined up to fit the square grid, or their outlines can assert themselves to determine new arrays. Regular pieces of material in familiar geometric shapes of circles, equilateral, right, and isosceles triangles, squares, rectangles, pentagons, hexagons, and octagons can fit with themselves or with each other to cover the surface without spaces.

Pieces of different shape or orientation can be used in place of a different color to contrast a letter with its background. This kind of mosaic will not retain legibility at a distance, but effects of great subtlety and originality can be achieved. Even a grid of identical pieces of material can be read if some of the pieces are slightly rotated. This technique can be combined with other design choices to heighten the effects of color contrast, density, and orientation.

Irregular pieces can be used in a number of ways: to fill in around regular ones in either letters or background; to create new irregular mosaics; or to be reassembled along their fracture lines. These pieces can be broken geometric shapes, truly irregular, or fractured along

A second-century mosaic at Carthage contains letters built on subservient array. (With permission of the photographer, Brian McCallen.)

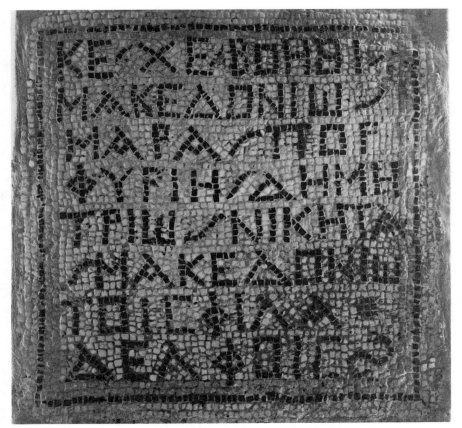

Rotating some pieces in this square grid makes an intelligible letter.

Fifth-century mosaic letters in subservient array offer less detail than the Carthage mosaic at bottom left. Compare the resolution of phi *in the last two lines with the elegant arrangement of bits around* phi *in the other mosaic. (Gift of the Department of Classical Art; reproduced with permission of The Museum of Fine Art, Boston.)*

nongeometric but still highly organized lines. Many organic non-repeating patterns, like sunflower centers, chambered nautilus shells, or ceramic crazing, can accept letter shapes. Some already existing formal systems of nonmatching pieces, such as the Oriental tangram, can be enlisted in the process of visual experimentation with letters.

The specialized mosaic components of liquid crystal displays, which portray a small and predictable selection of characters, can be limited to a specific grid of interchangeable parts that allow just

Interchangeable parts fit together to create these sixteenth-century Gothic letters. (From Of the Just Shaping of Letters *by Albrecht Dürer, Dover Publications.)*

enough choice to distinguish the letters of numerals from each other. Several traditional alphabet styles that have been revived for contemporary calligraphy are taught in letter families according to this assembly-line principle of providing a basic kit of a few strokes that can be combined in various ways to form twenty-six distinct letters. The components can be specialized or general-purpose; while a formal

Leaving the joins incomplete reveals the mosaic nature of some simple alphabet styles that are built up of a small number of interchangeable basic strokes.

Gothic style demands perfect dovetailing, whole and half chopsticks will do for the child who wants to practice spelling while he waits for the waiter to bring his Peking ravioli. Limiting the selection of basic strokes throws the calligrapher back on his mental resources. How can a message be expressed with the fewest M&Ms on a birthday cake, or a request for aerial help spelled out with the sleeping bags of six marooned campers?

MATERIALS
broad-edged pen, brush, or marker
Speedball pen, A, C, or D point

graph paper

mosaic tiles, sugar cubes, marbles, or any other small, uniform
 objects

oak tag paper or file cards

scissors

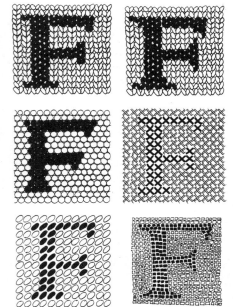

Knit, duplicate stitch, beaded, cross-stitch, needlepoint, and mosaic versions of the same letter.

TECHNIQUE
To design a mosaic letter for any medium, first consider the design choices that will be right for your needs. There is no point limiting yourself to a square grid if your letter medium does not demand it, or trying to stretch a grid that will not tolerate it. Look, too, at the exact shape of your bit of material and check whether its array is square, near square, or of another pattern. A needlepoint letter will not transform directly to a knitted one without some alterations and may even surprise you when you try it in cross-stitch. Be sure that your design takes into account all the basic characteristics of your chosen medium. Remember, for example, that the visual difference between duplicate-stitching and knitting is in the reduced addressability and color range of the knitted letter, or that the difference between a marching band

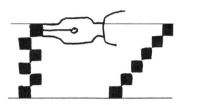

Pen strokes determine letter height for any nib width.

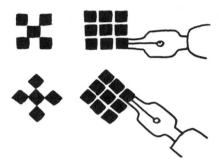

Pen strokes can form mosaic designs. Work with two different colors to design letters on backgrounds.

Various pens and pen strokes produce mosaics of different character.

and a seated card section is in the availability of color changes, the presence of a background, and the potential difficulty of maintaining the array. Learn to see analytically, probing for similarities and contrasts among different media.

Beginning with a square grid can let you observe and experiment with those designs that do transfer readily from one medium to another and also to make the greatest use of the familiar broad-nibbed pen of the traditional calligrapher. A precise square bit can be made easily with a short stroke that is the same length as the width of the pen. For now, avoid using graph paper to align the strokes. Part of the initial exercise is to strengthen your sense of the imaginary horizontal and vertical lines the page creates. If you are disoriented, use a pad of lined paper to remind you of the horizontal, but try to avoid relying on the lines as measurements for your grids.

One mosaic fragment already familiar to some scribes is the small stack of pen strokes used to determine the correct height for a letter to be done with a particular width of pen. Turn the pen and, working from the bottom up, make a row of squares. These are usually offset into a stick of two rows or a diagonal march so that the scribe can clearly see the corners and make sure that they just meet without overlapping.

Now you can write a square grid made up like a checkerboard of alternating full and empty squares, and orient it along 90 degrees or 45 degrees. If you want to fill the empty squares with pen strokes as well, you can reduce the density of the mosaic to allow for a thin space between individual strokes, so that instead of a checkerboard you have windowpanes. Letters that you invent in this way can translate into a multitude of other mosaic media.

Pen strokes of other shapes can instantly change the topology of your mosaic or can be repacked into the same space to offer new design possibilities. With very little distortion, the pen can approximate the effect of brick, tapestry, woven, knitted, or even computerized letters. Gradually expand your repertoire of different pen strokes and try different combinations to see what happens when you duplicate and rearrange them.

You may be pleasantly surprised to find that the mosaic grid is hospitable to a wide variety of letter styles and decorative elements. Don't automatically choose the one that puts the fewest demands on the medium and the viewer. And don't underestimate the creative potential of grids that are slightly finer than the minimum demands for legibility.

Some of the newer pens available to the calligrapher offer strokes that can make specialized mosaic letters. A fat flat circular monoline pen makes dots, while a square flat monoline pen shapes the familiar edges of the segmented character display.

Finally, go back to the alphabet styles of traditional calligraphy and look with a fresh eye at the mosaic nature of each. Try variations

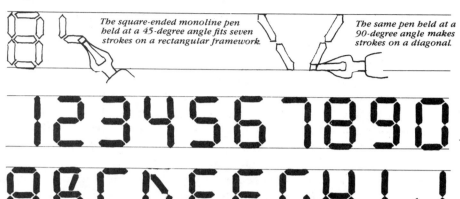

The square-ended monoline pen held at a 45-degree angle fits seven strokes on a rectangular framework.

The same pen held at a 90-degree angle makes strokes on a diagonal.

Numerals can be constructed without leaving the rectangular frame.

of these pen letters based on their underlying kinship with the vast visual family of letters made up of bits of things.

The modern calligrapher is frequently motivated, or requested, to translate traditional letters into media other than pen and ink or to integrate letterforms into lessons about other techniques of visual art—there may be a job to complete or a class to teach. Mosaic letters can be explored with many simple materials: graph paper, ceramic tiles, sugar cubes, marbles, computers, and specially cut bits of eraser, wood, foam-core board, or cardboard. Beginning calligraphy students, particularly young or poorly coordinated ones, can grasp the principles of the Gothic alphabet style much more easily if they first move around some real squares and parallelograms to form letters and then apply this visual understanding to creating the letters with a broad pen.

SUGGESTED READING

Mosaics: Principles and Practice by Joseph Young (New York: Reinhold, 1963).

Of the Just Shaping of Letters by Albrecht Dürer (New York: Dover Publications, 1965).

On Growth and Form by D'Arcy Wentworth (Cambridge: Cambridge University Press, 1952).

Tex and Metafont: New Directions in Typesetting by Donald Knuth (Bedford, Mass.: Digital Press, 1979).

SOFT EDGE

The Diffuse Presence

*. . . but until now I never knew
That fluttering things have so distinct a shade.*

Wallace Stevens

Hard-edged letter. Soft-edged letter.

the image *what the
eye transmits*

*The eye heightens contrast even
along a clear boundary.*

the image *what the eye
transmits*

*The eye sets an edge when the
image is ambiguous.*

SOME OF THE EARLIEST art done by Neolithic human beings utilized a technique that is considered avant-garde today: the soft-edged line, made by blowing pigment onto a surface. Unlike many other artistic media, the soft-edged line can create an image without any tool having touched the surface. The distinctively twentieth-century element of chance is introduced and welcomed as an integral part of the process of getting pigment through the air onto the page. Old as these soft-edged lines are and experimental as they seem today, much of the understanding of how the eye actually sees them is still in the future.

Like the mosaic letter that is made of pieces of information, the soft-edged line is made of particles that the eye interprets. The soft-edged letter is unique, however, in the distribution of those particles and how the eye sees them. Its essential characteristic is what ought to be its ambiguity, and its visual importance lies in the way the human eye resolves that ambiguity.

The human eye is extremely interested in edges and will devote most of its available neurological energy to delivering detailed information about boundary areas, while only roughing in the enclosed areas where nothing seems to be going on. In the retina at the back of the eye, before an image is transmitted to the brain, border areas are given a little visual boost to heighten contrast and foolproof them against possible ambiguity. Even when the edge is in unequivocal black on white, the eye exaggerates the contrast; the blacks are made blacker and the whites whiter where they touch each other.

The eye's ability to heighten existing contrast is of great use when it encounters two adjacent tones of low contrast. The eye readily distinguishes a gray letter on a slightly paler gray background, not by struggling to register the faint gray boundary between the two areas of tone nor by reporting the exact tones of the two areas, but by exaggerating the contrast along the boundary where they meet. The seemingly "all-black" paintings of Ad Reinhardt, which after minutes of careful observation reveal slight contrasts between the black hues in different quadrants of the canvas, illustrate the exquisite sensitivity of the eye to the most minimal differences in tone.

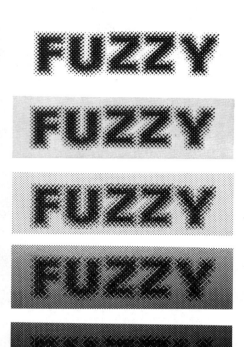

Darkening the background seems to make these fuzzy letters smaller.

The eye is not limited, however, to accentuating a faint but already existing boundary. When the eye cannot find a sharp "edge," it simply makes one up—and adds several extra backup edges next to it to ensure that the image will be sharp in the brain. These created edges, known as Mach bands, can actually be seen on the retina in laboratory experiments, but the conscious brain is not aware of them. The bands are decoded in the brain so that the eye can detect an edge where none objectively exists.

Thus, when a fuzzy letter with no clearly observable edges strikes the retina, an edge has to be invented somewhere along the gray continuum from black to white. Where exactly the eye decides to put this edge depends on several interacting factors: the starting and ending tones of the gradation, the texture of the surface, the contrast with the background tone, the overall brightness of the ambient light, and the cognitive clues to the probable shape that the edge is creating. The most common such clue in dealing with soft-edged letters is that there is likely to be one tone of gray for the letter and another, usually lighter, tone for the background, and the eye simply needs to establish ground rules for where one leaves off and the other begins.

Once the eye has made a determination about which tone of gray indicates letter and which indicates background, it does not need to keep deciding this for each boundary. A precedent has been established for that particular viewing experience. Sometimes a clue in one area of the image can provide the key to the tone of the whole and help to decipher ambiguous shapes in other regions.

The contemporary photographic process of Kodalith posterizing approximates, crudely, what the eye does, elegantly, with the problem of turning an analog or continuous-tone image into a digital one. The film in this process "sees" all grays that are lighter than some arbitrary midtone as white, and all grays that are darker than that midtone as black. Where midrange tones are uneven or the process imperfect, however, the camera bogs down, and mottled or visually garbled areas emerge. It is to eliminate just this kind of ambiguous area that the eye evolved a way to create and emphasize boundaries. While a soft-edged image is a challenge to mechanical photographic processes and to the reasoning powers of the conscious brain, it poses only a routine visual task for the retina itself.

The fascination of the true soft-edged letter is that while you know visually that an edge exists, you cannot—and need not—objectively locate where it is. Your eye does that for you. This distinguishing characteristic of the soft-edged image comes from the distribution of pigment, which normally follows natural laws of randomness, letting the eye determine edges rather than giving visual cues. The concept of randomness in the visual arts has been thoroughly explored, giving the calligrapher some theoretical framework to amplify what can be learned by simply looking and thinking.

The most ambiguous and therefore the most visually intriguing

distribution of pigment follows the outline of a bell-shaped curve, the same distribution that exists in the natural world at the edges of shadows and sprays. Randomness can be created in a number of ways, through airborne pigments, camera focus control, diffused shadow, or prepared graded surfaces.

Soft-edged letters, like mosaic letters, may also be made of a wide variety of particles—dots, lines, real objects, shadows of real objects. As long as the distribution of particles is characteristically indeterminate and the eye is guaranteed its proper role in deciding where it wants to see the edge, soft-edged letters can safely mimic many of the characteristics of mosaic letters. They can be similarly categorized in terms of their resolution, scale, density, topology, orientation, array, bit shape, color, and style.

One of the most important aspects of the soft-edged line is its resolution. Like mosaic letters, soft-edged letters can be made of large, visually distinct pieces or of bits smaller than 0.1mm, the threshold of visibility. Many familiar soft-edged lines are made up of these particles "smaller than the eye can see" (that is to say, smaller than the brain can see), and the eye performs virtuoso feats of visual perception that turn imperceptible boundaries into hard-edged information and nearly scrambled images into coherent ones.

The soft-edged letter, however, is a prodigious waster of particles, and where resolution is low and every bit of information must count, soft distribution is a very inefficient way to convey information. The statistical uncertainty about the exact placement of each particle makes it hard to get much across to the viewer. Furthermore, the inevitable overlapping of particles in the dark areas and the needless dusting of particles over the light areas, while it does not necessarily interfere with perception, simply wastes a lot of particles in redundancy. On the other hand, for some purposes soft-edged letters make eminent good sense because of the eye's willingness to overlook the imprecision in placement. In high resolution they can be particularly efficient just because the boundaries and not the large areas carry most of the information.

High-resolution soft-edged letters can be made with an airbrush, fixative blower, camera focus control, or aerosol spray can. One of the simplest and most familiar soft-edged lines is made of airborne dots of pigment distributed from a nozzle onto a flat surface. The particles radiate from the nozzle in decreasing density. And while the writer cannot control where each dot will go, the line can be shaped by precise control of the distance of the nozzle from the surface, the angle of the spray to the surface, the speed of the nozzle's movement, the ratio of air to pigment, the size of the nozzle opening, the shape of the nozzle opening, the size of the individual dots of pigment, and the opacity and reflectivity of the pigment. The spray can be continuous or intermittent.

Soft-edged letters combine readily with the use of stencils. The

The eye can discriminate between almost identical shades of black. (Courtesy of The American Foundation for the Blind.)

Soft-edged letters can be expressed in a variety of media.

stencil is, in essence, a continuation of the nozzle; it directs or interferes with the natural tendency of the particles to radiate in all directions from a central source. The position of the stencil can vary all the way from nozzle to frisket, from directly in front of the source to flat in contact with the image surface. The edges of the stencil may be rough or smooth; the stencil material may be impervious to the airborne particles or may let some of them through. In every case, the effect is to alter the random distribution of pigment at the edge and substitute some other pattern of distribution.

Stencil letters may be inlined or outlined. Many overlapping images may be built up, either in distinct layers or in intermingling ones.

Ambiguous edges can also be created by using water instead of air to distribute the pigment. A sheet of wet paper can gradually diffuse ink into the background.

Light itself can contrast with shadow either sharply or in diffusion. A stencil can shape the edges of light that hits a page, just as it shapes airborne pigment. Alternatively, a sharp photographic image can be fuzzed by defocusing the camera lens.

MATERIALS

spray mechanism such as:
 fixative blower
 spray paint can
 empty household spray bottle
 perfume atomizer
 airbrush and compressor

water-based ink or paint
papertowels
food coloring

TECHNIQUE

The airbrush, the tool that offers the finest control in creating soft-edged letters, is also the most expensive and the hardest to learn to use. Many other simpler and cheaper tools exist, however, which have some of the same features. If you are adventurous, you can use them to gain hands-on experience with the visual effects of soft-edged letters.

Sprayed letters, similar to airbrush letters, can be made with an aerosol can of paint. The can's nozzle makes a wide stroke of pigment and generally allows little control over its width. Some nozzles are available that make a faintly "broad-pen" stroke with thick and thin directions. Commercially available aerosol cans contain enamel paint, which makes an opaque image on the surface.

Hand-operated pump spray bottles are a familiar item in kitchen and laundry, and after they are emptied of their cleaning fluids they can be used to spray any liquid dye or pigment. Such bottles cannot provide a constant spray, however, so they best lend themselves to

SOFT-EDGED ALPHABET

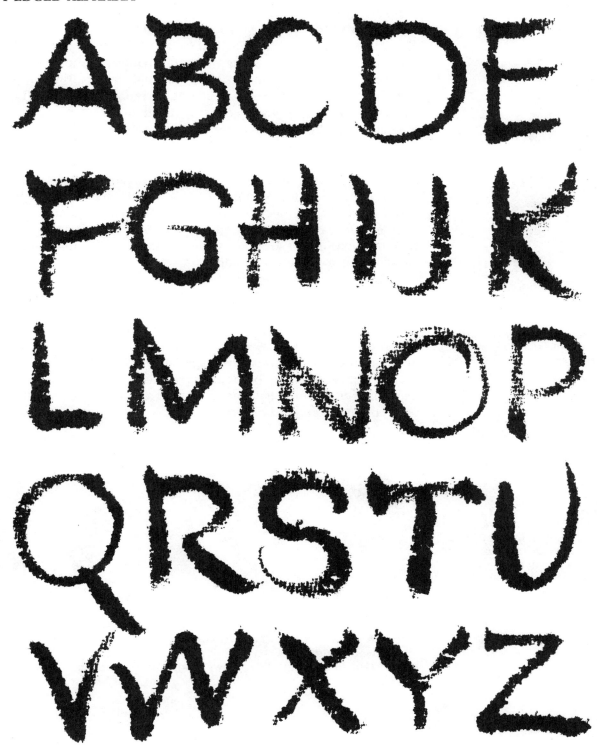

This alphabet was done with a pointed brush on a dry paper towel.

built-up, multilayered effects or letters with short strokes. Empty perfume atomizers, too, produce short bursts of spray.

A fixative blower lets you use your own breath as the air source to make as long a stroke as your lung capacity allows. It also is easier to clean and to change from one bottle of pigment to the next.

Wetting a sheet of absorbent paper and then writing on it with water-soluble ink can make fascinating and unpredictable soft edges. Different effects are controlled by the length of the fibers that make up the paper and the strength of the sizing, the thin layer that coats many papers to reduce their blotting ability. Blotting paper or paper towel will diffuse ink most quickly; watercolor papers offer a wide range of absorbency; sumi papers from the Oriental calligraphy tradition are increasingly available for experimentation. The thicker the paper, the easier it is to handle once it is really wet. Thin papers tend to curl and buckle unless carefully pressed while drying. Some papers and inks will sustain repeated soaking, inking, and drying, allowing you to overlap different tones and line edges.

Other forces on the simplest of materials can produce visually interesting soft-edged lines. A soft pencil on rough paper, applied in layers to approximate a graded edge and then rubbed to merge the gradations, can give you great control over the contours of the soft-edged line. A pencil eraser can eliminate single strokes that grade a pencil-rubbed area from white paper to black background. Pressure with a semi-soft eraser or blunt instrument on the back of carbon paper makes a soft image, and even a fingertip or a fingernail can be used to write with carbon paper.

Spraying at an angle to the paper makes a stroke with one sharper, harder edge and one softer, drifted edge.

Diffusion can be directed, as in these wet letters on a vertical surface. The ink responded to the pull of gravity by spreading downward and to the forces of diffusion by spreading outward.

SUGGESTED READING
Air Powered by Elyce Wakerman (New York: Random House, 1979).
Airbrush: The Complete Studio Handbook by Radu Vero (New York: Watson-Guptill, 1983).
Eye and Brain by Richard Gregory (London: Weidenfeld and Nicholson, 1966).

II.

NEW
VISUAL PURPOSES

Enough of words.

Sophocles, *Oedipus at Colonus*

CALLIGRAPHERS who have learned some of the many techniques for shaping letters on the page can then apply their knowledge to the variety of graphic purposes that pen strokes serve. Not every pen stroke forms a letter, nor is every letter written to be read. The ink that makes images also defines spaces. The pen that writes letters writes serifs, swashes, and pictures as well. And calligraphers who turn their pen to these uses will expand their concept of the pen's capabilities.

SPACES SPACES

The Defining Line

Well-timed silence hath more eloquence than speech.

Martin Farquhar Tupper

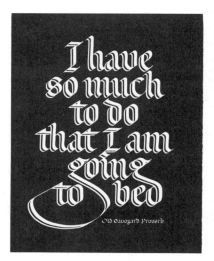

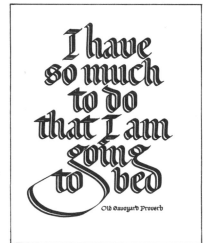

The white letters above seem to carry more weight than the black letters below. The thin line in the middle of each stroke seems consumed by the white around it, but dominates the black stroke. Black and white letters look equivalent if the black ones are slightly heavier.

BECAUSE THE PEN puts ink marks on the page, calligraphers usually begin learning to letter by controlling black ink on a white background. To the informed eye, however, calligraphy consists not of black marks but of white spaces. Calligraphers who learn to watch the spaces taking shape under the pen will add a valuable visual skill to their technical expertise.

There are many different kinds of space on a lettered page. Some of the simpler areas are the larger spaces in the margins and between the lines. The smaller spaces between words, between letters, inside letters, and within the letter stroke are increasingly complex. The more carefully the eye looks, the subtler and richer the spaces become. Spaces of different scale and depth can coexist and overlap; the spaces made by grouped letter shapes form building blocks for larger shapes.

The calligrapher can deal with graphic space indirectly, shaping it with black strokes on a white background, or directly, writing with white on a black background. Shifting the eye's attention will accomplish the first; several new techniques and specialized materials will help accomplish the second.

The most important step is to educate the eye to what happens when ink is seen on paper. A black image on white will appear smaller than a white image on black, no matter what its shape or edge is like. The same image, transformed photographically from positive to negative, will not look the same without some compensating weight either added or taken away. The architecture that modifies the shape of the simplest letter stroke makes allowance for these basic optical illusions. The calligrapher can begin learning about space from the emptiness that is created within the stroke itself when figure and ground are reversed.

The space inside the letter, shaped by the black strokes of the typical alphabet, is the next concern. This space takes shape as the letter strokes are penned and joined together. What shapes the pen's path is not always identical with what shapes the letter's space; a broad pen, for instance, that travels in a perfect circle to write an O creates an elliptical space inside the letter.

The stroke of the pen shapes the space just outside a letter, too. The same O whose pen path is circular and whose interior space is

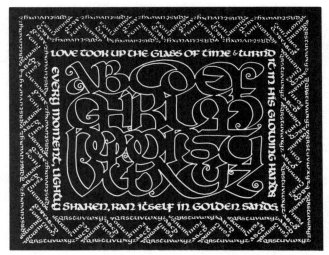

elliptical occupies an elliptical exterior space on an axis perpendicular to the interior space. A symmetrical inner space may coexist with an asymmetrical outer one. Minute, nearly imperceptible changes in the structure of the letter or the weight of the stroke can affect the balance between the two spaces.

The space between one closed letter and the next can be described simply; the space between open letters is more complex. Open letters let inner and outer spaces touch each other at an invisible boundary line, a kind of impermeable elastic membrane between two cells.

Spacing between words and between lines interacts with the overall texture of the chosen letterspacing.

The latest findings of psychological research show that, at their most basic conceptual level, reading and writing are the grasping of spatial patterns made by groups of letter spaces, not the sequential processing of a series of letter strokes. By learning to direct the eye of the viewer to the visual dynamics of space on the page, the scribe will understand how to shape space with the stroke of any pen.

MATERIALS
brush or dip pen
white paint or ink

Winsor & Newton removable resist material or rubber cement

pen dipped in laundry bleach
colored paper

Marvy Color Tricks pens

construction paper
scissors
glue
scratch board (white board coated with black paint)
scratching tool

Letters can be reversed photographically to drop out of a dark background, or so that just their outlines drop out.

simple geometric straight lines and curves

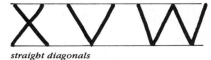

straight diagonals

nongeometric curves

internal spaces that flow into external ones

ascenders and descenders

Every alphabet contains categories of letter combinations that generate different spaces.

Chemical bleaching lightens the background color.

A rubber-cement-resist letter.

TECHNIQUE

In traditional calligraphy, white shapes are formed indirectly on the page when black ink is applied with a pen. Learning to pay attention to these white shapes requires a shift in attention, but no special new materials or techniques. There are many special techniques, however, for creating white space directly, which can be used to produce finished work and to try visual experiments.

You can produce light hand-lettering on a dark background in a number of ways, depending on the materials at hand and the ultimate purpose of the work. Many works of calligraphy are intended to be exhibited as is when they are complete; these "one-off" pieces pose a challenge to the calligrapher who wants to reverse the usual coloration of dark letter and light background. If the existing surface is dark, then use either opaque paint to lay a lighter image over the dark surface or abrasion or chemical bleaching to remove color from the background. (Transparent ink of any color, even a shade lighter than the background, will simply add to the background color, making the letter darker than its background and thus defeating the purpose.)

Instead of lightening the letter stroke, you can darken the background. Write the desired letters with a resist material, apply dark tone overall, and remove the resist. Light letters will remain where the resist prevented the tone from touching the surface. You can also make light letters on a dark background if you outline and fill in the surrounding background by hand and leave the paper surface blank where the letter is. It is important to remember to outline the space, not the letter, as the width of even a very narrow outline may eat into the letter's contours.

Cut-paper letters can create letter space out of any shape of background. Pieces may be trimmed out and removed to form serifs, or simply shifted in relation to one another.

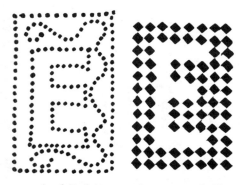

A white letter can be surrounded by virtually any kind of background.

When the work is intended not for immediate viewing as is but as an original for subsequent reproduction, the job is easier. Black letters on a white background can be photographically reversed into white letters on a black background. Mark your black-on-white original "reverse dropout" and send it out for stats or give it to a printer. You will find that letters change when they are lighter than their backgrounds, a white letter appearing to occupy more area than a black one. This is particularly noticeable in small letters when the letter is first written

in black on white and then a reverse dropout is made. You can allow for this by using a lighter-weight letter stroke.

When you work for print reproduction, take particular care to compensate in advance not only for these optical distortions of white on black, but also for the possibility that the printing process itself will physically squeeze ink into the white areas. You may find that while you have to narrow the heavy parts of the letter, you must also strengthen the more delicate ones.

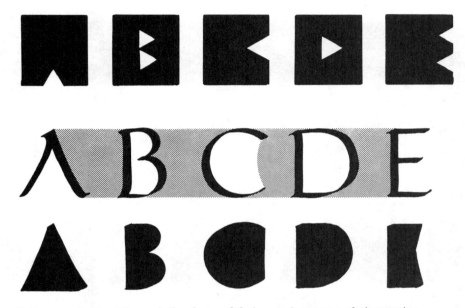

Letters can be read through the shape of their exterior spaces, their exterior contours, or the placement of their internal spaces.

A heavier and heavier H is implied by the position of these identical cutouts.

When experimenting with letters and spaces, you may enjoy working with cut paper. Here exterior and interior spaces start out united and the letter nonexistent. The balance between image and background, and its impact on legibility, can be explored by moving the pieces of paper farther and farther away from each other.

Letters can give up either their exterior or their interior spaces and still be read. These spaces can be bounded by the letter stroke or can include it. Solid letters can be center-punched with abstract shapes, representative forms, or other letters, to test the eye's capabilities.

SUGGESTED READING

Gödel, Escher, Bach: An Eternal Golden Braid by Douglas Hofstadter (New York: Basic Books, 1979).

A Renaissance Alphabet by Giovan Francesco Cresci by Donald M. Anderson (Madison, Wis.: University of Wisconsin Press, 1971).

The World of M. C. Escher by Maurits Escher (New York: Harry Abrams, 1972).

SERIFS

The End of the Line

A beginning is the time for taking the most delicate care that the balances are correct.

Frank Herbert, *Dune*

Rounded serifs characterize this sixteenth-century Italian manuscript by Francesco Moro. (With permission of The Victoria and Albert Museum, Crown copyright.)

FG

A variety of set-pen angles adds serifs to this seemingly monoline style.

LETTERS ARE MADE UP of strokes. Where the strokes do not join each other they can end with a serif. Serifs allow the scribe to shape the letter stroke with great distinctiveness, variety, and control. Since a small, simple change in serif design can make a big, rich change in the flavor of the letter, the calligrapher should not pass up the opportunity to look carefully at the art of using the serif.

Serifs, almost by definition, seldom play a role in identifying the letter or distinguishing two similar letters from each other. They serve two functions, one technical, the other visual: they help the writer write and they help the viewer see.

Every stroke has a beginning and an end, whose characteristic contours reveal the shape of the pen, the angle of the pen, and the path of the pen. Each pen makes technical demands on the skill of its user, who must compensate for its weaknesses and accentuate its strengths. The broad-edged dip pen, for example, needs slight extra downward pressure and a side-to-side wiggle to get the ink flowing. The airbrush's ink spray must be started while the hand is already in motion to avoid a bone-shaped stroke or a drip.

To get the best out of a pen, the calligrapher can choose a number of ways to control the path of motion as the stroke starts and stops: slowing down or speeding up; prolonging or interrupting contact with the surface; gradually or abruptly moving in a new direction; returning to add an extra stroke. Beginning with the most modest serif that is intrinsic to the pen's functioning, calligraphy can include serifs that express the full range of the pen's capabilities.

Serifs help the calligrapher solve not only the technical problems of writing but the visual ones of reading. They aid in the process of orienting the eye to the underlying horizontal axis of lines of text on the two-dimensional page. A serif in any form helps strengthen the base and waist line of the letter and make more distinct the difference between letter body, ascender, and descender. The serif marks the end of the stroke clearly, exaggerating it so there can be no doubt about where it terminates. Even an apparently sans-serif monoline letter

Some familiar alphabet styles, deprived of their customary serifs.

usually incorporates a slight widening of the end of the stroke to compensate for the eye's tendency to distort what it sees.

Serifs help define letter spaces as well as letter strokes. They widen the distance between strokes, preventing the letters from bunching up. By rendering the letter stroke more concave and the space more rounded, the serif accentuates the contrast between figure and ground; the white shapes between letters are more sharply defined and do not visually leak into the white spaces between lines of letters. The serif also sharpens edges of the visual groove for the eye to follow. This holds the eye tightly in its rhythmic shuttle path, gathering up and interpreting white shapes in clumps as it moves from left to right along the rows of letters.

The serifs of the Roman lowercase in particular are not a decorative afterthought but an intrinsic part of the integrity of the letter. They not only guide the eye to read, but also help give the alphabet a strong stylistic unity that overrides the distinct shape of each letter.

Serifs run the gamut from the almost imperceptible widening that supports the illusion of a pure monoline, to the flashy appendage that overshadows the form of letter itself. No one style is better than another—only less or more suited to the various needs of the reader. Serifs can fit any alphabet style to a number of different purposes: The eye-stopping serif that interferes with the need of the book reader to find out fast whodunit may be just what the poster reader needs to fill the visual vacuum of a slow subway ride. What reads well at a height of two millimeters may offend the eye at an inch. A stroke ending that appears too heavy in black ink on white paper may assume ideal weight when the contrast is reversed. A serif style that lends dignity to a company's gold-embossed letterhead may not make its red-packaged products jump off the shelves.

Notice how serifs accentuate small differences between similar letters to enhance readability.

abfchvai abfchvai

gpronydl gpronydl

MATERIALS
rigid broad-edged pen or marker
flexible broad-edged pen or brush
flexible pointed pen or brush
monoline pen or marker
airbrush, spray can, or spray blower

TECHNIQUE
Choose a pen, choose an alphabet style, and letter it without its serifs. Notice how hard it is to omit them, and pay attention to the efforts of

the pen to put them back. These intrinsic line endings that assert themselves in the path of the pen's natural motion will lead you to understand the technical function that serifs fulfill.

Now look at the wide range of serifs that you can make through added motions of the same pen that makes the letter stroke. They fall into three main categories: integral strokes, added single strokes, and compound strokes. A fourth kind of serif is added with a different pen.

Integral, added, and compound serifs.

Integral strokes can vary in their angle and their gradualness.

Integral strokes touch each other end to end, so that the motion that makes the serif is part of the motion that makes the letter stroke. The pen may hesitate, change direction, or stop, but it is not lifted. No backtracking is needed, and the strokes do not overlap.

Added strokes can overlap the main stroke, and necessitate repositioning the pen and making extra motions.

Compound strokes build up a complex serif shape with added and overlapping strokes.

Serifs added with a different pen can be thoroughly controlled but must be integrated into the letter stroke carefully to avoid incongruity.

Overlapping entry and exit serifs form clubbed serifs reminiscent of ninth-century Carolingian hands.

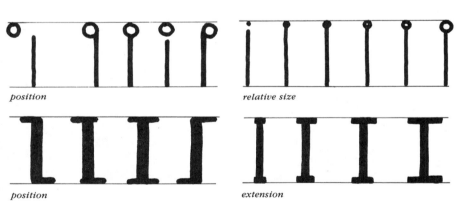

position

relative size

position

extension

Variables in an added serif.

Serif pen angle versus letter pen angle.

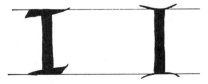

Pen can be turned or skated.

CAROLA

AN ALPHABET OF SERIFS

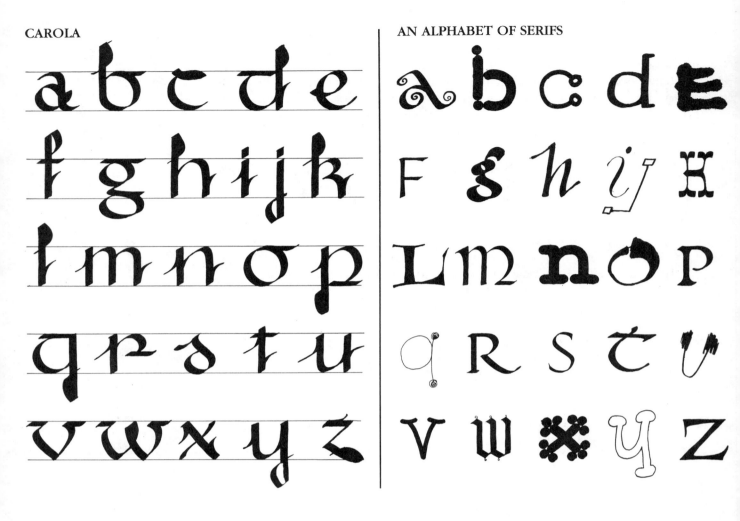

The alphabet of serifs shown above—twenty-six for each of the half-dozen major traditional alphabet styles and the dozen contemporary ones—illustrates the versatility of the serif in lending visual flavor to the page.

SUGGESTED READING
An ABC Book of Lettering and Printing Types by Erik Lindegren (New York: Pentalic, 1976).
Lettering by Hermann Degering (New York: Pentalic, 1965).

Flourishing

The Swashed Line

Charlotte climbed to a point at the top of the left-hand side of the web. Swinging her spinnerets into position, she attached her thread and then dropped down. As she dropped, her spinning tubes went into action and she let out thread. At the bottom, she attached the thread. This formed the upright part of the letter T. Charlotte was not satisfied, however. She climbed up and made another attachment, right next to the first. Then she carried the line down, so that she had a double line instead of a single line. "It will show up better if I make the whole thing with double lines."

E. B. White, *Charlotte's Web*

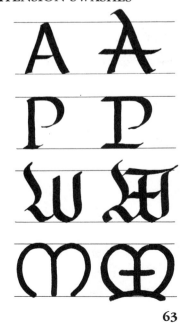

(Illustration by Garth Williams from Charlotte's Web *by E. B. White. Illustration copyright 1952 by Garth Williams; renewed 1980 by Garth Williams. With permission of Harper & Row, Publishers, Inc.)*

A BEAUTIFUL LETTER, well selected and lovingly executed, gives a gift to the reader from the writer with every reading. In the medium of calligraphy, a swash gift-wraps the treasure.

Swashes come in different shapes for many purposes. Some extra letter strokes or extensions stick close to the original letter construction. The simplest is the stroke that extends beyond the template of the normal alphabet. Even a slight lengthening of a crossbar or serif softens the mechanical rhythms of the simple reading pattern and differentiates a page of calligraphy from type. Since the reading eye constantly compares letters with each other, looking for similarities and differences, small variations stretch the template and teach the eye to accept variations on a basic letterform.

From serifs to flourishes is a small step—almost but not quite an indefinable one. Many historical letter styles seem to have extra strokes that aren't essential to the letters' identity and that do not

EXTENSION SWASHES

Five different categories of flourishes.

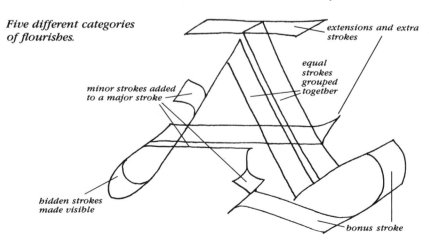

extensions and extra strokes

equal strokes grouped together

minor strokes added to a major stroke

hidden strokes made visible

bonus stroke

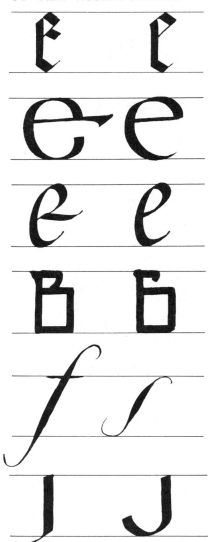

Streamlining is a process that can be reversed to produce serifs.

serve the logical function of differentiating one letter from another; the older the alphabet, the more of these strokes it has. The road the capital alphabet has traveled to its present stripped-down, streamlined form of Roman lowercase is littered with this cast-off baggage of strokes that became too much trouble to carry. The midstroke of the Roman capital E survives in lowercase only in the thin, accidental hairline that led the pen to it; B lost its upper story in the Dark Ages; L lost its foot; one-half of an R was found still identifiable; and the second and third strokes of Y have merged into one. More strokes seem to be in the process of changing from essential to decorative.

The calligrapher can reverse the passage of time by restoring traditional but redundant strokes to these letters. In addition, imitation restorations can add inessential but harmonious extra strokes to the letter, strokes that look like they might have been part of the letter in a more leisurely era.

A second kind of flourish is the addition of a minor stroke to a letter stroke. The minor stroke can cross, join, or parallel the major stroke, but it is always clear which is which. Though the writer relies in part on the reader's familiarity with the basic letter stroke to keep the difference clear, a minor stroke is also usually shorter, narrower, less rigid, or in some way less important visually than the major stroke. Even a proliferation of minor strokes still leaves the basic shape of the major stroke unaltered; if the minor strokes are removed, the letter may appear austere but it will still work.

Decorative strokes not only can be added one by one to individual letters, but can also be superimposed on entire alphabets. The same decorative element can attach itself to horizontal, vertical, diagonal, or round letter strokes, to joins, or to letter spaces. To get the full impact of minor flourishes, however, the scribe should stick to a small selection of stroke shapes, and use them not automatically but flexibly from letter to letter. The visual rhythms of the decorative stroke should evoke the intermittent, pleasant, mild surprise of a cricket chirp, not the relentless, inescapable, repetitive banality of a knock-knock joke.

Swashing becomes more complicated when the calligrapher groups equal strokes together. These strokes may be concatenated,

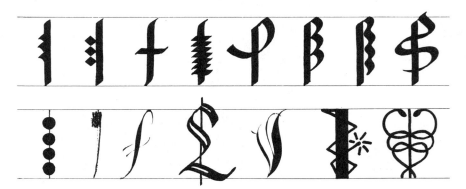

A selection of added minor strokes.

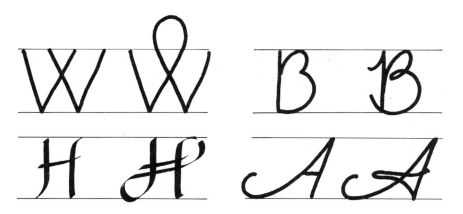

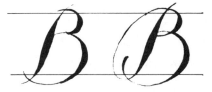

Hidden motions become swashes when the pen is kept in touch with the writing surface.

offset, parallel, crossed, or bouqueted, in groups of two, three, or a multitude. Their shapes can come from the repertoire of any alphabet or geometry. Whatever the array, however, each stroke contributes to forming the aggregate stroke, so that while no one element is solely responsible for carrying the meaning of the letter, if one is removed the letter will not work.

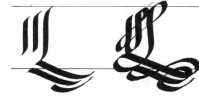

A complicated letter built up of a combination of both minor and major strokes and equally important strokes gives the viewer a visual puzzle similar to the soft-edged letter. But unless the writer has willfully hidden the clues, a heavily flourished letter can be as easy to read as a plain one. The brain knows that some of the strokes count as letter and some form the background, but the eye does not care.

A fourth category of flourishes emerges when the writer makes hidden strokes visible. Calligraphy is full of motions, only some of which are made when the writing tool is in contact with the surface: motions within the letter between the end of one stroke and the beginning of another, and motions between the end of one letter and the beginning of the next. By making more of these motions visible, the writer reveals decorative strokes. Wherever the dance of the pen leaves its footprints, round loops appear at the corners of square

all you do is sit staring at a blank sheet of paper until the drops of blood form on your forehead.

A swash can be sent from one letter to another.

This logo design offers a wealth of traditional pressure-sensitive swashes. (With permission of The Mayfair Regent Hotel. Designed by Diana Graham, Gips + Balkind + Associates.)

A variety of swashes ornament the tails of three Qs.

letters, single strokes acquire graceful echoes, grouped strokes gain new visual coherence, and small lines spring up to trace the shortest distance between two points. The natural trail of the hand's progress can also be mimicked with swashes that seem to follow this track, but are actually carefully added on. Swashes can be transmitted in either way from one letter to another or even from one line to another, in direct or purposely circuitous paths.

A fifth category of swashes does not stand on ceremony or wait for a letter as an excuse to exist. The pen's generosity adds bonus strokes to letters—or anywhere the eye likes them. The viewer, however, may tire of a sustained state of gratitude and, if given too many free swashes, can come to feel entitled to them; redefinition helps remind both writer and reader of the difference between a salary and a bonus. By this token, the simple stroke on the Italic G is not a swash, since it is needed to distinguish the letter from the Q; but the identical stroke in another position on the Q is therefore not needed and can be considered a swash. If the G in this same alphabet style had no extra stroke, however, the Q would need one, so that what was formerly defined as a swash would become instead an essential stroke in the letter.

Removing the swashes from all but the most strictly necessary places makes for an alphabet style that is intellectually correct but visually very bare; just one or two swash bonuses added to this alphabet can have more visual impact than a whole pageful of routine strokes added to every letter. The tails of the Roman K, Q, and R delight the eye not only by their restraint but also by their rarity. A complete set of similar curves appended to the rest of the alphabet would dilute, not amplify, this effect.

Solo swashes that are not integral to the letter offer the calligrapher great expressive latitude. They can cross or parallel themselves, they can move to another part of the page or coil inward to a predictable destination, or they can do both.

Almost any pen, brush, or tool can govern the stroke shape of these flourishes: broad-edged, turned, pressure-sensitive, monoline, and soft-edged.

Within the contours of the stroke, many kinds of line texture are possible: outlined, striped, dotted, ornamented, mosaic, grained. They may be pen-executed or drawn and filled in.

Flourished strokes follow many different paths: straight, spiral, zigzag, looped, freehand. They can speak with the vocabulary of the other arts: the motions of the jazz dancer or the classical ballerina, the filigree trills of the harpsichord that cannot get any louder or the shaped notes of the violin that can, the sound of constant background music or the crash of one big surprise, the even texture of woven cloth or the individualistic path of an embroidered exploration, the rhythmically correct turns of the eighteenth-century drawing room or the Brownian movement of the twentieth-century laboratory, and the

Restraint helps these Roman swashes retain their visual strength.

A mix of swashes emanating in a relaxed manner from all available letters strokes forms a distinctive logo. (With permission of J. M. Cook Boutique, Boston. Designed by Sue Morrison, Beverly Farms.)

A contemporary swash design reveals the hand's path. (Courtesy of Karlgeorg Hoefer.)

Regards,

Pencil swash shows hand motions before, during, and after the scribe's signature. (Courtesy of Marc Drogin.)

strange accents of the Oriental syllable or the familiarity of the conversational Italic farewell.

MATERIALS

pen, brush, or marker with self-contained ink supply such as:
 Platignum, Osmiroid, or Sheaffer No Nonsense broad-edged pen
 chisel-tipped marker
 Pentel Color Pen
 wide-diameter technical fountain pen
 spray paint in aerosol can

Avoid wide and sharp broad-edged dip pens, sharp metal crow-quill dip pens, and extremely thin technical fountain pens. While you can compensate somewhat for the tendency of sharp pens to dig into the paper on pushed strokes by using paper of extremely hard polished surface, nothing will make up for the loss of rhythm that comes from running out of ink in midswash.

TECHNIQUE

Swashes of any kind, unless they are too small to be fun to look at, demand the large motions of a relaxed and confident arm. The less your hand touches the writing surface at first, the better your swash will be.

At the same time, after you have set your arm free to make the kind of strokes that come from the natural motion of your body, you should still keep the pen or brush in touch with the writing surface during as much of the motion as you can. Later you can exploit what you have learned, selecting parts of the continuous stroke for more formal, controlled treatment. Now is the time to explore all the pen's possibilities. The best swashes will contain many unpredictable and unclassifiable "errors," or unplanned visual events. The key to making intelligent use of this serendipitous property of flourishes is to make hundreds of them, and then learn to approximately re-create the body motions that produced the most beautiful accidents.

Using thick tracing paper and the pen you are most comfortable with, trace the traditional alphabet styles from the first, second, third, and fifth chapters of Section I without pausing or losing contact with the writing surface. (If you are writing in soft-edge, simply do not interrupt the air flow.) First write each letter without lifting between strokes. Next write the alphabet and then typical words in sentences with a continuous line. Now just write the same word over and over, slowly, watching the casual connections shape up into decorative swashes.

Not every swash has to recall the smooth motions of the controlled arm. Letters or alphabets can follow jagged, hesitant, formal, or arhythmic stroke paths, or contain both smooth and intermittent strokes.

Each kind of pen, furthermore, calls for a slightly different swash path. Intersections in the broad-edged style are most pleasing when thick crosses thin. Changes of direction work gracefully along some axes and clumsily along others. Some optical illusions can be maintained only with slight distortions to compensate for the workings of the eye. Broad-pen swashes can also echo many historical styles, including the idiom of the turned pen. The pressure-sensitive pen or brush presupposes a thick or pressured line on the downstroke and a thin or unpressured one on the upstroke. Because the scribe controls not only where the line will widen but how much, he or she can shape the ends of the line. The monoline evokes the coils and knotwork of Celtic borders, and can break to heighten this impression of weave, knot, and overlap. Geometric figures can be expressed precisely. The changing widths of the broad or pressure-sensitive pen lines do not disturb the symmetries of the monoline spiral, helix, or band of fretwork. Monolines can also refer visually to the consistency of the neon tube as it melts to turn corners and then resolidifies. Finally, airbrush technique by its very nature uses rhythm. The invisible arm motions it takes just to lay a smooth field of flat and textureless color can easily reveal their swash-like path.

Some swashes start from letters that launch them in a particular direction, and while the swash can then develop in any number of different ways, it is not always easy to tack it onto another letter. Roman lowercase g, for example, is distinctive in this way, as is Roman capital Q.

Many flourishes, however, can be used interchangeably as extensions of a number of similar letters. The alphabet contains families of these similarly swashable letters and a repertoire of characteristic all-purpose swashes. Some letters beg to be flourished and persuade neighboring letters to join in. Others stand aloof.

Some swashes have moved on from their parent letters completely, to form abstract decorative elements on the page. Every dash or hyphen in the Roman alphabet is a swash under wraps, and follows

Letterless swashes form decorative elements, each in its characteristic style.

Swash strokes form other lettered symbols.

CONTINUO

SWASHED LETTER STYLES

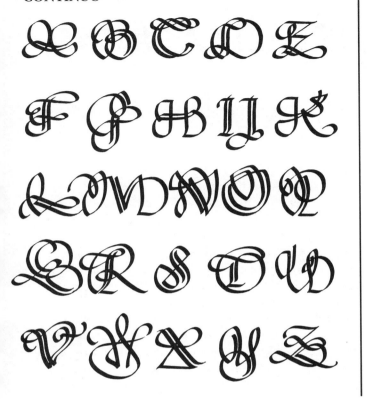

the rules established by the other letters. Freed from the context of the written word, these abstract letter elements take on architectural dignity and weight. Celtic space-fillers happily stretch an existing letter or fill out lines on their own. The cadences of one virtuoso Italic swash can fill a whole page, and even beyond. Sometimes the simplest swash has the most impact. The restrained Italic wave of a swashed underline gives a unified graphic identity to the many nonalphabetic translations of the name of one of the world's most ubiquitous products.

Pressure-sensitive swashes are legendary in their abstract expressiveness. In contemporary flourishing, such modern artists as Jackson Pollock have provided the conceptual framework for calligraphic flourishes as a set of motions made visible with pigment. Spray-gun technique liberates the motions of the arm from the frictions of the surface, and the monoline in motion caught by a camera can write in the nighttime air with an ethereal swash of light.

SUGGESTED READING

New Calligraphic Ornaments and Flourishes by Arthur Baker (New York: Dover Publications, 1981).

Pictorial Calligraphy and Ornamentation by Edmund V. Gillon (New York: Dover Publications, 1972).

(Courtesy of the Coca-Cola Company.)

Drawing with the Pen

The Calligraphic Idiom

I always aim at resemblance.

Pablo Picasso

A seventeenth-century capital N flows into two drawings in one continuous pen stroke. (From The Pens Transcendencie; or, Faire Writings Labyrinth *by Edward Cocker, with permission of The Victoria and Albert Museum, Crown copyright.)*

THE SAME PEN that makes abstract strokes into letters, serifs, and swashes can also be put to work on the first, purest kind of writing—the drawing of pictures. There are many ways for the calligrapher to draw with the pen. Individual letters can contain representational decorations that grow organically from the structure of the stroke. Simple emblems executed with calligraphic pens in calligraphic strokes can harmonize with letters on the page. Groups of abstract letterless swashes can line up to portray edge, mass, and texture, and familiar pictures can at second glance contain hidden letters.

The building block of both letter and drawing is the stroke—its shape, the path it follows, its relative size, the pattern of its repetition, the way it attaches to other strokes. Since each alphabet represents a set of these characteristics, a drawing can borrow the calligraphic style by borrowing the same contour, path, scale, rhythm, and joins.

Drawings can be especially calligraphic when they are actually part of a letter stroke or swash. Many small pictorial fragments can be integrated into the letter itself, accentuating some of the inherent similarities between pen strokes and natural objects. A minor stroke of the pen added to a major stroke becomes a leaf on a branch, a flower on a stem, a kernel of wheat on a stalk, a blade of grass on a lawn, a drop of rain, sleet, or snow in the air.

Although drawings spring from letters, they also live independent lives. The twenty-six alphabet letters form only the tip of an iceberg, a much greater mass of symbols that, since they are "read" like letters, can be "written" like letters. The calligrapher who wants to master the art of drawing calligraphically should explore what lies below the

Who hath not courage needs legs.

A freely written and flourished Italic, right, is echoed in the drawing by the lively strokes of a similar pen in a different hand. (Drawing by Warren Chappell, calligraphy by Rick Cusick from The Proverbial Bestiary, *with permission of TBW Books, Publisher.)*

alphabet's waterline before venturing off the iceberg altogether. Signs of the zodiac, heraldic emblems, musical notation, typographic ornaments, and even the familiar numerals and punctuation marks come from nonalphabetic worlds. The pen that learns to letter them is at the same time learning to draw them.

In rendering nonalphabetic symbols, the pen teaches the calligrapher how to draw things beyond the world of the letter. The pen or brush can also draw real, nonsymbolic objects, without losing the flavor of the alphabet. The calligraphic line gives the writer great versatility to describe edges, planes, mass, and surface texture.

MATERIALS
rigid broad-edged pen or marker
flexible broad-edged pen or brush
flexible pointed pen or brush
monoline pen or marker
airbrush, spray can, or spray blower
watercolor and wetted watercolor paper

TECHNIQUE
Every alphabet style is composed of a limited set of basic strokes. To look calligraphic, a drawing should be composed from the same basic strokes. Analyze each alphabet to isolate the characteristic strokes that will be useful for the kind of drawing you have in mind. Strokes from each basic alphabet style have a distinctive contour, path, scale, and join. Use these characteristic elements, rather than just any old strokes, unless you have a good reason not to. If the contour of the typical letter stroke does not suit the drawing, it is better to change either the nature of the drawing or the choice of alphabet style than to dilute the graphic connection between them. A clearly different drawing stroke is better than one that just misses.

You can integrate drawings into letters by using segments of letter strokes. Select a set of strokes from the repertoire of a specific alphabet style, and then, using minor strokes or parts of major ones, incorporate representational ornaments into individual letters. If the strokes of the drawing have to deviate too far from the typical path followed by the letters, then the lines of the drawing should be rethought to make them more similar to the letters.

Advancing to symbols, you can borrow not only parts of letter strokes, but also parts of letters. Since you will have to depart from the characteristic letter shapes to express some nonletter shapes, the letter joins must convey much of the stylistic identity. Find sympathetic letters to use as role models for similar symbols. Pay particular attention to how the strokes meet, cross, join, and terminate.

Where strokes are repeated in any figure, you must decide how much you will make them resemble each other to create rhythm.

With realistic drawings, use every bit of ammunition the alphabet

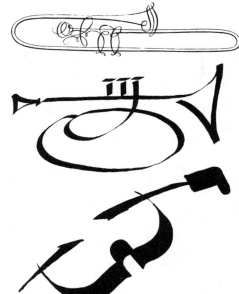

In drawing three-dimensional objects, two narrow pressure-sensitive pen strokes can outline a solid, one medium broad-edged pen stroke can stand for both edges, or a wide broad-edged stroke can portray in depth one whole side and imply the other. (Trombone is from Pictorial Calligraphy and Ornamentation, *Dover Publications.)*

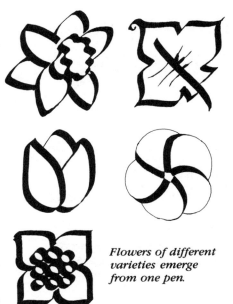

Flowers of different varieties emerge from one pen.

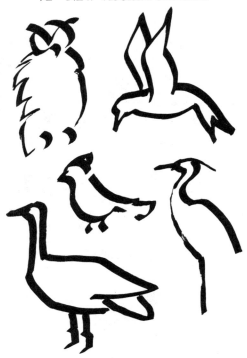

Imaginary birds convey character and mood with a variety of pen lines. (From Birds Without Words, *courtesy of the artist, P. L. Giovannetti.)*

The more specific your drawing, the more strength it will have. These birds, each drawn with a few pen strokes, are clearly defined.

style offers. Dots, serifs, and hyphens form small elements; straight strokes and curves make outlines; swashes fill spaces. The scale or relative size of the stroke is crucial. A thick line reveals its calligraphic affiliations more boldly and gives the illusion of three-dimensional mass, while a thin line expresses edges and can portray surface textures.

Scale also determines the relationship between the drawing and any letter that may be present. Drawings can be subordinate parts of letters, equal partners, rulers, or free agents.

Elaborate nineteenth-century pen-stroke drawings frame a name and a quotation.

The scribe in this twentieth-century pen-drawn self-portrait holds a frame for his own greetings. (Courtesy of Marc Drogin.)

SUGGESTED READING

Birds Without Words by P. L. Giovannetti (New York: Macmillan, 1961).
Heraldry for the Designer by William Metzig (New York: Van Nostrand Reinhold, 1970).
Recollections of the Lyceum & Chautauqua Circuits by Irene Briggs DaBoll and Raymond F. DaBoll (Freeport, Me.: Bond Wheelwright, 1969).
Saul Steinberg by Harold Rosenberg (New York: The Whitney Museum, 1979).
Symbols, Signs, & Signets by Ernest Lehner (New York: Dover Publications, 1950).

III.

NEW HUMAN INTENTIONS

Nothing is more injurious to the character and to the intellect than the suppression of generous emotion.

John Jay Chapman

THERE ARE not only many ways to write but many reasons. Each person writes from a different need and with a different vision. The reasons change from time to time, from place to place, and from person to person. People outside the boundaries of formal calligraphy still imagine, design, plan, and letter pieces of calligraphy that define new expressive styles. The needs that shape these images can deepen the calligrapher's understanding of how the human imagination works.

One of the most intriguing aspects of the current revival of interest in traditional calligraphy is that it has begun to go beyond simply copying the letterforms and materials of the past and has fostered an understanding of the underlying processes by which calligraphy grows and changes. This understanding extends to critical judgment. Letters by the nonartist, whether immature, hostile, disturbed, handicapped, or simply untrained, deserve evaluation on their own merits. Criteria of the fine arts can apply to the crude ones: the writer confronts a surface at a particular site, makes choices about materials, has a number of letters to write in a particular shape; those letters will not only be read, but will also convey other information about the writer's state of mind toward the message and toward himself or herself. The letterer whose interest in letters is fueled by concerns different from those of the craftsman, professional, hobbyist, or scholar offers new sources of energy for change and for the enrichment of calligraphy.

The Preliterate Mind

I never imagine anything until I experience it.

John Cage

A four-year-old used several approaches to determine how an A might be constructed.

THE CHILD WHO LEARNS to write before learning to read—as most children do—explores lettering at its most naive, as a purely visual art. Children's pictures and letters look the way they do because they represent the child's search for structure. The child looks at letters with a careful and impartial eye, and then draws them. The distinctively childish appearance of the letters often reflects the child's conscious artistic choice more than simply showing a lack of expertise. Children's letters can, therefore, give the inquiring calligrapher a new way to look at the basic structure of the alphabet.

Children's letters pass through many of the same developmental stages that their drawings do. Single letters, particularly those that initiate or appear in the child's name, are mastered first. Then the alphabet is slowly assembled and painstakingly practiced. At this point, extraneous "letters" sometimes have to be edited out as the child recognizes that variants of the same letter are inherently similar and that many common symbols of daily life are not letters at all. Many children, writing but not yet reading, regard letters as fetishes, magic keys whose use they control but whose function they do not understand, and they cling dogmatically to strict rules in forming each one. Some parts of the letter are desperately essential to the letter's iden-

Aesthetic tastes evolve and attitudes toward ornamentation change as the child matures. When asked to decorate a word, a four-year-old analytically added dots underneath to indicate the number of strokes in each letter. A year later, the same child's letters began to sprout serifs and swashes.

74

tity, while others are highly expendable and likely to be truncated or obscured in a surprising way. As the child begins to read, the letters can be manipulated and elaborated freely without threatening the reading process. The child in the Western world learns when to see letters as pictures and when to read them as words.

Much of this individual development parallels the larger evolution of writing. Letters move through prehistory and history first as talismans, then as pictures of specific things, next as symbols of general categories of meaning, finally as abstractions representing sounds. Even specific developmental stages find their echo; the letters of preschool children, like those of the ancient Greeks, do not distinguish between a letter and its mirror image and freely mix the two. Children write backward, forward, up, and down without preference.

Both for themselves and for the window they open on the mind, the first letters of a child learning to write can invigorate the adult calligrapher's vision of the familiar twenty-six letters.

This typical five-year-old's numerals progress across the calendar in the right direction, but many are reversed and the five is upside down.

MATERIALS
crayons
large blunt markers

large pieces of newsprint or construction paper

TECHNIQUE
A truly naive letter can only be made by someone who cannot read. A preliterate child can open your eyes to the purely visual side of letters better than any other teacher. An Oriental saying goes, "If you have a child of five in the house, you have a Zen master."

Sit down with a child under the age of five; provide plenty of paper and an easy-to-hold marker; ask the child to write the alphabet and any favorite words, and to describe what he or she is doing. Then watch carefully and listen. (You may want to tape-record the narrative.) Notice the order in which the strokes are written, what direction the pen travels to make the strokes, what strokes are omitted or added, where the child sees the lines of the letter's structure. Now try to replicate what the child lettered. The child may enjoy teaching you his or her system. You will probably find it rational, logical, and distinctively different from anything you have learned.

If you do not have a small child handy to teach you how to see letters without reading them, cultivate the approximate state of mind of someone that age. Forget that letters carry any meaning. Look instead at each letter as a thing. Where can it be embellished? What potential do its strokes offer for strengthening and elaborating? Try reversing or scrambling the order and direction in which you normally construct the letter. Try also to feel something about the letter as a picture. What kind of personality comes from an R in contrast to an O? Write each letter backward so that you look at it anew before you read its customary meaning. Forget the architectural rules of

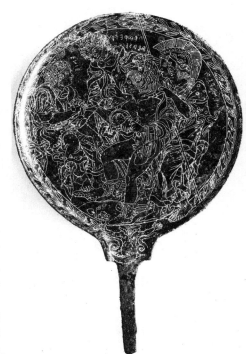

Etruscan letters from the fourth century B.C. read backward and forward to spell the gods' names: Enie, Pemphetru, Pherse, Menarea. (Mirror, with permission of The Metropolitan Museum of Art, Fletcher Fund, 1926; all rights reserved.)

letter design, based on constructing the letter to resist the downward pull of gravity. Instead, put the letter on a flat page where every element is independent of the others.

Letter the alphabet from Z to A rather than from A to Z, so that you come at each letter in a slightly different order from what you are used to. Slowly copy words backward, upside down, or in a language that you do not know how to read. Calligraphy embraces all the meanings that a letter can carry in addition to its function of spelling out words. Forget what you know about reading and try to recapture what those visual meanings are for someone who cannot read.

You can enhance the naiveté of your letters by choosing the tools and materials that a nonreader would prefer. Since you are in essence drawing, rather than writing, use general-purpose drawing materials in preference to specialized writing materials: crayons, round-tip markers, soft pencils, and tempera paints on newsprint, typing paper, and notebook paper.

Naive letters, after you have learned how to approach them, can fit into many designs: titles, posters, calendars, family trees. The important thing is to make them not mock-childish but truly fresh and original—a weak imitation of a naive letter is worse than baby talk. The naive point of view, without the truly naive letter, can help you if you want to revive a worn-out design or a hackneyed letter. Many historical letters show evidence of the scribe's willingness to start the design process with the structure of the letter rather than with what he or she knew about the letter. This is the origin of visual innovation.

Letters and symbols are combined by a seven-year-old. (Courtesy of Lydia Murphy Savage.)

Letters drawn by a six-year-old are filled with decorative strokes.

SUGGESTED READING

Art and Visual Perception by Rudolf Arnheim (Berkeley: University of California Press, 1974).

PRIMITIVE

The Untrained Eye

The lettering was laborious and of an impressive variety. On a good day, one could count as many as twenty different versions of the figure 2 alone.

Ben Shahn, *Love and Joy About Letters*

PEOPLE LOOK at letters differently during the course of their lives. The child who can write but cannot read gradually grows into the adult who must write but does not see. Many, perhaps most, adult readers write script but read type, and would be hard pressed to reproduce from memory the familiar forms of the lowercase A or G, remember whether serifs were present or not, or notice the details in a capital W. They are almost completely unaware of the graphic content of the information they read.

This untrained eye manifests itself when people are faced with a lettering, rather than a handwriting, task—a poster, a sign, a formal award. The ballpoint pens and thin markers of everyday writing are inadequate for the graphic needs of the potential viewer, the materials of other visual arts offer no guidance, and the forms of the handwritten letter become unfamiliar when they are enlarged and turned to new purposes. Cast adrift, some adults draw on a vague impression of the traditional alphabet forms and try to imitate them with tools inappropriate to the task. The result is often an alphabet of primitive block letters, each about the same width, containing carefully built up thicks and thins in some of the right places but more of the wrong ones. The "mistakes" are so characteristic—the orientation of A and O, the diagonals of M and N, and the serif strokes of I, for example—and the overall alphabet is so distinctive, that primitive writing has come to be considered positively on its own merits as a style, rather than negatively on its shortcomings.

The independent variability of thick and thin strokes finds many historical precedents. The runic alphabet of seventh- and eighth-century Ireland, for instance, allowed the scribe to put line weight where a particular design seemed to need it. Twentieth-century designers have invented several alphabet styles of thick and thin letters whose thick and thin strokes follow rules other than those of the traditional broad pen.

Primitive letters carry a kind of echo of the classic Roman letter

Letters from a variety of hand-lettered signs show visual improvisation about placement of thick and thin strokes.

Hand-painted signs include a wide variety of calligraphic inventions.

often painstakingly executed by someone grimly determined to express himself who has not been taught to look. Many teachers of calligraphy observe that untrained students almost always take a kind of masochistic joy in laboriously lettering a piece of calligraphy, but have to be almost forced to learn how to see, plan, and imagine. Primitive letters display this love and labor—and this blindness.

Although these primitive grass-roots letters may have only a tenuous connection to the main tradition of Roman capitals, they have a strength and distinctiveness of their own that makes them a genuine letter style. Twentieth-century graphic artist and painter Ben Shahn, stringently trained in classical letter design, embraced the primitive alphabet as a graphic and calligraphic tool of great expressiveness. He defended its use by linking it both to its roots in the hand-drawn capitals of earlier centuries and to its relatives in the other American arts of the twentieth century: jazz, architecture, and the folk arts of popular culture.

The contemporary calligrapher can participate in this strongly original style of calligraphy. Design ideas can be found in the lettering of the traditional seventeenth-, eighteenth-, and nineteenth-century American craftsman or journeyman: alphabet samplers, gravestone inscriptions, locally printed broadsides, handwritten deeds, ranch brands, Fraktur birth and marriage certificates, advertising showcards, and decorative ironwork. Some contemporary ideas can come from the materials and designs of craftspeople in related traditional arts today: quilts, paintings, carvings. Further inspiration can be gotten from letters in the hands of today's professionals, the designers of type,

Distinctive, powerful letters portray the last words of a controversial figure whose execution became a cause célèbre. *(The words of Bartolomeo Vanzetti lettered by Ben Shahn, with permission of VAGA, New York, © 1984 by the Estate of Ben Shahn/VAGA.)*

IF IT HAD NOT BEEN FOR THESE THING, I MIGHT HAVE LIVE OUT MY LIFE TALKING AT STREET CORNERS TO SCORNING MEN. I MIGHT HAVE DIE, UNMARKED, UNKNOWN A FAILURE. NOW WE ARE NOT A FAILURE. THIS IS OUR CAREER AND OUR TRIUMPH. NEVER IN OUR FULL LIFE COULD WE HOPE TO DO SUCH WORK FOR TOLERANCE, FOR JOOSTICE, FOR MAN'S ONDERSTANDING OF MAN AS NOW WE DO BY ACCIDENT. OUR WORDS-OUR LIVES-OUR PAINS NOTHING! THE TAKING OF OUR LIVES-LIVES OF A GOOD SHOEMAKER AND A POOR FISH PEDDLER-ALL! THAT LAST MOMENT BELONGS TO US- THAT AGONY IS OUR TRIUMPH.

Appropriately primitive lettering captures the spirit of an unofficial ceremony.

computer graphics, packaging graphics, and especially that most American of art forms, the corporate identity symbol, who draw on both classical lettering traditions and contemporary innovations.

In rediscovering the local roots of national culture, calligraphers join creative artists in other fields—distinctively New World composers, painters, philosophers, poets, and sculptors. Primitive letters offer the inventive scribe a chance to elevate folk art to fine art.

MATERIALS
broad-edged pen or marker
any paper

TECHNIQUE
Pure beginners who have not yet learned the rules of traditional broad-pen calligraphy are perhaps best equipped to make primitive letters. If you want to add this element to your existing calligraphic skills, you should first deprogram your eye by paying attention to the work of untaught letterers wherever you see it. Several guiding design principles will help you understand the virtues of their style and develop your own version of it.

Primitive letters are characterized by an almost fanatical attention to where the thicks and thins of a letter will go, coupled with an almost complete disregard for where they in fact most naturally or traditionally do go. You can use a monoline to draw the letter in outline and fill it in, or build it up with overlapping strokes to put the thicks and thins where you want them, not where the broad-edged pen puts them. This effect, however, is easiest to get by using a broad-edged pen, turning it between the strokes of the traditional capital letters, as described in the second chapter of Section I, but turning it to put the thick and thin strokes in unexpected rather than traditional places. The thicks and thins can create any texture you desire, from the staccato rhythms of the Ben Shahn alphabet to the enigmatic machinery of computerese. You can create a typeface of twenty-six letters and use them predictably, or you can simply treat each letter as an individual and let the overall texture of the piece of lettering guide your thicks and thins.

Primitive letters can lend themselves to the portrayal of everyday speech, populist sentiments, and the cadences of the unsophisticated voice; they evoke the sound as well as the flavor of American folk arts.

Primitive letters echo some characteristics of naive letters in that the writer, unaccustomed to writing, must devote so much concentration to the visual construction of the letters that there is none to spare for the overall meaning of the words. Naive writers, however, rely on intense visual study of the letter they are trying to draw, while primitive writers rely on a general mental recollection of the letter they are trying to write.

Primitive letters are also characterized by the designer's inability

Disingenuous lettering transmits practical information.

PRIMO

ABCDE
FGHIJK
LMNOP
QRSTU
VWXYZ

to visualize the piece as a whole. Each letter or decorative element seems to have its own unique role. Generalized rules are not evident. Each letter is a problem that is solved as it comes up without much reference to the way similar problems have already been solved.

Pay attention to primitive hand-lettered signs when you see them; examine them for eye-catching innovations and striking letter designs. Any letter, ancient or modern, that shows the hand of the individual can enrich your calligraphic repertoire.

SUGGESTED READING

The Art of Written Forms by Donald Anderson (New York: Holt, Rinehart and Winston, 1969), Chapter 9, pp. 221–24.

Early New England Gravestone Rubbings by Edmund V. Gillon (New York: Dover Publications, 1975).

Love and Joy About Letters by Ben Shahn (New York: Grossman Publishers, 1963).

BRUT

Disturbed Connections

Art does not come and lie in the beds we make for it. It slips away as soon as its name is uttered: it likes to preserve its incognito. Its best moments are when it forgets its very name.

Jean Dubuffet

ART IS confrontation, not decoration. Its goal is to express the inner vision of the artist rather than to comfort the viewer. The history of progress in the arts is made by people whose work was at first shocking and controversial but later grew to be accepted. To the degree that a calligrapher chooses to work as an artist, rather than as a craftsman, a successful work of lettered art will inevitably shock someone.

Almost by definition, an artist is someone who sees things differently from other people and is willing to share that different vision. Every artist is somewhat out of line, maladjusted, operating under difficulty, and so every work of art is more or less therapeutic. Although this dislocation does not in itself ensure great art—talent and good luck are needed, too—talent and good luck by themselves will not produce great art if the fundamental disquieting impetus of something new to say is not there. When that impetus is channeled through accepted artistic traditions, fine art is created. When, on the other hand, the artist stays outside the traditional routes of artistic develop-

*Letters in this mid-twentieth-century work reflect the inner conviction of a missionary whose private religious revelations seemed stronger than the outside world. (*There Is an Eye Watching You *[c. 1965–75] by Sister Gertrude Morgan, with permission of Alan Jaffe, New Orleans.)*

ment, working without traditional training, art materials, role models, cultural cues, visual preconceptions, or human companionship—when the vision seems to originate solely in the person's inner needs—then *art brut,* or "raw art," is created.

The passage of time blunts the shock value of many great works of art. Art by the disturbed takes numerous forms, from the paintings of van Gogh and the late symphonies of Beethoven to the architecture of Watts Towers and the works of mental patients. Lettering that at some time seems beyond the fringes of acceptability, similarly, can run the gamut from the elaborate uncials that excited the dislike of fourth-century scholar Saint Jerome, who felt that their use turned books into "written burdens," to the monolines, turned lines, and airbrushed lines that threaten the peace of mind of many twentieth-century calligraphers. The history of lettering is full of daring departures that became standard procedures.

Calligraphy departs from its own traditions at many junctions. The writing of letters is a complex human process; if that process is disturbed at any point, a distinctive kind of letter will result. Some of these letter styles may be useful to the practicing calligrapher, to add a specific look to the meaning of some words that deal with the phenomenon of disturbance itself. Some may give inspiration to the visual artist who wants to express disturbance in a general way. Others may point the way to new alphabet designs that ultimately will lose their shock value and be absorbed into the mainstream. No piece of calligraphy can have artistic significance if it simply repeats comfortable visual information; there must be some small element of the disquieting, the unfamiliar, the risky, the jarring. Art critic Peter Schjeldahl, describing the art of Jean Dubuffet, says, "To imagine this, think of a crippled person with a bad limp, distressing to watch. Gradually, as one watches, the limp is subtly transformed, becoming articulated, purposeful, inspired—a dance! The person is dancing!"

Studying extreme examples of disturbed lettering will enable the scribe to acknowledge, respect, and articulate similar feelings from within. Furthermore, all of the styles offer priceless insight into the artistic process itself, and help the calligrapher to appreciate the complex interdependence of mind, eye, and hand.

The letter that the eye sees is not always the same letter that gets transmitted to the mind. Optical problems in the eye, such as astigmatism, can skew the image along an angle, widen it, or elongate it. The writer produces a letter that looks right to him but distorted to the outside world.

The eye may see properly but the image may lose information on its way to the brain. Dyslexia, a reading difficulty, often also manifests itself in dysgraphia, a corresponding writing difficulty where the letters are inadvertently written backward. All children go through this stage, using letters and their mirror images interchangeably, but some have trouble later learning to distinguish between the two.

This R by a four-year-old reflects the anger the child was trying to work off with a brush.

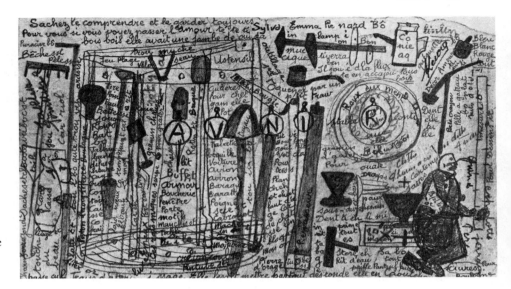

Mid-twentieth-century art brut mixes cryptic lists of words and emblematic sketches. (From Co Coco Cocoo Poulette en voilà la joie s'en va ça ira *by Sylvain, with permission of Collection de l'Art brut, Lausanne.)*

July 19

Dear Margaret

I cracked a bone in my wrist July 13.

Geoff has given me a Black Hills gold ring.

Eleanor We will be home July 22.

In a determined effort to circumvent her neurological difficulties, a seventy-five-year-old aphasia victim dictated this message through sign language, pictures, and a spoken vocabulary that lacked nouns, and then copied it in her own hand.

Sometimes the writing problem lies in the brain itself. Aphasic stroke victims frequently show evidence of knowing perfectly well what they want to say or write but being unable to articulate it. This disability is spotty; the person may be unable to do more than scribble unintelligibly when asked to reply to a question, yet can adequately copy a written passage. A lesion in the brain may cause conscious blindness, yet tests designed to probe other areas of the mind show that images gathered by the still unimpaired eyes can influence reflex action and unconscious thought.

The writing of an adult who has lost previous abilities differs from the writing of someone who has missed a crucial stage in development. Medical specialists occasionally are able to restore sight to adults who were blind from birth. These patients rarely learn to read, often experience profound anger and depression, and remain in many ways in their familiar sensory world of sound and touch.

People who write may see perfectly, think clearly, and yet still encounter problems somewhere between mind and hand. From the tremors and paralysis of old age to the simple writer's cramp of overindulgence, the unwilling hand challenges the determined writer to overcome a physical barrier to otherwise clear artistic sight. The late-nineteenth-century painter Pierre Auguste Renoir continued to paint into his late seventies with the brush strapped to his stiffened fingers.

The person who does not merely experience problems in connecting eye, hand, and mind but whose connections with the world are disturbed produces the most powerful artistic images. The artist may feel alienated from life and fellow humans in general, or more specifically from the traditions in the artist's own field. In true *art brut* the artist's eye seems directed toward his own inner vision and not to the mainstream of art. And yet this isolation ultimately reconnects the artist with the greater world of art. To quote the scholar Michel

An awkward writing tool, such as an ink stopper, can make attention-getting, original letters.

Thévoz, "Art Brut should not be envisaged only as a discovery of works that had passed unnoticed, but as a branch-line of a current that by degrees can act even on works endorsed by tradition and reactivate an energy pent up within them whose very existence had gone unsuspected."

MATERIALS
broad-edged marker
wide rubber bands or masking tape

malfunctioning pen

TECHNIQUE
To make a brut letter, put yourself in the place of someone for whom writing is a familiar idea, but who, for mental or physical reasons, experiences some difficulty in expressing the letters he or she wants to write. To approximate the perspective of disturbed vision, simply distort the original you are trying to copy, by inverting it, tipping it, mirroring it, or laying a lens over part of it. Then try to letter it the way it should look, transforming the image before your eyes into what your mind knows it should be. You will probably be able to accomplish this, but the effort it takes may surprise you. Now try a further step; turn the original sideways and letter it just as it appears to you, reproducing what you see even though it feels almost intolerably awkward to eye and brain. These two exercises will give you an inkling of the visual world of the disturbed eye.

A handicap, however, can be turned into an advantage if you handle it right. If you try to letter blindfolded—not formal manuscript lettering but free, cursive script and swashes—you may be pleasantly surprised by the grace and vigor of the results. Next, attach a marker or brush to your forearm and letter only with the large arm motions that any good calligraphy teacher will tell you are the proper way to practice lettering. Move the marker progressively down to the back of your hand and to each bone in your finger to see exactly what each part of you contributes to the physical process of writing. If your eye is good, you should be able to letter with your elbow.

You may want to write, or at least to understand, the letter that reflects disturbance between mind and hand. There is one almost surefire way to produce this tense, awkward, and disturbed line. Change the pen from the hand you customarily write with to the other one; for extra effect, wear heavy mittens and, instead of your usual pen, use a malfunctioning ballpoint or an uncooperative fountain pen. (If you are ambidextrous, put the pen between your toes.) Pick a time of day when you are particularly hurried, tense, or tired, and sit in a chair that is too low for the work surface. Now try to express yourself by writing; try as hard as you possibly can. The letters you make under these strenuous conditions will have the same raw edge of tension that characterizes all the forms of *art brut.*

DISTURB

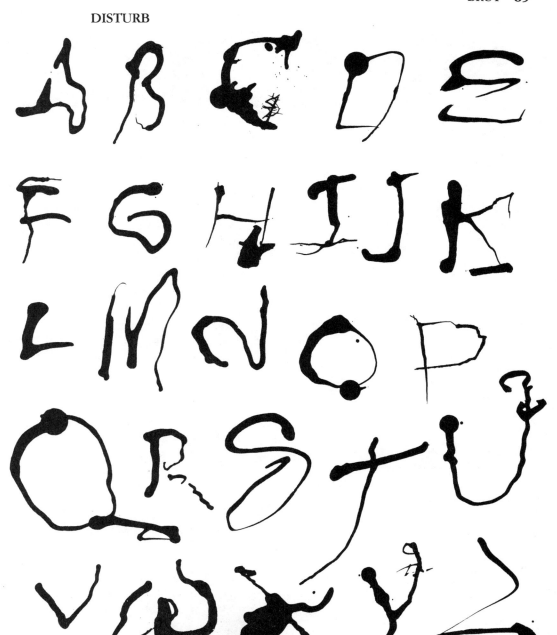

SUGGESTED READING

Architectural Graphics by Frank Ching (New York: Van Nostrand Reinhold, 1975).

The Impossible Coloring Book by Oscar Reutersvärd (New York: Perigee Books, 1983).

Visual Communication, Architecture, Painting by Herbert Bayer (London: Studio Vista, 1967).

![TACTICAL!☆](graffiti-style title)

Hit-and-Run Artist

Kilroy was here.

World War II graffito

PERHAPS THE ULTIMATE in contemporary folk art confronts many unwilling viewers in some way every day, through the visual guerrilla warfare conducted in public places with felt pens and spray cans—graffiti. This medium of self-expression (or rampant public nuisance, depending on one's viewpoint) sends a visual and cultural message that some think could only arise, and only be tolerated, in fast-moving, dirty, anonymous, dangerous, postliterate, urban America. It has succeeded in getting a reaction from everyone, pro or con, as have few other developments in contemporary visual culture.

Graffiti writers who seek establishment approval can point to a long traditional association between graffiti and calligraphy, from the anonymous insults and electioneering slogans that graced the walls of the ancient Romans through the marginal notes and opinions of medieval clerics, including the formalized dissent of the posters on a Chinese "democracy wall."

Graffiti has not only deep roots but many branches. Graffiti writing is just one end of an array that ranges from the *samizdat* self-publishing that every Xerox-era American takes for granted as a facet of the First Amendment, through the utilitarian advertising sign, to the posted position statement and the ultimate *cri de coeur* of the hand-carried protest placard. One branch in particular is emerging as a unique art form in its own right, set apart from the main body of public written expressions by three characteristics; it is illicit, personal, and expert. The writer places a great premium on the illegality of the process, from stealing the tools to trespassing on the surface. The

This spray-stenciled graffito created by Alastair Johnston publicized a lecture for the Pacific Center for Book Arts. (Courtesy of Alastair Johnston.)

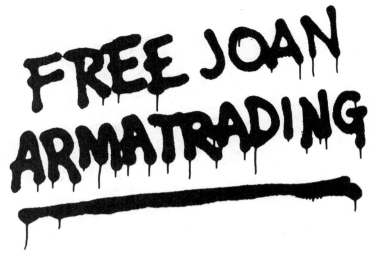

Record-cover graphics pack visual punch. Note how the artist has included the characteristic drip that emerges if the paint spray lingers too long in one place. (Courtesy of A & M Records, Inc.)

subject matter is seldom political or even topical, but instead focuses on the graffiti writer's name, "getting up" with the most distinct, frequent, and widespread trademark possible. And the work is seldom primitive or awkward, but shows evidence of graphic talent and skill.

Because of the premium on secrecy and speed, the dedicated writer employs efficient tools, spray paint or wide markers, and evolves a fluent logo of outlined letters or space-filling flourishes. The main distinguishing characteristic of the graffiti writer's style is that it covers the most area the fastest. Any calligraphic artist who needs to write large, striking letters efficiently will do well to look at the alphabet style of public graffiti.

MATERIALS
spray paint in aerosol can

huge sheets or rolls of paper
masking tape or thumbtacks

TECHNIQUE
Tactical letters, because of their guerrilla origins in graffiti, have evolved along the lines of greatest speed. The writer wants to cover the most area with the greatest visual impact in the shortest time before a rival or the authorities stop him from writing. The writer also wants materials that are hard to wash off and come in containers that are easy to steal (the favorite method of acquisition) and to transport. The aerosol spray can fills these requirements. Calligraphers who want to purchase spray paint and write letters for more legal purposes can still borrow some of the graffiti writer's other techniques. Graffiti media include felt pen (preferably ineradicable), ballpoint pen, chalk, pocket knife, and aerosol spray can. Surfaces include tile, brick, subway car, bathroom partition, tree, concrete (preferably wet), blank billboard, fence, and advertising poster, to name only a few.

One kind of graffito—"getting up" with one's highly stylized name, nickname, or initials—is of particular interest to the cal-

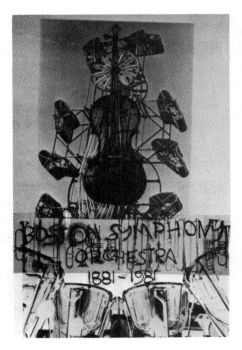

Graffiti-style letters on this centennial poster reflect the orchestra's place in a changing time and urban setting. (Courtesy of the Boston Symphony Orchestra.)

GRAFFO

A B C D E
F G H I J K
L M N O P
Q R S T U
V W X Y Z

These brush-painted monoline letters, laboriously built up and carefully swashed, communicate rather than confront. (From a photograph by Mike Mazzaschi, with permission of Stock, Boston.)

ligrapher, who can learn three valuable lessons from its technique. First, work large; second, work fast; third, repeat often. The resulting graphic image is usually fluent, economical, and distinctive. (Unfortunately for urban aesthetics, it is also usually ubiquitous.) Put up lots of wrapping paper and write with a spray can or a very wet marker. To fill the space with the letter image, try fat, outlined letters that overlap each other or heavily swashed elaborations. Add stars, stripes, and exclamation points wherever you can work them into the letters. Once you have worked out your design in large letters, you can scale it down or have it reduced photographically.

Graffiti, whether you enjoy it or not, is a part of the urban scene. You can give your legitimate work the same visual punch by following the principles of scale, speed, and repetition. Apply them to any short passage, logo, monogram, or initial that needs a slick, freewheeling, street-smart appearance.

SUGGESTED READING
Getting Up by Craig Castleman (Cambridge, Mass.: MIT Press, 1982).

Antiquarian

Amateur Enthusiasm

*The history of art
is the history of revivals.*

Samuel Butler

A twentieth-century illustration of a book of magic spells for a children's story draws upon antiquated letters, spelling, design, and ornamentation to set a medieval mood. (Illustration by Pauline Baynes from The Voyage of The Dawn Treader *by C. S. Lewis, with permission of Collins Publishers, London.)*

MANY CALLIGRAPHERS have gotten interested in calligraphy as a revival of traditional craft, studying the letterforms and writing materials of the Middle Ages before moving on to other centuries or to the present day. For some, the quills, parchment, and gold leaf of the illuminated book not only define the calligraphy of that period but set a standard for today.

Antiquarianism is not new to calligraphy. The history of the alphabet is full of revivals of letters from an earlier age. Charlemagne sponsored a ninth-century Revival of what he thought were the authentic Roman letters. The scholars of the Renaissance, in turn, revived the Carolingian minuscule as an authentic Roman letter. The Victorian designers of the Arts and Crafts movement adapted this Renaissance version of the Carolingian version of Roman into their Foundational hand. Similarly, our perception of the Gothic letter of today comes from not only the 1330s but the 1930s. As André Malraux writes in *The Voices of Silence,* "By the mere fact of its birth every great art modifies that that arose before it; after Van Gogh Rembrandt has never been quite the same as he was after Delacroix."

Although art progresses through periodic revivals of past traditions, the revivalism that punctuates the history of calligraphy carries

An early-fifteenth-century manuscript includes a portrait of Geoffrey Chaucer. (From Thomas Hoccleve's De Regimine Principum, *Harley MS. 4866 f88, with permission of The British Library.)*

some hazards for the beginner. The Gothic Revival of the early nineteenth century, for example, sparked a fad for copying medieval illuminated books. The amateur enthusiasts, however, drew in with a crow quill the thicks and thins of the typical Gothic letter, thus not only getting some of the forms wrong, but also making the job more laborious than necessary. This exaggerated reputation for crabbed tedium clung to the Gothic letter for a century.

No discussion of innovation in contemporary calligraphy would be complete without recognition of its intrinsic revivalism. The beginning scribe can reap the benefits without suffering the perils of grafting letters from one period or culture onto another. The best learning process is one that helps students to identify and articulate their own questions, rather than to learn and repeat a set of someone else's answers. For example, the ratio of pen width to letter height that a student first learns is just a rule until the student understands visually what happens to the letter when other ratios are tried. A rule should be a window, not a wall; if it is a wall, even the beginner should feel entitled to put it comfortingly behind his back. It should immediately suggest some "what if" experiments to illustrate "how come" and make the student ask "why not."

Traditional standards in the visual arts are not inseparable from traditional materials. A well-proportioned Gothic letter does not lose its essential integrity if it is done on paper with a metal pen instead of on parchment with a quill—and certainly gains nothing from being lettered with sepia fountain-pen ink on imitation paper-parchment with burned "olde" deckle edges. People who love calligraphy as an heirloom from the past need to be clear about what they admire more—the object or its patina.

Adherence to traditional materials can play a positive role when it is recognized for exactly what it is and what it contributes to the integrity of the overall creative process. Thus, for example, one of the important virtues of hand-ground ink is not just its visual effect on the final viewer, but the physical interval of calm and focused meditation it imposes upon the calligrapher doing the grinding. The scribe who works with ready-to-use ink does not have to forgo all that; other elements of the preliminary preparation, such as the rhythmic, repetitive ruling of a page of guidelines, may be called upon to provide this same mental and physical warm-up period.

One should experiment conservatively. Nontraditional materials are to be observed, considered, and experimented with freely and without prejudice; but they should, in the last analysis, be used only if they serve the purpose of the visual meaning, if what is being said can be said better—not just in a more startling way—with those materials and forms. Imitation modernism is as pointless as imitation traditionalism.

Ultimately, the study of traditional calligraphy will lead the calligrapher toward the future as well as back to the past.

The second-century Roman origins of the modern diploma. (With permission of The Metropolitan Museum of Art, all rights reserved.)

Two centuries of Harvard diplomas trace changing graphic taste within the confines of the formal academic presentation. (By permission of the Harvard University Archives.)

MATERIALS

small sharp knife
plastic drinking straw
short dowel and scrap of veneer or Popsicle stick
sponge and clamp

TECHNIQUE

Calligraphy brings together materials, a style, an artist, and an occasion. Each of these has changed through the centuries of writing as an art, and calligraphers who write today need not simply copy role models from the past. Instead, they can examine how earlier scribes worked and apply this insight judiciously to today's writing. The techniques suggested in this chapter have as much to do with what goes on in your head as with what appears on the page. You will find that the desire to work with the materials, forms, and techniques of earlier ages can broaden your understanding of calligraphy today.

Scribes of the past faced the same decisions you make; choosing and making materials, determining style, acknowledging their own abilities, and recognizing their cultural role in the larger scheme of things. Traditional perspectives on this process help you find new answers to age-old problems.

The occasions for calligraphy today vary from the traditional to the futuristic. You may be lettering diplomas for graduating scholars in a way that a scribe in twelfth-century Oxford would recognize immediately; the occasion of graduation is permeated with medieval costumes, language, and assumptions. (The custom of awarding a certificate for a prescribed course of service, like the word "diploma" itself, reaches all the way back to imperial Rome, when legionaries who had served seven years received a hinged lead plate attesting to their citizenship.) When you design and carve a stone inscription, letter and bind a manuscript book, or gild a Gospel page of ornate capitals, you can, with complete appropriateness, draw on the forms and materials of centuries long gone by.

Other occasions that may confront you will demand new materials or new forms, or both. The materials of medieval illuminating are wasted on the camera-ready artwork of contemporary photo-offset; if you want to participate creatively in designing for reproduction, you

Gothic

Half Gothic

Rectigothic

Letter styles can start from traditional basic shapes and slowly evolve along contemporary lines. This familiar pointed Gothic hexagon can mutate into a very twentieth-century rectangular letter.

must master specialized materials and understand printing technology. A hand-lettered poster calls for different media from a hand-lettered poem. Type designers accustomed to working with black images on white backgrounds must learn new optical laws when they work with light-emitting images on dark backgrounds. You need new maps to navigate this new territory.

Although your choice of materials may be governed to some extent by the demands of the occasion and although traditional materials are frequently unsuitable for today's calligraphy, the ideas behind traditional materials and forms are often of great value. Medieval materials, for example, such as feather pens, bark ink, sheepskin parchment, animal-hair brushes, earth pigments, are characterized by great ingenuity and self-sufficiency; they could be made from items commonly found on a country manor. If you want to recapture the essence of the medieval experience, try improvising your writing implements from things you find around the house. A pen can be cut from a plastic straw, a sponge, your own fingernail, or a Popsicle stick. Ink can be mixed from coffee, tea, leaves, or soot, and borrowed from the iodine, shoe polish, or wine bottle. You can write on paper towels, aluminum foil, waxed paper, or plastic wrap. You are surrounded by potential writing materials.

You are also surrounded by alphabet forms. Each age tailors its letter styles to the content of its literature. Just as Renaissance scribes evolved the cursive Italic for semi-official correspondence and the Humanistic bookhand for new works of poetry and philosophical thought, many new letterforms are evolving today to express today's new thinking. Not only letterforms, but styles of decoration and illustration harmonize with the spirit of the age. One outstanding characteristic of the medieval illuminator, for example, was the mundane and commonplace sources of his miniature illustrations; people from the Biblical past are pictured in jobs and costumes of the scribe's own era and the landscape comes from just outside the scriptorium window. Today, scribes who admire the medieval style can emulate it by incorporating into their work visual ingredients from their own surroundings.

The situation of the artist has changed over the centuries, too. The scribe of classical Rome or medieval France worked in relative anonymity. Job skills were specialized; the designer of a carved inscription might not be the same person who was to do the carving, and a manuscript book could be the fruit of a dozen copyists, illuminators, gilders, and binders. Today's calligraphers work mainly as free-lancers, or support themselves with another job. Institutionalized calligraphy jobs are rare. Formal apprenticeship is rarer still. The calligrapher who wants to earn a living usually works alone, learning by trial and error, doing a mixed array of projects. The working day of the average full-time calligrapher bears more resemblance to that of a self-employed attorney than to that of any scribe of the past.

GOTHIC

abcdefghijklmn

opqrstuvwxyz

HALF GOTHIC

abcdefghijklmn

opqrstuvwxyz

RECTIGOTHIC

abcdefghijklmn

opqrstuvwxyz

BAUHAUS

abcdefghijklmn
opqrstuvwxyz

TYPEWRITER

abcdefghijklmn
opqrstuvwxyz

A basic twentieth-century letter can, with subtle adjustments, reflect the graphic themes of different decades.

The monk in the Xerox Corporation advertisements symbolizes the era of human toil that is being ended by labor-saving machines. (Courtesy of Xerox Corporation.)

Today, the calligrapher's profession itself is indistinct to the outside world, briefly touching people's lives only at scattered intervals through school diplomas, party graphics, honorific presentations, and occasional commemorative commissions. Much of the scribe's work processes, in addition, are submerged in the still far from familiar processes of graphic design and printing, or surrounded by the halo of the bohemian artist's life. People who can instantly identify the profession of a medieval monk who holds a feather are simply not sure what a modern calligrapher does.

A few genuinely twentieth-century forms are emerging from the desires of the average person and the abilities of the average calligrapher. The hand-lettered, one-of-a-kind piece of poetry or prose, intended for exhibition or commissioned by a client, is becoming familiar as a new staple of the calligrapher's profession. The hand-lettered invitation, reproduced photographically and inserted in a hand-addressed envelope, is another.

The challenge, and the opportunity, that calligraphy offers in the twentieth century is to integrate yesterday's traditions with today's needs. Intelligent, objective, and creative study of the roots of traditional techniques will lead to innovation for the future.

SUGGESTED READING

The Artist's Workshop: Tools and Techniques from the School Picture Set (New York: The Metropolitan Museum of Art, n.d.).

The Arts and Crafts Movement: A Study of Its Sources, Ideals, and Influence on Design Theory by Gillian Naylor (Cambridge, Mass.: MIT Press, 1971).

Graphic Designer's Production Handbook by Norman Sanders (New York: Hastings House Publishers, 1982).

Lost Country Life by Dorothy Hartley (New York: Pantheon Books, 1979).

IV.

NEW PERCEPTIONS

And see, no longer blinded by our eyes.

Rupert Brooke, *Not With Vain Tears*

LETTERS ON THE PAGE, like actors on a stage, deal in the stuff of illusion. The writer can convince the reader that depth exists, that letters present are absent and letters absent are present, that a letter is two things at once. New knowledge about how the eye sees images is helping calligraphers to understand and expand the visual language of letters.

Transparent Windows

It puzzles me now, that I remember all those young impressions so, because I took no heed of them at the time whatever; and yet they come upon me bright, when nothing else is evident in the grey fog of experience. I am like an old man gazing at the outside of his spectacles, and seeing, as he rubs the dust, the image of his grandson playing bo-peep with him.

R. D. Blackmore, *Lorna Doone*

Cartoon figures within this letter from a twentieth-century magazine logo race around an imaginary landscape. (Courtesy of Mad *magazine and von Pollern, © 1956 by E. C. Publications, Inc.)*

These letters seem to offer a view of a light source behind the black surface of the page.

THE FIRST INKLING we get of a world beyond the page comes from looking carefully at the familiar pen-and-ink letter on the page. Yet it cannot actually be seen. Since the black ink absorbs light and the white page reflects it, only the light from the white space strikes our eyes. Optically speaking, the letter "isn't there." It's almost as if the ink has eaten its way through the paper, to make a visual hole in the page.

This illusion can be made to work in reverse; the space around the letter can make a hole in the page. Many examples of this can be found in illuminated manuscripts, where the artist traditionally filled the spaces with glimpses of an imaginary world. Whether letter or space, the window opens.

A wealth of stylistic tools and precedents is available to the calligrapher to make artistic use of the imagined letter opening and the space behind the page. The window can appear to let air through it, in which case something must appear to support the pieces of wall cut off by enclosed letters. The familiar forms of the stencil cutout illustrate how the letter can perforate the page without letting any pieces crash down. An alternative to the cut-out window is the glassed-in window, where the force of gravity does not appear to operate, and isolated segments of the wall can float just where the letter strokes put them.

Windows in the page can do all the things that real windows do—let light in, filter it, screen it, and change its color. Window frames can suggest many materials and styles, from stone Gothic arches to draped velvet curtains. Window openings can be filled with transparent plate glass or mullioned panes, translucent paper, Venetian blinds, latticed fretwork, or bug-proof screening; they can be rendered realistically or may borrow their shorthand from the language of architecture. In addition, like real windows, they open to somewhere. The viewer can seem to be looking out or looking in; viewing a bright room from a darkened world, or a dark scene from a dark interior. The other world can be filled with air or water. The viewer can see just the view, or be conscious of his or her own world reflected on the surface of the glass.

Chapter I. MERRYWINK IN THE SILVER MOUNTAIN.

The view surrounds this nineteenth-century letter, even extending slightly forward through it. (From The Adventures of Merrywink *by Christina Gowans Whyte, illustrated by M. V. Wheelhouse.)*

Since people draw on their experience of a real three-dimensional world when they look at an illusion of it, the calligrapher who fulfills these expectations will create the most convincing illusion. The space behind the page appears very similar to the world outside a window; the plane of the letter (the wall or window frame) fills the foreground, and the plane of the view (what is depicted behind the frame) makes the background. There is seldom any middle ground strong enough to bridge the two elements.

Behind the frame and filling of the window lies the view—a glimpse of another flat surface, a scene in shallow relief, or a seemingly realistic three-dimensional world. Some letter windows open up scenes of different depths behind the same page. There can even appear to be nothing behind the letter but space and light. But there will always be some sort of illusion of depth.

In the typical medieval letter illustrated here, for example, three worlds of different depths are shown. The one on the left recedes to a horizon many miles away; the middle one, in ambiguous perspective, extends in front of the page as well as in back; and the one on the right can be no deeper than the corner of the room three or four yards

A fifteenth-century capital frames three completely distinct worlds. (With permission of The Victoria and Albert Museum, Crown copyright.)

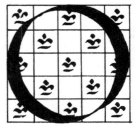

Each letter in this contemporary calligraphic design frames a different human face. (From Non Nobis . . . *by Henry Cust, written out and decorated by Hella Basu, with permission of The Victoria and Albert Museum, Crown copyright.)*

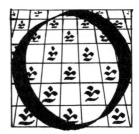

a flat background

converging lines point to a horizon

away. Even the source of light seems different for each vignette. In addition, a shallow space must be assumed to exist around the letter itself to allow the curving stems and tendrils of the white vine to twine around it.

MATERIALS
pencil and large eraser
tracing paper, or opaque paper and light table

TECHNIQUE
Artists have struggled for thousands of years with the problem of portraying depth. The scribe who depicts something behind the page joins the mainstream of representational art and will find inspiration in the solutions that other artists, as well as other scribes, have found in the past. Every work of art establishes a plane of focus, or picture plane, whether it is at the same level as the surface of the page, in front of it, or behind it. The artist can make use of a number of visual cues to imply depth: smaller size, grayer color, denser texture, converging perspective, and overlapping elements. The scribe's job is not to search for the one best way to portray depth or to use every method available, but to explore the variety of visual tools and choose among them. Everyone's choice will be different and distinctive.

To create a letter window on the page, first decide, in general terms, how you want to "open up" the page. Will the scene behind the page show through one opening or many, plain outlines or elaborate, conspicuous frames or simple? A clipping or rough sketch of the world beyond the page will help you define and arrange what it contains.

Now work with two pieces of tracing paper, or opaque paper on a

large size seems close

small size seems far away

Tricks of perspective help create a view in back of the page.

GOTHIC WINDOW

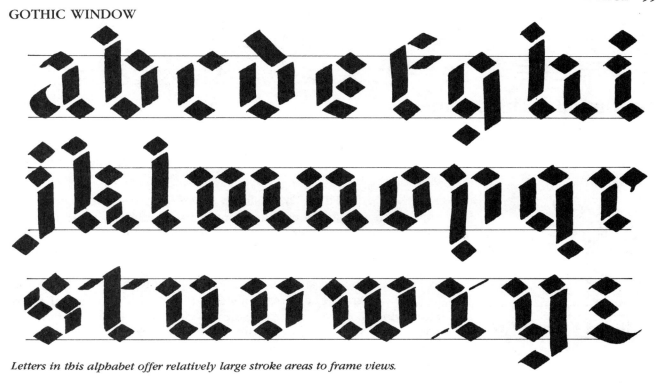

Letters in this alphabet offer relatively large stroke areas to frame views.

light table. Draw your letter on one piece of paper and lay it over the sketch of the view. Move it around, framing one or another part of the sketch to see how they interact. You may want the window to frame the view neatly without cutting off any of the elements. You may want a less formal effect, where, as in nature, some parts of the view are blocked by the frame without affecting the viewer's comprehension of what is going on. Or you may wish to delay comprehension and heighten dramatic impact by positioning the frame to block much of the view.

At this point, you may also want to alter the relative size of the letter, or reverse its values of figure and ground, to be sure that the frame enhances the view. Also try lightening or darkening the edge of the frame to control how much of a barrier the page puts between the viewer and what is behind the page.

After you have roughed out your design, you can render it in whatever finished medium you wish. Try emphasizing the two planes of vision by treating them differently: juxtapose a black-and-white world with a colored one, a soft landscape with a roughly stippled wall, or airbrushed sunlight with inked shadows.

SUGGESTED READING

Decorative Alphabets and Initials, edited by Alexander Nesbitt (New York: Dover Publications, 1959).

The Illuminated Manuscript by Janet Backhouse (Oxford: Phaidon, 1979).

A contemporary logo design depicts, in a few lines, a runway leading to a horizon. (Courtesy of Pilot Software. Art direction, Kayo Burmon; design, Sue Morrison.)

Mapping the Third Dimension

It's just ink on paper, folks.

R. Crumb, *Zap Comix*

Drawn letters act solid. (From Broom-Hilda *by Russell Myers, with permission of Tribune Company Syndicate, Inc.)*

A powerful illusion of depth is created by simple manipulation of these numerals. (20-20-20 by Edward Ruscha, courtesy of the artist.)

THOUGH THE THIRD DIMENSION seems an exotic province on the fringe of the calligrapher's kingdom, no scribe has to blaze a lonely trail to it. The illusion of solidity can be reached by half a dozen well-traveled highways. On these roads the calligrapher will join company with the artists, craftsmen, draftsmen, scientists, and philosophers who have made it their goal to understand and portray the third dimension.

The calligrapher can make a letter drawn on the surface of a two-dimensional page appear three-dimensional through its context, its surface contour, or its edge definition. Each of these methods has historical ancestors in traditional calligraphy as well as relatives in other arts.

Context can create a powerful impression of the third dimension by implying that the letter is made of a material other than the thin layer of ink on a flat surface. The familiar texture of gleaming silver, rough stone, or grained wood gives the letter solid bulk that convinces the eye. The renderings do not have to be minutely realistic. The conventional shorthand from the architectural world for surfaces like brick, wood, or flagstone can convince the viewer that several inches of some substance depth must lie behind the surface.

In addition, the letter can seem not only to be made of real material, but to be a real three-dimensional thing. A detailed snake, a realistic vine, a collection of spoons, all make reference to objects that exist in real space.

Context makes things act as well as appear. A letter or word that behaves like an object can create the illusion of real existence, even if no other clue to its solidity is present. Some additional behavioral clues, however, can further strengthen its identification. Objects in real space take precedence over each other by overlapping. A formerly two-dimensional image suddenly transforms itself into a very thin, but nonetheless solid, three-dimensional object when it appears to overlap a two-dimensional shape behind it. If both shapes are similar, the three-dimensionality of the one in front carries over to the one behind.

Letter artists who have explored the overlapped outline may enjoy a related technique borrowed from the cartographers—relief mapping. In this system, the artist builds up imaginary stacks of overlapped

A contour-mapped L.

A tilted contour-mapped O.

A square grid stretches where an O projects upward from below it.

Interlaced strokes in this drawn seventeenth-century capital imply three-dimensionality. (From a writing master's copy sheet, with permission of The Victoria and Albert Museum, Crown copyright.)

A square grid stretches where an X seems to recede behind it.

shapes whose thickness is indicated by a prearranged number. The artist floods the imaginary landscape with a gradually rising tide and, from a vantage point directly above the scene, records the imaginary high-water line at regular intervals.

A letter can be mapped as though it were a mountain seen from above. Contour mapping derives its visual content not just from the prior agreement among mappers to use this arbitrary system to represent altitude; visual psychology shows that the eye naturally assumes that concentric irregular shapes are stacked or represent some sort of three-dimensional surface in relief.

These surface optical clues come not from perspective but from pattern, and rely on the eye's ability to infer many kinds of information from, and to reason visually with, a linear image. If the surface is then made to appear to tilt away from the viewer, the visual mechanics of overlapping add to the illusion of solidity and reduce ambiguity. Tilting strengthens and streamlines contour mapping.

Other forms made of ink on paper can take the viewer into the three-dimensional world along a different route. Changes in a surface can give powerful clues about what lies behind it. The surface can be imagined as a two-dimensional elastic skin that stretches to cover a three-dimensional letter; if the skin is marked with a pattern before stretching, the viewer can deduce the letter shape from deformations in the grid. This grid can be expressed by squares or polygons of various sizes and shapes, or by lines whose width can be increased by pen manipulation or pressing.

Once a surface appears to be tilted, the artist can use perspective to make the illusion of solidity even more convincing. The human eye learns early on to interpret depth through changes in the shape of a square grid, to associate smaller size and convergence of parallel lines

Perspective projections.

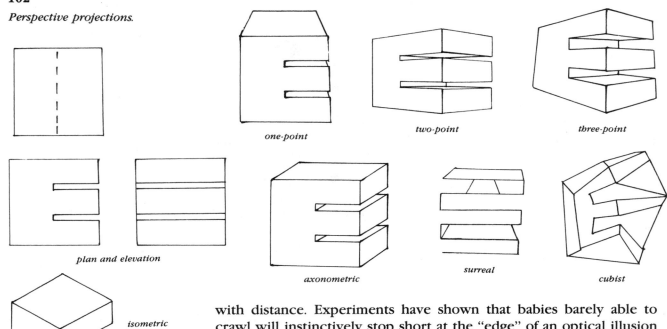

one-point

two-point

three-point

plan and elevation

axonometric

surreal

cubist

isometric

with distance. Experiments have shown that babies barely able to crawl will instinctively stop short at the "edge" of an optical illusion that looks like a sharp drop-off.

Any system that portrays a letter in perspective propels the calligrapher into the visual realm of edge definition, and into the arms of the draftsmen. The letter becomes a solid, the edges of whose surfaces can be described according to various systems of representation: plan and elevation, axonometric projection in various degrees, isometric projection, one-point, two-point, and three-point perspective, cubist perspective, and surreal perspective. None of these systems is exactly accurate, but each relies on the willingness of the viewer to go along with its basic rules and balance what is known with what is seen. Three-dimensional forms on a two-dimensional surface are distorted in different ways, but comprehension of them remains constant. Each has its laws and rules; each has its strong and weak points; each has its distinctive character; each has its group of professional practitioners; each has its practical applications in the real world; and each has its own interesting life history.

From time to time in the arena of the visual arts, one or another system has prevailed, not, as seems increasingly evident, because of the ignorance, provincialism, or stubbornness of the artists, but because one effect was genuinely preferred over another. Today, similarly, calligraphers can choose the perspective that best suits the letter they have in mind.

Perspective drawings originate in the artist's knowledge of three views of the letter: plan, elevation, and side view. The solid letter can

Mosaic letters, below, even in very coarse resolution, can create an illusion of three dimensions in axonometric perspective.

ONE MILLION DOLLARS

be assembled in the reader's mind from the information presented in the drawings.

In axonometric, or Japanese, perspective, one flat view of a rectangular solid is kept unchanged. The other two views, which would in reality be invisible to a viewer who saw the first plane flat on, are compressed into parallelograms that approximate only crudely the shapes created by real perspective. (The lines that indicate external edges, where figure meets background, are heavier than those that indicate internal ones, where planes meet each other.) This artificial system reflects only approximately what the eye sees in nature. It does, however, allow information on one face to be seen completely undistorted, while giving the viewer a distorted, but nonetheless useful, glimpse of the other two sides.

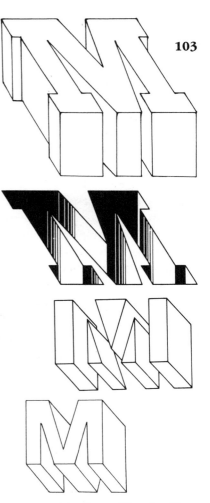

Axonometric views of two positive and two negative letters in three dimensions.

Shading and outlining create depth in these nineteenth-century ornamental initials.

If the artist puts the three views together and tilts each one at an equal or nearly equal slant away from the plane of vision, isometric projection is created. In this treatment, no side is given complete predominance over another, and some of the basic characteristics of realistic perspective are preserved. The relationship of the three planes to each other is made clear. If the object is by implication relatively small or distant, the eye suspends the normal laws of perspective and accepts the image. If the object seems or is large or nearby, it can give the eye an unsettling sense of distortion, since by the laws of perspective the only solid that could appear to be made up of equal faces and parallel lines is one that was larger at the back than the front.

One-point perspective introduces the viewer to the optical distance clue known as the vanishing point, an imaginary spot on the horizon where parallel lines seem to converge. One-point perspective is particularly useful in depicting the interior of a square structure.

Two-point perspective shows an object where two sets of parallel lines recede to two different points on the horizon. As with one-point perspective, the horizon can be lower or higher than the object, or can lie behind it.

Three-point perspective represents the vanishing point that appears when the viewer looks up at a tall structure. Vertical edge lines appear to converge toward the sky.

Isometric perspective.

Many clues of context can be added to perspective renderings to heighten their realism. Scale can be implied if an object of known size, like a person or a paper clip, is shown next to the letter. Distance affects texture by making it denser, color by graying it, focus by blurring it, and atmosphere by clouding it. Letters that have no conceivable existence in real life can be given a satisfyingly convincing identity by superrealist tricks of texture, scale, human figures, or, perhaps, landscape.

Two more perspectives exist at the fringes of the third dimension, those that reflect not visual reality but the invention of the artist's mind. Cubist perspective derives from the premise that any kind of perspective drawing distorts reality, and that the most faithful rendering of an object reflects what the artist knows about it; that it has a front, sides, and back, and that the parts that cannot be seen from any given vantage point do not cease to exist just because they are temporarily hidden from view. Cubism, at heart, is no more inaccurate than other systems of perspective.

Surreal perspective plays on the eye's gullibility to create improbable and impossible visual puzzles. They appear to the cursory glance to be familiar, conventional, two-dimensional renderings of three-dimensional objects, but on closer examination they contain conflicting visual statements that cannot be resolved by imagining the object in real space.

One-point perspective.

Two-point perspective.

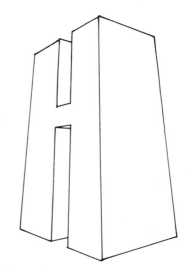

Three-point perspective.

The monumental superrealism of this twentieth-century film title is enhanced by its three-point perspective, realistic stone texture, and tiny human figures. (From the MGM release BEN HUR © 1959 *by Loew's Incorporated.)*

Two axonometric views of solid letters.

Surrealistic overlapping.

Surreal reverse one-point perspective.

Cubist double perspective.

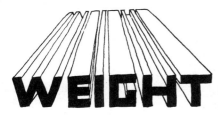

One-point perspective.

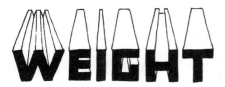

Surreal multiple one-point perspectives.

Axonometric perspective of transparent solid.

Pen strokes of controlled widths stack to create real or surreal landscapes.

TECHNIQUE

Techniques that you learned in "The Turn of the Pen," the first chapter in Section I, will be of great use to you in exploring the potential of the letter for portrayal of the third dimension. Some subtle, almost imperceptible turns of the pen can create and reveal surprising optical illusions.

Before you get into tricks of perspective, try some simple pen turns to relief-map a letter. By changing the incidence of thick and thin and controlling the transition between one and the other, you can show an imaginary contour, locate the light source, and manufacture clues to height and edge shape.

The broad pen can give the illusion of depth through several different systems of projection. A Roman O can seem to be a cylinder in a variety of axonometric perspectives, depending on the choice of pen angle. (The cylinder can also appear to be of various proportions, depending on the relative width of the pen.) The compressed oval of the Italic O changes the broad-pen letter to a flattened cylinder.

Pen turning can introduce several realistic perspective devices, some of which you may recognize or already be using. One- and two-point perspective can be controlled through pen manipulation that changes the curve of the Roman O just as distance would change the curve of a cylinder. The reader is given a slightly more realistic letter, whose curves reflect the optical distortions of the real world.

Calligraphers who examine the historical record can detect many further subtleties of perspective in the Roman capitals. The slightly above-center cross strokes, the smaller upper halves, the below-center weighting of rounded letters, all combine to create the powerful illusion that the reader is looking up at the letter from below. The letters are designed to seem, by the laws of perspective, to be very large and the reader to be very small. The monumental, architectural quality of the Roman alphabet style, quite apart from its origins in stone and its history of use in inscriptions, is built into its very form, and the optical lessons that it teaches through careful study can be applied to many other alphabet styles.

Shading creates three-dimensional effects.

SUGGESTED READING

Architectural Graphics by Frank Ching (New York: Van Nostrand Reinhold, 1975).

The Impossible Coloring Book by Oscar Reutersvärd (New York: Perigee Books, 1983).

Visual Communication, Architecture, Painting by Herbert Bayer (London: Studio Vista, 1967).

SURREAL AND IMPOSSIBLE LETTERS

THE MIND'S EDGE

Deduced Contours

Strange to relate, but wonderfully true,
That even shadows have their shadows too!

Charles Churchill, *The Rosciad*

A solid letter can cast a shadow or can catch it. Sometimes the edge that the eye supplies is stronger than the one drawn on the page.

FLAT LETTERS, a mere layer of ink on the surface of the paper, can appear to have three dimensions. The inventive calligrapher can use a number of tricks to convince the eye that the letters really use up space—space behind the page, space within the page, space on top of the page, space without any page in sight. One of the most convincing ways to occupy space is to stop the light that passes through it. Any object that does not cast a shadow in sunlight, no matter how convincingly drawn, dreamed, or described, cannot be anything but a figment of the imagination. And something that casts a shadow, no matter how featureless it is itself, has a claim to solidity that no eye can argue.

Shadows that appear to be cast by a solid letter rendered in line perspective add extra realism to that rendering. The simplest axonometric-projection drawing shaded with just one additional tone gives the letter real visual weight.

The shadow that a letter casts can either change the tone of the background on which the letter stands or lies, or darken the side of the letter that faces away from the light source. In addition, the shadow's outlines make the terrain of the background more explicit, its density implies the presence of any reflected light, and the sharpness of its edge definition can make the very quality of the air—dry, hazy, foggy—more convincing. In a related idiom, the flat letter that hovers just above the surface, casting a shadow on the paper, offers the calligrapher many opportunities for subtleties of expression and visual complexity.

Shadows can also be thrown in front of a vertical letter by light coming from behind. The length of the shadows shows how high the light source is.

As soon as the letters are raised from the surface they lie on, a distinction between two kinds of shadows emerges, cast and caught. While most letters in the three-dimensional world are not raised enough to make their cast shadows significant, even a slightly raised and rounded letter will reveal its contour and texture by the nature of its caught shadow. This caught shadow can be imitated in two dimensions.

Many historical and contemporary letter renderings that use shadows to create the illusion of three dimensions treat the letter as

Numerals and letters surrealistically catch shadows in two directions. (Courtesy of WGBH-TV, Boston. Designer, Chris Pullman and Chermayeff & Geismar Associates.)

though it has no background on which to cast a shadow, but just floats alone in airy, well-lit space. No shadow is shown except the shadow the letter catches on itself. Even the slightly raised gilded letter of a medieval manuscript will glow brighter on the side closer to the light source than on the other, an effect mimicked by Renaissance and Victorian illuminators with lighter and darker shades of paint. This specialized self-shadow lends itself to optical illusions on the page by depicting the change in letter contour not through edge outlines, but through surface tone contrasts.

The self-shadow apparently caught by a solid letter carries such a strong message to the viewer that the shadow alone—without any edge outline at all—will convince the eye that the letter is there. The eye that is willing to create edges from the subtlest shifts of tone is also capable of "seeing" an edge that is not there at all. Forever extrapolating from the shapes on the page and always seeking the most likely explanation, the eye can detect letters from the scantiest clues. In some cases, shading a letter's surfaces makes its edges almost redundant. The shadow of a letter that isn't there can create a stronger image than the outline of one that is.

MATERIALS
flexible broad-edged pen or brush
flexible pointed pen or brush
monoline pen or marker

rigid broad-edged pen or marker

tracing paper, or opaque paper and a light table

This raised letter-map gives a strong impression of three dimensions, even though many parts of the image are omitted.

The eye supplies many edges in this piece, including the completely invisible one at the back left corner of the cube.

BEWARE THE IDEAS OF MARCH

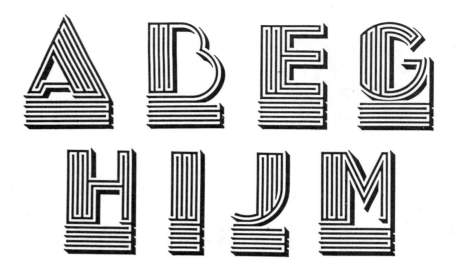

Even a complicated, multistroke swashed letter can be rendered with implied edges. (From Fantastic Alphabets, *Dover Publications.)*

TECHNIQUE

Using simple calligraphy materials and techniques to create the shadow of an invisible letter is surprisingly easy. Even in this strange never-never land of the imagination, the visual problems still have straightforward solutions.

The first letters shown here are, for the sake of simplicity, imagined as flat with rectangular edges, such as a cookie cutter would make from a smooth, thick slab of dough. You may try a number of pens, broad-edged, pressed, or monoline, as long as the invisible edge is sharp. Even a mosaic letter can create a convincing shadow. (This is by no means the only three-dimensional shape that the calligrapher can represent; after you are thoroughly familiar with the simple method for shadowing rectangular letters, you can apply what you know to more exotic shapes and perspectives.)

Several cautions will help you avoid confusing the viewer—or yourself. Misinterpretation is less likely when the light that casts the shadow seems to fall from the left and above (the customary light source for right-handed writing), and when the color balance resembles what exists in nature. The viewer is most accustomed to light

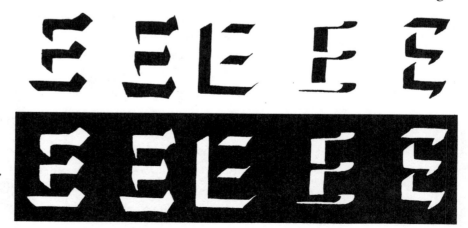

Conventional shading and some other views.

Reverse letters, where the "shadows" are light and the letters are dark, can have great impact if the image is clear.

Start with any letter.

Lay translucent paper over it so it shows faintly.

Turn both sheets sideways and letter shadow strokes.

Remove bottom sheet.

being white and shadows being black. Observe, too, that some styles lend themselves more readily to shading than others; stay with those if you want to avoid awkward anomalies and laborious touch-ups. When you know more about the strengths and weaknesses of shaded letters, you can try more unusual light angles, values, and styles.

Using a broad-edged marker, write several single strokes on a sheet of paper. Fasten a translucent sheet of tracing paper over it (or use ordinary opaque paper and lay both papers on a light table) and turn either the papers or your pen 90 degrees. Following the contours of a stroke, write along what were the right and lower edges. Next, follow the same procedure with a Roman O. Trace along beside the curve, stopping the stroke when it gets thin. Now trace an L. You may find that the shading will not fit the inside corner without some adjustment. Touch up the gap later or modify the "face" of the original letter to accommodate this dovetailing by curving all such corners or squaring them off octagonally. Finally, write a V. Notice that when you shade it there is no shadow to indicate the thick stroke. You will have to bend the invisible contour a bit to squeeze out a small shadow at each end to clue the viewer in to the presence of the stroke. Very little hint is needed, though. Don't overdo it.

Your eye will guide you with greater fluency if you periodically take your attention away from the letters you are tracing and look only at the shadows. Reorient the paper to the regular reading position. Squint at it, hold it at arm's length, or prop it up and look at it after first briefly looking away.

In a broad-edged alphabet done with one pen, the letter stroke will look about as deep as it is wide. You may want to work with two pens of different widths to create the illusion of a thin flat letter, or a narrow tall letter.

As the pen width increases, areas needing touch-up on this rectangular style enlarge.

Many letter faces can be expressed with implied edges.

You can apply the two-step technique to broad-edged Gothic. If you try a true black letter, one where the space inside the letter is narrower than the width of the stroke, you will have to settle for an illusion of very shallow depth.

A simple mosaic letter can have great visual liveliness and legibility. First work out the construction of the letter on a grid of at least ten by ten, remembering to leave enough space between the "pieces" to allow for the width of the shading pen.

Also try some letterfaces with turned broad-edged pen, monoline pen, or pressed pen. An alphabet of suggestions is included here for you to try out various combinations of letter style, pen width, perspective, light direction, and value systems. Try to derive a whole alphabet from each of the letters given here, and experiment with how far you can stretch the eye's credulity by mixing letters of different styles.

So far you have been using the broad-edged pen to shade letters of a uniform thickness. You may ultimately want to move on to letters of more complicated contour than the cookie-cutter shape. The traditional V-shaped carved Roman letter can be vividly suggested by tracing its pen stroke with a pen of half that width. Reverse the light and shadow on curves where experience tells you it would change. A gradual contour with only one edge or none can be suggested with a soft edge, or a gradual change in depth by the rising and falling of a pressed line.

THE EYE OF THE TRUE BELIEVER

Interpolated Strokes

*There is only one art: to omit.
A man who knew how to
omit could make an* Iliad *out
of the morning newspaper.*

Robert Louis Stevenson

THE HUMAN MIND displays the utmost tolerance and creativity when it interprets the meaning of written marks. The eye searches for visual clues in a number of ways: establishing boundaries between image and background, noting and forgiving the difference between information and error, smoothing apparent gaps in continuity, and determining which characteristics of a letter are attributable to the style of the alphabet it belongs in and which are its own unique properties. Vision, according to the psychologist Rudolf Arnheim, "is not a mechanical recording of elements but the grasping of significant structural patterns."

The brain can do more, however, than merely interpret what is seen. It can actually supply missing parts when the visual information it receives does not seem to make sense without them. Since the dawn of writing, calligraphers have relied on the reader to do some of the work. Indeed, this cooperation liberates the writer to invent new ways of using letters.

Students of paleography, the study of ancient writing, are often struck by the prevalence of ligatures, joined letters, and abbreviations that permeate the pages of medieval manuscripts. While abbreviations rely on the reader's knowledge of the text and of the grammatically accepted ways of shortening words, ligatures that involve the joining of two letters give more scope to the visual inventiveness of the scribe. The time-honored device of letter joining runs like a thread of unity through the manuscripts of the Middle Ages, through the type fonts of the Renaissance and the monograms of the Victorian age, to the logos of the twentieth century.

Although no ligature is simpler than the shared stroke, none is more paradoxical. In this device, two letters share the use of one stroke. The reader is not conscious of anything missing. If, however, the joined letters are separated, the reader is not conscious of anything extra. Thousands of ligatures were common in medieval lettering—where space was at a premium and the final stroke of one letter was so unlikely to resemble the first stroke of the next—and survived the translation to Roman lowercase type through the momentum of custom.

Fifteenth-century joined letters. (With permission of The Victoria and Albert Museum, Crown copyright.)

Two letters share a single stroke. (Courtesy of the National Theatre, London. Designers, F. H. K. Henrion and Ian Dennis.)

Spaces and letters impinge on each other just enough to render an invisible letter visible. (Logo designed by Deborah Discount DeBrino.)

114

Missing-edge letters show how the eye supplies a missing edge when the rest of the letter is present. Legibility can survive removal of a letter's center or extremities or of the whole letter, leaving just its outside space.

Two letters can share a single stroke. They can also, in disregard of the laws of physics, both occupy the same space. A peculiarly twentieth-century idiom allows the designer access to the shape inside or around the letter. Figure and ground are given equal rights to deliver an image to the eye, sometimes of another letter, sometimes of a familiar geometrical shape or symbol.

Joined letters use one stroke twice. The eye gets accustomed to dividing that one stroke into two half-strokes and then reconstituting each half-stroke into a whole stroke. It can similarly complete a single half-stroke when it sees one alone, enabling the writer to streamline letters when style demands it. Like the unresolved chords of modern music—which grow out of musical ideas from as far back as Bach's Goldberg Variations—the "unfinished" letter stroke relies on the viewer's dissatisfaction with the suspense. The writer can leave the crossbar of the T half finished because the readers are so accustomed to seeing the whole crossbar that they will supply the missing half themselves, probably without ever knowing that they do it. Incompleteness permeates modern art and life. The crowds that leave *Madam Butterfly,* filled with the satisfactions of a dramatic night at the opera, are blissfully unaware that the last crashing chord of the finale has left them musically unfinished, making them subconsciously hear a resolution that exists only in their minds. An incomplete visual image, skillfully handled, can in the same way have a stronger impact than a complete one.

The eye is so willing to supply missing parts and clone shared ones that the writer can venture even farther and leave out entire strokes with the assurance that, given the right context, the reader will

One of the most important visual lessons the classic Roman alphabet teaches is that the eye can participate in completing an almost complete letter. In certain letters these subtle omissions distinguish truly refined Roman penmanship from block lettering.

MINIMALIST ALPHABET

This alphabet is drawn from many historical and contemporary examples in type design, logo design, and information research.

EMMEBI

A contemporary Italian logo's incomplete letters are still easily legible. (Courtesy of Emmebi Industria Mobili, Milan. Designer, Luigi Losi.)

Gutenberg

Letters can be two things at once— themselves and another letter inverted or mirrored. (From Inversions *by Scott Kim, with permission of the McGraw-Hill Book Company. Copyright © 1981 by Scott Kim.)*

interpolate the missing elements. This streamlining is distinct from the sharing of the strokes or the visual completing of truncated letter parts. Instead, the distinctive parts of the letter are visually strong enough to be read without the help of the more redundant ones. The Western alphabet style is the outcome of two thousand years of such ongoing experiments in simplification. Some letters have shed all the extra foliage they can. In other cases, letters seem ready to sustain further pruning.

Some of the radical new stripped-down forms reveal a surprising kinship with earlier pre-Roman letters. This is entirely within the time-honored tradition of borrowing disused archaic Greek forms to recycle as new Roman letters—phonetically unrelated to the original, but echoing its style.

The eye's determination to supply missing parts and wring extra information out of the ones that are there makes it perfectly able to read one letter twice. A letter whose form or orientation makes its identity ambiguous is given the benefit of the doubt and vetted for

MINIMALIST SWASH CAPITALS

TRUNCATE

A B C D E
F G H I J K
L M N O P
O R S T U
V W X Y Z
a b c d e
f g h i j k
l m n o p
q r s t u
v w x y z

Grunch*
of
Giants

R.
Buckminster
Fuller

*Gross Universal Cash Heist

*This very contemporary type relies
on the eye's desire to fill in what it
perceives as missing strokes. (From*
Grunch of Giants *by R. Buckminster
Fuller, with permission of St.
Martin's Press, Inc., New York.
Copyright © 1983 by R.
Buckminster Fuller. Drawing by R.
Buckminster Fuller; design by Andy
Carpenter.)*

extra meanings. In addition, one letter can be read two different ways in two different words. If a letter is rotated or mirrored, the eye is capable of righting it and reading its original, intended form. But if other clues lead the eye to suspect that the revolved form also contains information, the eye can make the conceptual leap to read the letter as is, in its new position. Letters change to numbers, words mirror themselves or become new words, images contain two different meanings.

The desire of the eye to make the word fit the template can lead it even to supply a missing letter if the sound or meaning of the word suggests it.

MATERIALS
rigid broad-edged pen or marker
flexible broad-edged pen or brush
flexible pointed pen or brush
monoline pen or marker
airbrush, spray can, or spray blower

TECHNIQUE
You can start with any alphabet style—even, if you have happened to begin this book here, with your own handwriting—and learn about ligatures. Write out the 676 letter combinations and, to save some time, throw out the pairs that are unlikely to occur in English. Bind the others two by two in any way that seems both efficient and legible. Study type books, facsimile manuscripts, and the work of your contemporaries for solutions.

After you have mastered some combinations and worked them into your repertoire of lettering techniques, try another alphabet style with a different pen. You will find that new ligatures suggest themselves. Put any future alphabet style you learn through the same process. It will help you understand the style, master its technique, and give it your personal stamp of individuality.

After you have explored the combinative potential of ligatures, turn to the subtractive process. Letter your most familiar alphabet style and take away one whole stroke from each letter. This will probably be extremely difficult, since not only does your eye, accustomed to those strokes, demand them, but your hand is physically habituated to the sequence of writing them. Leaving them out feels at first like skipping a note in every bar of your favorite song. Gradually, however, by looking at them objectively and by attuning your eye to the many similarly stripped-down letters that you read without effort, you will begin to get accustomed to the process. Subtracting a stroke can add to the letter.

SUGGESTED READING
Lettering by Hermann Degering (New York: Pentalic, 1965).

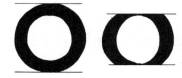

This broad-edged pen alphabet of partially obscured letters is derived from a type style called Threshold.

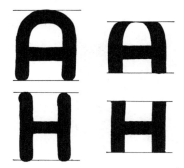

On the right, what the eye sees. On the left, what it can be persuaded to think it sees.

To enhance the intriguing illusion that part of a round monoline letter has been sliced off, turn the broad-edged pen to make the horizontal center strokes appear to be monoline.

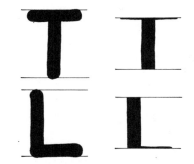

Top and bottom strokes can be thin lines, to imply that a thicker stroke was truncated.

If you omit this thickened midstroke, the eye's visual logic will detect the characteristic thicks and thins of the broad-edged pen and start to mistrust the illusion of the trimmed monoline.

Intentional and Coincidental

. . . to hold, as 'twere, the
mirror up to nature.

William Shakespeare, *Hamlet*

People, animals, plants, and a lettered banner combine to form this sixteenth-century English H. (From a master copybook engraved by Noel Garnier, with permission of The Victoria and Albert Museum, Crown copyright.)

A wine glass forms the center stroke of this W.

The futuristic letter and video-screen-shaped frame of this logo suggest the company's commitment to modern forms of communications. (Courtesy of Warner Books, Inc.)

LETTERS SPRING FROM pictures. The word "alphabet" itself comes from "aleph" and "beth," the Hebrew words for ox and house, whose shapes form A and B. An image can have a dual identity, as a letter and as something else at the same time. There are many different degrees of kinship between the letter and the thing that resembles it, ranging from one-to-one correlation, through the merest whiff of allusion, to the delayed double take of recognition, and decorative but meaningless conjunction. Objects that look like letters can be drawn calligraphically, depicted realistically, lifted from other sets of written symbols, or detected in the real world.

To begin, an object can be posed in a way that makes it resemble its own initial. The link between the shape of the thing and the shape of the first letter in its name can be emphasized by the writer. Many complete alphabets of this kind of letters exist, representing either miscellaneous collections of objects or tightly organized systems.

An object can also be shown in a position that resembles the first letter not just of its own name, but of the proper name of a person, company, or institution associated with the object.

Sometimes an object can resemble any letter in a word except the initial. The name of the object does not have to appear, but it is associated with the meaning of the word in which it appears.

Letters can be grouped together to look like the word they spell, or to form a shape that is explained in an accompanying text.

All or some of the letters in a word can be altered to resemble an unnamed object suggested by the word.

Letters—usually whole alphabets—can be made of objects that do not necessarily have any connection with the meaning of the words they form. One object can be distorted or a number of objects regrouped to form all twenty-six letters.

A written symbol that normally means something else can be used in place of a letter that it resembles. The context—usually the other letters in the word—helps the reader make the substitution. Frequently, the written symbols add extra meaning, make reference to another art form, or imply a tone of voice.

Objects in the real world may impersonate letters without any effort on the calligrapher's part beyond the revelation of seeing them. They are everywhere.

Cloth is arranged to suggest the word it initializes.

By using one I of standard height, an L with a dot added, and another I of lower height, this simple but intriguing logo design contains what it spells. (Courtesy of Reader's Digest. *Art direction, Herb Lubalin and Don Duffy.)*

A READER'S DIGEST
PUBLICATION

A contemporary magazine cover captures the hidden letter-identity of otherwise nonalphabetic objects. (Courtesy of Abitare *magazine, Italy. Design, STZ agency, Milan.)*

The felinization of these words turns them into what they spell: cat sleeping and dreaming, toy, and mouse; striped cat, mouse, and hole; bowl, cat, and kittens.

The animals in this bestiary pose to form their own initials.

Silhouetted figures form the letters of this nineteenth-century alphabet. (From
Recueil d'alphabets dedie aux artistes *by Jules Blondeau.)*

Everyday implements form letters in this sixteenth-century design by Albrecht Dürer.

Fanciful birds in stylized poses form the letters in this fourteenth-century Armenian manuscript. (With permission of The Metropolitan Museum of Art, Rogers Fund, all rights reserved.)

Two alphabets of symbols can, with the proper context, impersonate letters.

SE7EN

Pr1ority 1ne

Here ingenious substitutions challenge the eye to literally turn a numeral 7 back into a letter and to read the same numeral 1 as an I in the first word and as an O in the second. (Courtesy of WNEV-TV. Designer, Maria LoConte.)

crown

Slightly separated square serifs evoke a crown in the middle of this word. (Courtesy of and registered trademark of Crown Service Systems, Inc., Boston.)

MATERIALS
stiff cardboard, 8″ by 10″
sharp knife
metal straightedge

TECHNIQUE
Seeing the hidden personalities of letters, like seeing those of people, is sometimes just a matter of coaxing them out from a crowd. Any frame will do: two L-shaped pieces of mat board, a camera viewfinder, even your four fingers. A convenient frame can be made by cutting a rectangular window about 1 inch by 1¼ inches from the center of a stiff piece of white paper, a file folder, shirt cardboard, or poster board.

The easy but important part of this exercise is to position the frame carefully. Hold it perpendicular to the view and slowly move it away from your eye. The view will narrow, isolating individual objects. Then slowly move it closer to your eye. The view will open up, grouping a number of objects into patterns.

Next, move the window sideways and up and down to frame other views.

This framing technique can be applied to a number of views: landscapes, cityscapes, lettered pages, human figures, household objects. Once you have paid attention to the visual personalities of ordinary things by framing them with the window, you will begin to be able to frame them without the window. This informed eye will help you in all the lettering you do.

SUGGESTED READING
The Alphabet of Creation: An Ancient Legend from the Zohar by Ben Shahn (New York: Schocken Books, 1954).

The Chinese Word for Horse by John Lewis, illustrated by Peter Rigby (New York: Schocken Books, 1980).

Inversions by Scott Kim (New York: McGraw-Hill, 1981).

Just So Stories by Rudyard Kipling (New York: New American Library, 1974).

Visual Puns by Eli Kince (New York: Watson-Guptill, 1982).

Turned-pen strokes and slightly varying ascender heights map the surfaces of imaginary hills.

V.

NEW
DIMENSIONS

Be careful how you interpret the world: it is *like that.*

Erich Heller

THE FLAT BLACK-AND-WHITE image that has dominated the visual vocabulary of calligraphy for five centuries represents only one facet of the alphabet. Letters, whether hand-lettered or typeset, do not stop at the edge of the page. The third dimension has always been their native land. Other dimensions further challenge the eye, the mind's eye, and the other senses.

ᐅ HARD ᐊ EDGE ᐊ

Graven Images

"Why, you chump!" said Scrubb. "We did see it. We got into the lettering. Don't you see? We got into the letter E in ME. That was your sunk lane. We walked along the bottom stroke of the E, due north—turned to our right along the upright—came to another turn to the right—that's the middle stroke—and then went on to the top left-hand corner, or (if you like) the north-eastern corner of the letter, and came back. Like the bally idiots we are."

C. S. Lewis, *The Silver Chair*

These sixteenth-century letters, lowered in the original mold, are raised when cast. (With permission of The Victoria and Albert Museum, Crown copyright.)

TRADITIONAL PEN CALLIGRAPHY on the page treats the eye to a rich visual feast of two-dimensional images. With ink on paper, the beginning student can mimic traditional forms easily; the advancing calligrapher can choose from a nearly infinite number of lines, letters, and optical phenomena to add artistic weight to the reading experience; the skilled scribe can even convince the reader that a third dimension lies somewhere on the flat surface.

The surface of a page, however, is not the only stage on which letters perform. One reason for the eye's willingness to participate in illusions of the third dimension is that for thousands of years the alphabet has been shaped more by the solid materials of the real world than by the flat images of the graphic world—by carving and casting more than by drawing and inking. The twenty-six letters spent not only their infancy and childhood, but also their adolescence and early adulthood speaking the idiom of the graven image.

The graven line breaks through the surface of solid wood, stone, metal, wax, soil, concrete, clay, or even paper to create a three-dimensional letter whose primary function is still to convey two-dimensional information. The third dimension accomplishes other aims beyond the simple function of making the letter physically permanent. It may catch the light or cast a shadow, thus obviating or reducing the reliance on pigment to put the message across, and it shelters from wear any pigment added for emphasis or decoration. Moreover, with some materials—slate, for example—merely exposing a different layer of stone uncovers a contrasting color underneath.

The graven letter, like its two-dimensional inked graphic counterpart, is by definition a letter that is not there. Visually, it can be seen because material has been removed from a background. Raised letters, from which the background has been removed, are somewhat less common and are usually the result of a further step in the process of making reproductions from a graven letter.

Since the warm sunny climate of the Mediterranean basin inflicts

less wear through freezing and thawing and facilitates reading with sharp and reliable shadows, it is no surprise that the graven letter figures particularly strongly in the formative period of Western history when culture centered around the temperate climates of the Mediterranean and Middle East. The carved capitals of imperial Rome shaped two thousand years of pen letters and survive almost unchanged in the contours of today's calligraphy and type. Perhaps less familiar than the carved Roman capital, but no less a part of our alphabet's origins, is the unbroken continuum of other three-dimensional graven record keeping and communication artifacts, a heritage that leads from the prehistoric bullae of early commerce through cylinder seals, signet rings, runes, Roman capitals, woodcuts, block books, movable type, gravestones, rubbings, etchings, engravings. Together, these have shaped the letter of today and bound together traditional styles and techniques that stretch back seven thousand years. Our letterforms today show the shapes of their graven ancestors. In many respects the alphabet remains, as the typographer Stanley Morison said, "not script but sculpture."

The first practical writing, it seems increasingly clear, was what a

A twentieth-century graffito is carved into stone with many small strokes.

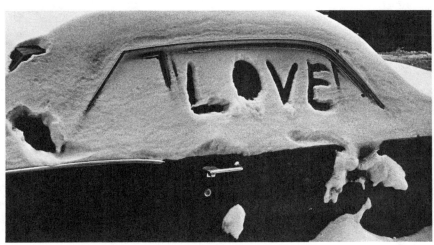

A contemporary graffito is excavated down to transparent material. (From a photograph by Jack Prelutsky, with permission of Stock, Boston.)

write rait pt. **wrote** rout, pp. **written** ri·tn form or delineate with an implement; inscribe (letters). OE. *writan*, pt. *wrāt*, *writon*, pp. (*ge*)*writen*, engrave, draw, depict, write = OFris. *writa* score, write, OS. *writan* cut, write, OHG. *riȝan* tear, draw (G. *reissen* †sketch, tear, pull, drag), ON. *rita* score, write (Norw. *rita*, dial. *vrita*) :- CGerm. (exc. Gothic; cf. WRIT) **writan*, of unkn. origin. ¶ The sense-development is due to the earliest forms of inscribed symbols being made on stone and wood with sharp tools.

(From The Oxford Dictionary of English Etymology, *edited by C. T. Onions, 1966, courtesy of Oxford University Press.)*

graphic artist would call printmaking, and it relied on impressions of small figurines of animals and goods as a form of record keeping. These miniature representations of livestock and merchandise, called bullae, were first used as tallies. Later they were pressed into soft clay and the impressions were counted instead. Thus, from the very beginning, *graphos,* the root of many of our words for writing, contained not just the abstract idea of making two-dimensional images, but also the specific connotation of scraping, routing, embossing, and carving in the third dimension.

Furthermore, the graven line lies at the heart not only of the concept of writing, but of the concept of printing. The writing of many other cultures shares with the Western alphabet some of the same kind of graven origins, and reminds the calligrapher that a carved inscription is nearly as useful for the reproductions that can be made from it as it is in itself for immediate display. The reversible Greek letter is particularly workable for this dual role. Chinese calligraphic inscriptions are intended as much to be printed or rubbed from as to be viewed themselves, and the prints, in turn, can be the models for further carvings. Carved Roman capitals can be similarly duplicated by printing, rubbing, or casting.

The movable type of traditional hand-set and hand-operated letterpress work is cast from a set of matrices, or master letter molds,

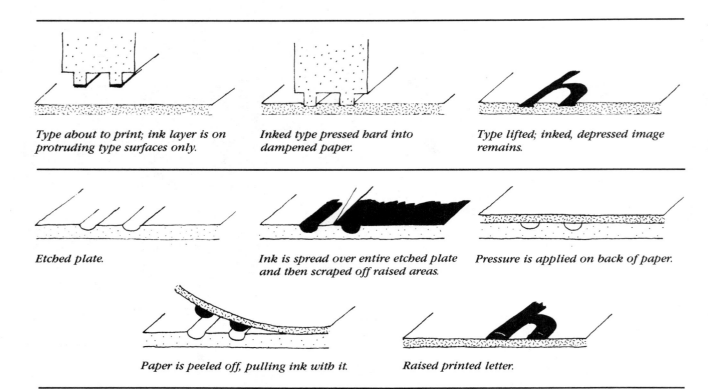

Type about to print; ink layer is on protruding type surfaces only.

Inked type pressed hard into dampened paper.

Type lifted; inked, depressed image remains.

Etched plate.

Ink is spread over entire etched plate and then scraped off raised areas.

Pressure is applied on back of paper.

Paper is peeled off, pulling ink with it.

Raised printed letter.

Cross-section of two printing methods that produce slightly raised or lowered relief.

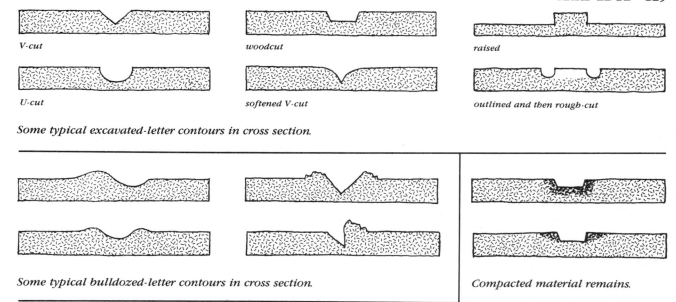

V-cut

U-cut

woodcut

softened V-cut

raised

outlined and then rough-cut

Some typical excavated-letter contours in cross section.

Some typical bulldozed-letter contours in cross section.

Compacted material remains.

which have themselves been struck from carved metal punches. Raised type not only puts ink on the page where it is needed to delineate letters, but also, because of pressure against the back of the page, smoothes out the area where the ink adheres and presses it down slightly into the rough surface of the dampened paper. This three-dimensional effect, called "sock," is now highly prized in the aesthetics of fine printing. It heightens the liveliness of the two-dimensional inked image and protects the printed ink from friction with the surface of the facing page. Even the graven letter on an engraved or etched printing plate prints a three-dimensional image of itself, adding not just black ink to the page but raised, rounded, three-dimensional black ink.

Calligraphers who want to study the graven letter can begin by learning how the basic carved letter is made, and then, if they like, advance to making additional images from it.

Most carved letters rely primarily on light to cast a shadow across their altered contours. There are two ways to alter a flat landscape so that it casts shadows—bulldozing and mining. The writer can either push the existing material around in such a way that hills and valleys are created or remove some of the material completely by stowing it somewhere outside the reading area. In the first category are all molded, impressed, or struck writing methods, such as cuneiform, sand writing, and wax tablets. In the second category are all carved, routed, excavated, or mined writing methods, such as classic Roman carved capitals, woodcuts, and type.

A molded image in cross section looks more or less like a furrow, depending upon the consistency of the material. The material dug up stays near the spot from which it came.

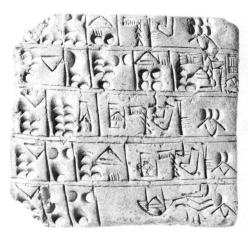

Cuneiform letters are made by compacting and piling up extra clay when a triangular or cylindrical stylus is pushed into soft clay. (With permission of the Trustees of The British Museum.)

A carved letter, in contrast, offers more variety of profile, according to the letter style, tools, and materials that the carver chooses. The material removed does not have to be kept in the immediate vicinity.

Some excavated letters are made by compression. The extra material is compacted so that it is not in evidence. Many of these compressed letters represent the second, printed stage of graven letters, where one image is used to create another.

A graven letter of either description offers the further option of printing from the initial image. One of two approaches is used: reversed, in which the image will appear as a mirror image of itself, and true, in which the image appears right way around.

The Greek way of writing lent itself to interchangeably identical legibility either of a carved original or of its struck image, since no classical Greek letter resembles any other Greek letter, no matter how it is rotated or mirrored. Thus a Greek coin, seal, or amulet loses none of its legibility when it is printed, since there is no such thing as backward. Not only letters but words pass through printing unchanged, as Greek writing more than one line long followed the *bostrophedon* arrangement—literally, "as the ox ploughs" or back and forth as one would knit or weave or mow a lawn. Although characters on alternate lines were what we would consider reversed, the Greek reader perceived no ambiguity.

Few other contemporary alphabets, either from other cultures or from descendants of Greek, grant this mirror image equal rights. If the letter is not to sacrifice some of its legibility through being reversed, one of three things must happen. The pigment must be applied not between the letter and the printing surface, but rather on the back of the printing surface; or the letter must be reversed by an intermediate step of casting; or the pigment must be offset before it comes into contact with the printing surface. Gravestone rubbings, typecasting, and offset lithography are familiar examples of these three solutions, all of them accessible to the scribe through experiment with everyday tools and materials.

Greek intaglio writing, though carved Dexamenos Enoie *from left to right and then, by modern standards, reversed in the printing, would not have seemed backward to a reader of the fifth century* B.C. *(Portrait from the Francis Bartlett Donation, with permission of the Museum of Fine Arts, Boston.)*

MATERIALS
clay and orange stick
wood and carving chisels
hard rubbing crayon or carbon paper, and thin paper
slate or marble and stone chisels and mallet

TECHNIQUE
To begin exploring the graven letter, provide yourself with a material that will not offer too much resistance to a tool—clay, soap, wax, or Plasticine for greatest ease. Wood or stone will give more authentic results for some of these experiments, but will slow you down too much in the beginning. Choose one blunt molding tool and at least one sharp carving tool.

First try simply making impressions of the tip of your molding tool to familiarize yourself with the shape of the tool and the consistency of the material. After you have gotten a feel for this medium, smooth the surface and press out a few letters. These little imprints form the basis for the wedge-shaped cuneiform letter stroke of 3500 B.C., and give your alphabet an antique archaeological look. Try mixing imprints of the side of the tool with imprints of its end.

Next, make not an imprint but a whole sustained stroke, and observe what shape of letter this kind of line lends itself to. You will be retracing the historical development of the Greek letter, which grew out of inscriptions scratched on metal and stone, and was taught in classical times with a wax tablet and a stylus. Letters were written into the wax, checked by the teacher, rubbed smooth, and written again.

Now try the same stroke but use a sharp carving tool instead of the blunt molding tool. You can remove a strip of material in one of the following ways: V-cut, U-cut, flat-bottomed cut, round-topped V-cut, rough-bottomed cut. Among the carving tools available are flat chisel, the V-shaped chisel, and the U-shaped chisel. The carving tool can, according to the hardness of the material and the relative size of the letter, be handled with smooth continuous pressure like a plow, or with separate percussive jabs or mallet-aided taps like a jackhammer. Early Greek letters and Celtic runes seem to have been shaped by single plowed strokes, while later Greek letters and Roman capitals seem to have been shaped with many strokes following a painted outline.

A graven letter, like an inked one, can be expressed as either an image or a background. The denseness of the chosen letter sometimes will dictate the choice in pure acreage; if there is to be more background than letter, it is easier to remove the letter.

In other cases, the surface may be so uneven that a greater area must be brought under control of the carved line to make the remaining image clear to the viewer.

The visual image created by the way light falls across this altered surface can be further strengthened by contrasting the texture or color of the letter and its background. Textural combinations of all kinds are available to the carver, ranging from a near-perfect, smooth overall finish to graining that almost camouflages the letter stroke. Many of the subtle visual ambiguities of the soft-edged letter, the flourished stroke, and the illusory edge can be made real with the graven line.

Color can be added to a carved letter, as archaeological excavations have shown was customary with the Roman letter. Or color may be uncovered in the material, as with cameo and slate carving. Or color may be produced by the process of raising or lowering the letter, as with modern Dymo label embossing technology.

The finished carving can be read as it is or can serve as a type from which to make reproductions. To make a reversed image, ink the

Extra wax dug up by the stylus that made these Coptic letters, which were used to teach children to write, remains next to the stroke. (With permission of The Metropolitan Museum of Art, Rogers Fund, all rights reserved.)

The background is excavated from these seventh-century Northumbrian runes. (From the Franks Casket in the collection of A. W. Franks, with permission of the Trustees of The British Museum.)

carving and press paper against it. Printing technology allows you to a certain extent to decide whether to ink the raised part with a flat ink roller and print from it by allowing the paper to touch only the raised parts, or to ink the whole area, scrape the ink off the raised parts, and print from the lowered part by pressing the paper into contact with both the raised uninked parts and the ink caught in the lowered parts.

To make a true image rather than a reversed print from a carved or engraved original, lay paper over the carved surface and rub a hard flat piece of pigment over it. The raised parts will create enough friction to rub pigment off the piece onto the paper; the lowered parts will not. Carbon paper can provide the pigment; properly placed, it can also render a reversed image if that is desired.

The carving can also serve as a matrix from which a further printing type is made, if you press moldable material against the surface or pour melted material on it to harden. Three-dimensional soft material will create a reversed letter. If you wish to mold a positive image, press a thin surface against the letter. (A sharper contour will result if you have both a positive, convex, "male" mold and a counterpart concave "female" mold.) A molded impression can be made with rag paper well dampened, pressed down hard into the recesses of the carving, allowed to dry and harden, and then peeled off. This "squeeze" can serve as either a reversed or a true image. (Along the same lines, early-twentieth-century advertisers provided newspapers with heavy, high-relief, paper "stereos" as matrices from which to cast printing plates.)

Observe when you print certain words that they read the same in reverse or upside down. This is only true in some cases. Unlike pictures, most words in English that read correctly on the original look completely wrong on the reverse print, and almost everyone who prepares lettering for reverse printing makes this mistake once.

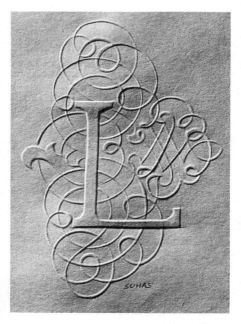

This raised letter was made by a unique twentieth-century expert, who hand-embosses intricate letters and designs with a specially sharpened fingernail. (With permission of Suhas A. Tavkar. Photography by Wil Blanche.)

SUGGESTED READING

Design with Paper in Art and Graphic Design by Raymond Ballinger (New York: Van Nostrand Reinhold, 1982).

Letters Slate Cut by David Kindersley and Lida Lopes Cardozo (London: Lund Humphries, 1980).

Tombstone Lettering in the British Isles by Alan Bartram (New York: Watson-Guptill, 1978).

TRUE ✦ ✦

Letter in Real Space

*The language of the sculptor
. . . requires the sublime. . . .*

Antonio Canova, in *Artists on Art*

This seventeenth-century American weathervane is perforated with numerals. (With permission of the Essex Institute, Salem, Massachusetts. Photograph by Mark Sexton.)

THREE-DIMENSIONAL LETTERS represent the final step in the process initiated by the first graven line and struck impression: the freeing of the image from its background to give it a life of its own. A letter that a person can walk around is no more—and no less—startling intellectually than a statue a person can walk around. Visual elements of light and shadow, depth and size, and relation to the scale of the human body that were begun with the carved Roman monumental letter are carried to a number of visually satisfying conclusions by the solid letter, with many new possibilities suggested for calligraphy of the future.

The three-dimensional letter can evoke its two-dimensional counterparts in some thought-provoking ways. First, a one-dimensional figure—a line—can occupy three-dimensional space. Next, a free-standing two-dimensional flat letter can create the illusion of a transparent page surface in the air and re-creates in real life the images of the space behind the page. The transparent image or the transparent page lets the viewer see from the back a letter that formerly had only a front, as though the ink layer that transfers from graven plate to printing paper was instead peeled from the plate and held up to view. This back view may not be particularly meaningful, or even intentional, but

The facade of this twentieth-century bank featured doors and windows shaped like letters. (From a photograph of the New Bank of Boston by Joe Dennehy, with permission of The Boston Globe.*)*

133

it exists. There may not be any edge to this two-dimensional letter in three-dimensional space, but the viewer can see through it from both directions.

The letter seen through glass or translucent paper that has a front and a back also has, however infinitesimal, an edge. If that edge is thickened only slightly, the letter will stand on its own as a three-dimensional solid. This edge may not be visually important, but it is structurally vital. The flat letter of significant height and width but negligible depth can still occupy all three dimensions; it can bend and curl out of the two-dimensional plane; it can turn nearly edgewise to the viewer; it can simultaneously occupy one, two, and three dimensions—all without stretching, thickening, or folding.

A further exploration of the flat letter in real space allows the artist to fold it, so that it occupies, and even appears to enclose, three dimensions.

The flat letter peeled off the page can gradually add depth until it is a solid letter occupying space. This transition seems to occur when the viewer senses that the letter will stand vertically on its own base

The translucent quality of the paper in this sixteenth-century manuscript book lets the reader see the back of the letter on the next page. (From a master copybook engraved by Noel Garnier, with permission of The Victoria and Albert Museum, Crown copyright.)

without propping. The simplest true solid comes from this cookie-cutter approach, but need not stop there.

Even the minuscule change of perspective that comes from shutting one eye at a time will produce two different visions of one solid object. Calligraphers familiar with twentieth-century art will recognize that this ambiguity of the binocular image is resolved in the style of cubism, which presents to the viewer a kind of unfolded, two-dimensional amalgam of what he or she would see on several planes of a three-dimensional object.

Integral as the solid letter is to the flat letter's visual identity, it also has a life of its own with its own peer group in the world of statues. The back of the letter may have something quite different to say from the front, or there may be no way to say which is the back and the front. The letter may be transparent, so that the back is visible from the front; the space may be formed by an armature of edge lines rather than a skin of surface planes, so that all of the letter can be seen at once; the back may be seen more often than the front; the letter may read the same way back and front.

The three-dimensional letter, like the two-dimensional, responds vivaciously to a change in the viewer's orientation. It can change its identity accidentally or on purpose when read in mirror image from behind, or it can reveal a different identity in each dimension.

The three-dimensional letter, like the graven one, can say more with its shadow than it does with its substance. Light falls on it, in it, and through it, in a way unattainable in any other dimension.

A public-television station's channel number has been transformed into the Channel 2-mobile, "the world's largest vehicular digit." (With permission of WGBH-TV, Boston. Designer, Chris Pullman; fabrication, Concept Industries.)

MATERIALS
drinking straws and heavy needle and thread

stiff paper and craft knife
glass and poster paint

foam-core board and craft knife
wood and jigsaw
soap block and knife

TECHNIQUE
The letter in three dimensions can be fabricated in many ways that retrace its gradual evolution from dimensionlessness to real substance. The thinnest wire, echoing the nearly widthless monoline, can be shaped into a letter that can be seen as a letter in one aspect but still looks like a line in two other dimensions. This same line can also, however, read in three dimensions if it is used as an outline for a flat letter and as edges for a solid but empty one.

If the monoline is allowed to widen to a strip, many elegant calligraphic letters can transfer from page to space. Angling a stiff strip edgewise to the eye echoes the visual dynamics of the broad-edged pen letter. Arranging a pliable strip in limp folds recalls the natural

A solid letter reads three ways in each of its three dimensions. (From the cover of Gödel, Escher, Bach: An Eternal Golden Braid *by Douglas R. Hofstadter, with permission of Basic Books, © 1979 by Basic Books, Inc., Publishers. Photograph by Douglas Hofstadter.)*

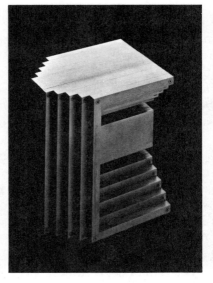
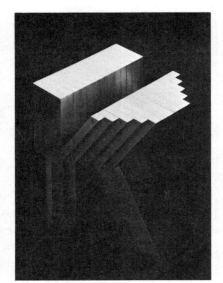

Layered metal letters reveal this contemporary Japanese artist's individual vision of each letter's invisible geometry. (Courtesy of Takenobu Igarashi, Tokyo.)

curves of relaxed swashes. Constructing a Moebius-strip letter baffles the viewer with apparent paradoxes of one-dimensionality.

The letter made of two-dimensional planar material need not be limited to the visual conventions of flat letterforms. Even the simplest cutout can be curved, pleated, or crumpled to engage the eye at various angles, or to contain more than one letter. A stretched surface can define a letter area along a series of points in a plane, or connect lines in all three dimensions. Simple bent wire coat-hanger letters, dipped into soap, can exhibit complex parabolic soap films that connect the seemingly simple outlines in mathematically intricate patterns.

Other solid construction methods evoke their two-dimensional counterparts. Mosaic letters can be built up from blocks, balls, or cream puffs. Letters can be built up additively, by putting more and more material together, or they can be sculpted subtractively by removing material—creating negative space—until the desired shape is attained. And the ultimate soft-edged letter enters the third dimension as a hologram, completely insubstantial yet solidly visible.

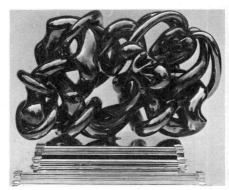

*These three-dimensional monoline letters assemble to form a statue. (*Homage to Picasso *by Miguel Berrocal, photographs courtesy of the artist.)*

SUGGESTED READING
"Vision by Man and Machine" by Tomaso Poggio, *Scientific American,* Vol. 250, No. 4 (April 1984).

Words and Buildings by Jock Kinneir (London: The Architectural Press, 1980).

Through the Prism

I fear no colours . . .

William Shakespeare, *Twelfth Night*

Colors react differently to their neighbors.

When color is present, an afterimage of the complementary color persists in the eye. Stare at the image above for thirty seconds, then look at the space below. You will see a green letter on red.

COLOR ADDS a further dimension to the shape of letters on surfaces and to the surfaces of letters in space. Color allows the artist to *say more* in the same space than can be said in black and white. According to contemporary information theoreticians, and reported in a recent issue of *Scientific American,* "The presence or absence of a mark at a predetermined position on a sheet of paper encodes one bit of information. If the mark is allowed to vary in color as well as position, the density of the information that can be stored in a given area is multiplied by the number of colors that can be distinguished from one another at each site."

Scientific research into color has much to offer the artist. The scribe who understands how the eye and brain see color can most intelligently and creatively combine color with letters. Some color vision affects the eye directly. Colors look different, depending on what color they are next to; orange looks reddish on a yellow background, yellowish on a red background. Colors are affected not only by proximity but by afterimage; the eye that has just looked at red carries a green afterimage for five to ten seconds that alters perception of the next color. Colors look not only darker but less colorful under weak light because the eye sees color with specialized receptors called cones. When the light is dim, the rods take over, and they only sense shades of black and white. Cones developed later in human evolution than rods, suggesting that color vision is more sophisticated than black and white.

Color can create abstract optical illusions, fooling the eye into believing that motion and depth are present on a flat surface. Color can heighten or negate existing three-dimensional effects of light and shadow.

The same letter can appear to change color or tone in relation to its background. The illusion that a letter changes color can be heightened by a continuous, gradually changing background.

137

Color can serve purely decorative purposes . . .

create surreal illusions . . .

or enhance existing illusions of three-dimensionality.

The brain, as well as the eye, sees color. Color can be used to depict objects in the natural world. When the brain interprets the visual images sent by the eye, color enhances recognition of the objects in those images. Sometimes, in return, the objects enhance recognition of the colors; brown shading and green highlights can paradoxically portray a very yellow lemon if the surrounding picture has led the viewer to expect this.

Color can reflect the historical world as well as the natural world. Some color combinations are so distinctive that their use can give a piece of lettering the look of a bygone era. Heraldic scarlet, crimson, and azure dominate the illuminated letters of the Middle Ages. The nineteenth century made popular the hues of the "greenery-yallery" period and the "mauve decades," while recent generations are marked by enthusiasm for platinum, all-white, or pink and gray color schemes. Although medieval colors, for instance, can be used with medieval letterforms to strongly evoke the style of the Middle Ages, the calligrapher of today need not stop there. A historical color scheme can amuse or surprise the viewer in conjunction with modern letterforms; it can intrigue and engage the viewer if it brings out some previously unnoticed link between a modern text and the spirit of another era. And new color treatment of traditional letterforms can make the viewer take a fresh look at the letters themselves.

There are many specialized vocabularies in the language of historical color. Color can imply a state of mind: red for sin, black for mourning, green for jealousy, white for purity. Speaking with color assumes that the viewer understands the language, however, since the same color can have a different meaning in another culture. In the Orient, for example, white is the mourning color, while red signifies joy and is the dress color commonly chosen by brides. Even in the same culture color can mean different things. Red ink means one thing to the calligrapher and another to the accountant.

Color can, by common consent, identify something as clearly as a word does. "The red, white, and blue" means "flag" to an American, while the color of the Soviet flag has come to describe that country's government as "the Reds" and its one-time ally as "Red China." "Greenbacks" are paper dollars in colloquial American usage. All over the world, a red light means "stop," a green light means "go." To a small population along the eastern seaboard of the United States, crimson, old blue, or tiger orange and black of the Ivy League command undergraduate loyalty and alumni nostalgia. Blue, red, and white ribbons are synonymous with first, second, and third prize in all walks of life. And few people in the Western world would confuse the traditional colors of Christmas with those of Halloween, or mistake St. Valentine for St. Patrick.

This hand of custom selects many of the traditional calligrapher's colors: red for headings, initials, marginalia, or the Word of God, purple for royalty, blue for the robe of the Virgin Mary. These colors were

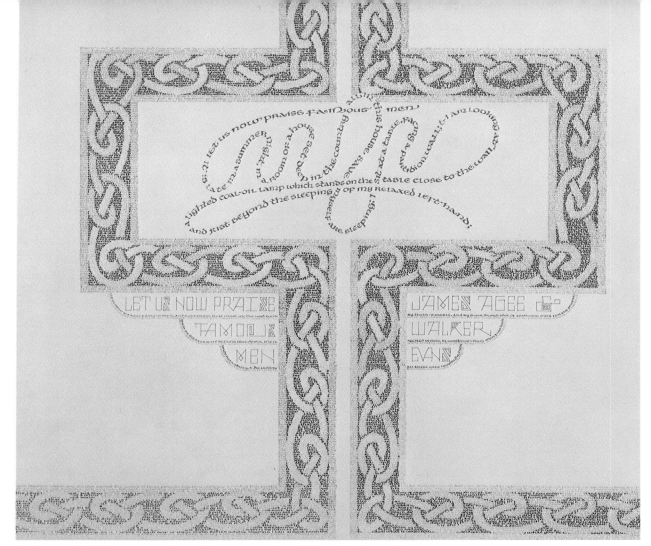

Color can let letters carry a decorative message in addition to information. Horizontal lines of letters, above, change color to form an intricately knotted border design.

governed by the pigments available to the medieval illuminator. Some customary letter colors have entered the metaphors of spoken language, such as the "red-letter day" that used to mark out a saint's day on the medieval ecclesiastical calendar. Custom does not explain every color choice, however, nor does it suggest new ways of choosing an appropriate color.

Color also talks to the viewer in emotional terms. Some reactions to color are ingrained in a way that could not have been learned but must be an innate part of the sense of sight. Actors, for example, dress and make up in a "green room" whose pale green walls are commonly supposed to soothe their nerves. (This could, conceivably, happen because the green somehow reminds the eye of the restfulness of green forests, but other colors directly affect the emotions without suggesting anything specific.) Violently disturbed mental patients have

been found to calm down noticeably after thirty minutes in a room with bright pink walls.

Emotional reactions to color may also be unique to each individual. In *Speak, Memory,* Vladimir Nabokov describes his own palette of "colored hearing":

On top of all this I present a fine case of colored hearing. Perhaps "hearing" is not quite accurate, since the color sensation seems to be produced by the very act of my orally forming a given letter while I imagine its outline. The long *a* of the English alphabet . . . has for me the tint of weathered wood, but a French *a* evokes polished ebony. This black group also includes hard *g* (vulcanized rubber) and *r* (a sooty rag being ripped). Oatmeal *n,* noodle-limp *l,* and the ivory-backed hand mirror of *o* take care of the whites. I am puzzled by my French *on* which I see as the brimming tension-surface of alcohol in a small glass. Passing on to the blue group, there is steely *x,* thundercloud *z,* and huckleberry *k.* Since a subtle interaction exists between sound and shape, I see *q* as browner than *k,* while *s* is not the light blue of *c,* but a curious mixture of azure and mother-of-pearl. Adjacent tints do not merge, and diphthongs do not have special colors of their own, unless represented by a single character in some other language (thus the fluffy-gray, three-stemmed Russian letter that stands for *sh,* a letter as old as the rushes of the Nile, influences its English representation).

I hasten to complete my list before I am interrupted. In the green group, there are alder-leaf *f,* the unripe apple of *p,* and pistachio *t.* Dull green, combined somehow with violet, is the best I can do for *w.* The yellows comprise various *e*'s and *i*'s, creamy *d,* bright-golden *y,* and *u,* whose alphabetical value I can express only by "brassy with an olive sheen." In the brown group, there are the rich rubbery tone of soft *g,* paler *j,* and the drab shoelace of *h.* Finally, among the reds, *b* has the tone called burnt sienna by painters, *m* is a fold of pink flannel, and today I have at last perfectly matched *v* with "Rose Quartz" in Maerz and Paul's *Dictionary of Color.* The word for rainbow, a primary, but decidedly muddy, rainbow, is in my private language the hardly pronounceable: *kzspygv.*

What happens to color in the eye of the beholder depends partly on how that color gets to the eye in the first place. Three major kinds

Color creates five separate worlds of different hues. (Courtesy of The Atlantic Monthly. *Designer, Robert Cipriani, Cipriani Advertising, Inc., Boston. C photograph by Cliff Feulner, The Image Bank, with permission; N photograph by G. L Francolon, with the permission of Liaison Agency, Inc.)*

of light convey lettered images to human eyes: reflected, filtered, and emitted. Most objects in the natural world absorb some colors from the light that strikes them and reflect others. The hues in the reflected light form the color. In opaque reflective media, pigments on a background reflect various colors; transparent or translucent reflective media simply reflect some of the background color as well.

Opaque media frequently change not only the background color but also its surface texture. The matte finish of Renaissance gouache and the smooth, silky surface of medieval egg tempera reflect light in different ways. The texture of the surface itself, if finely manipulated, can produce color through refraction; minute differences in the angle of reflection of light bouncing off grooves or particles will set up interference patterns that the eye interprets as color. Fish scales, butterfly wings, oil on water, some kinds of purple dye from antiquity, and the surfaces of modern laser-etched discs, all create color with refraction.

Not all color comes from reflected light. Filtered light makes color when a transparent substance intervenes between a light source and the eye. Some colors are stopped, while others pass through to reach the eye. Filtered images have been made for a thousand years with medieval colored glass and stained glass, and are familiar in today's black-lit signs, overhead projectors, and sunglasses.

Twentieth-century technology has given birth to the last major kind of colored letter, which neither reflects nor filters light from another source but emits its own. Since the neon of the nighttime marketplace, and the cathode rays, light-emitting diodes, and liquid crystal displays of the daytime work world have become such a familiar visual medium for the contemporary reader, it is only a matter of time until technical progress puts these truly "illuminated" letters within reach of the creative lettering artist.

MATERIALS

colored pigments (including white) such as:
 watercolors
 colored pencils
 colored markers

colored filters such as:
 stained glass
 transparent colored acetate gels

TECHNIQUE

Many of the black-and-white techniques and materials you learned about in the first section of this book lend themselves to color. Just substitute colored ink in your pen or colored paint on your brush, and letter as before. You will need, and want, however, to use the full potential that color offers. First, determine whether the letters you are imagining will reflect, filter, or emit light to the viewer, or will com-

bine two of these mechanisms. For example, people usually see the light filtered from a stained-glass window by gazing directly at it, but they see the light filtered from a photographic color slide when it reflects off a white screen. An illuminated initial, a billboard, a T-shirt, all reflect light. A neon letter emits light, as does a computer-screen display or a bank of lighted candles on a birthday cake.

It is important to have clear in your mind what kind of light you are dealing with, since many techniques do not transfer from one kind to another. A combination of red and green paint will create brown reflected light; a combination of red and green filters will create yellow filtered light. Reflective combinations are usually additive, filtered ones subtractive, and emitted ones are sometimes unpredictably catalytic.

Now look at the special decisions that each kind of light offers. Reflected color has different degrees of transparency; which one is appropriate to the effect you are striving for? You may trade off the brilliancy of a transparent hue for the covering capacity of an opaque medium, as long as you know what you are losing and gaining when you do this.

Filtered light behaves differently from reflected light. One of the most familiar filtered media is stained glass. The lead strips that support and connect the pieces of colored glass also divide them optically; but because light radiates from its source, the eye's perception is that these black lines drop out of view. (This is why a color print of a stained-glass window never reproduces the visual experience of actually looking at one.)

Things that emit light each have a characteristic light spectrum; although they may appear white or tinted, they are almost always

Color lets these letters interact with their background in a number of ways: first they change color abruptly to delineate the edge of the fire, then they allow the grainy texture of the flame to show through, and then they change to a solid red to contrast with the darker color of the flame's base.

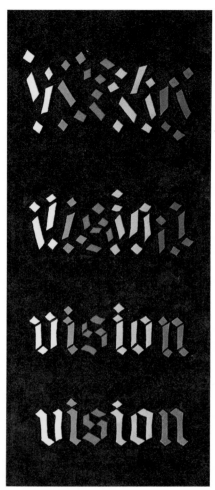

This calligraphic design embodies what the eye does to interpret filtered light.

made up of several colors. These spectra, useful in themselves as sources of color, become important to the artist when emitted light is combined with reflected or filtered light. A painted letter, for example, can look very different under sunlight, fluorescent light, ultraviolet ("black") light, incandescent light, or candlelight. If you know what kind of light is likely to illuminate your work when it is finished and displayed, you can take this into account from the beginning. If you do not know, you can hedge your bets by looking at the work in progress under fluorescent light, incandescent light, and a combination of both to approximate sunlight.

Furthermore, if you are lettering with color for reproduction, remember that the camera "sees" differently from the human eye. Blue and red look, respectively, white and black in the eye of the photostat camera. Color film of various kinds may heighten some colors and suppress others. (Kodachrome film, for example, is particularly sensitive to the tones found in skin color, while it does not discriminate as much in the blue-green area.) If you need to make an original for color copies of any kind, familiarize yourself with how the copied tones will differ from the original ones.

Next look at the history of each set of materials in relation to the history of the letterform you have in mind. What does each say about the other? They can contrast or agree, depending on your intentions. A twentieth-century letter colored with twelfth-century materials can say different things from a twelfth-century letter colored with twentieth-century materials. Neither is an automatic choice until you have thought through your whole piece of calligraphy.

After all these decisions, you can get down to the aesthetic pleasures of experimenting with color in whatever materials you have chosen. Begin by varying the color, lightening or darkening it by diluting or intensifying it. Add white, add black, add the color's opposite. Apply the color over a white background, a colored background, a black background, a transparent background. Get to know your color, how it behaves under stress and in a variety of situations.

Now look at two colors. Immediately you must decide how to place them in proximity to one another and learn to deal with their peculiarities when this is done. They can coexist, each occupying a different letter, word, line, or block of text. They can share one letter or one letter and its space, in which case you will find out a great deal about how each kind of color acts along the border where it touches another. Or they can overlap, creating new colors and planes of depth. Compare what happens when you juxtapose two colors and when you mix them.

Four experiments with color are described here to help you begin to explore color as it applies to letters. Many others, derived from what you observe in other people's letters, will suggest themselves.

The outlined letter changes subtly with a variety of changes in the

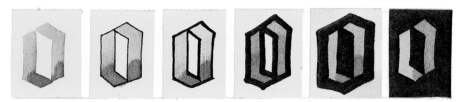

Color boundaries can touch each other or be separated by a line of any width.

weight, placement, and color of its outline. Try expressing its outline with a broad-edged line, a monoline, a pressed line. Let the line vary, in relation to the letter shape, from inline to online to outline.

Contrast the effect of the outlined and nonoutlined letter. When two colors touch each other directly without outline, new visual and physical rules apply. Look carefully at traditional techniques for color-

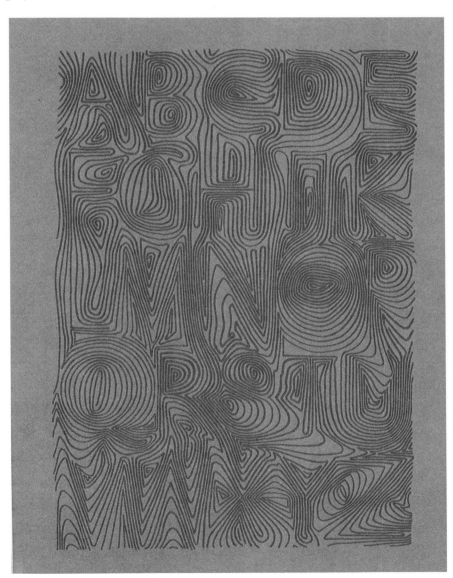

Color can be of different hues but the same intensity, creating a visual buzz and an image of ambiguous depth. This contemporary silk-screen design heightens the visual challenge of contrasting colors with a baffling soft-edged design. (From Graphic Variations, *courtesy of David Kindersley.)*

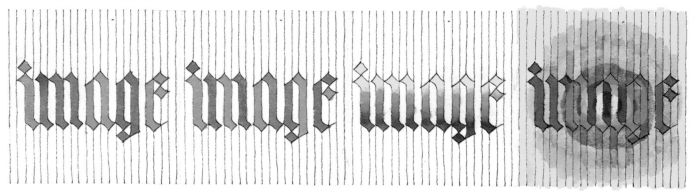

Letters can express color changes that are larger than the letter itself. In the Celtic-inspired design above, color boundaries go through the middle of letters. (The author's work, courtesy of The Cooper-Hewitt Museum, The Smithsonian Institution's National Museum of Design.)

Groups of letters may be colored to spell out a message or to add up to a larger visual image.

ing letters and try some of them on contemporary forms. Fifteenth-century techniques for shading acanthus-leaf borders can apply to twentieth-century letters as well. Victorian application of two colors to the upper and lower halves of split-pen letters can be expanded to shape the colors of a whole page along subtle contours. When you try traditional ways of combining colors, try taking them one step further.

Color that enhances the effects of perspective on the flat page can be manipulated to baffle and intrigue the eye instead. Study the ways color can be added to form. Using the same letter, try many different color schemes. Try traditional combinations from such historic models as medieval manuscripts or early printed books. Try color combinations derived from other objects: Oriental carpets, historic textiles, flowering plants. Try colors of different media together, mixing cut paper and spray paint, or brush-lettered tempera and potato-printed ink.

Finally, pick out the four ugliest colors you can find and work them into one color scheme. The results of your work with the four "uglies" can open your eyes to the only abiding rule that governs the use of color: it is not what color you choose but how you handle it that determines what the colored letter will say to the viewer.

SUGGESTED READING

Artists on Art, edited by Robert Goldwater and Marco Treves (New York: Pantheon, 1945).

The Göttingen Model Book with commentary by Helmut Lehmann-Haupt (Columbia, Mo.: University of Missouri Press, 1972).

Interaction of Color by Josef Albers (New Haven: Yale University Press, 1971).

Stained Glass Craft by J. A. F. Divine and G. Blachford (New York: Dover Publications, 1972).

Color can be confined to individual letters or carry from one to the next.

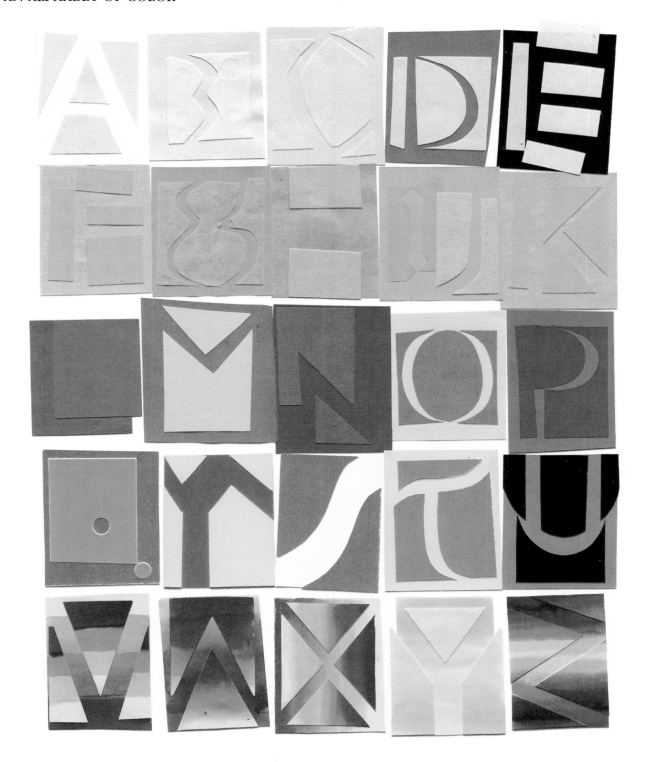

The Art of Reflection

. . . it was artistry that counted, not precious materials.

Millard Meiss,
introduction to *The Visconti Hours*

GOLD HISTORICALLY shares a special relationship with calligraphy, an exotic thread running through an ever-changing tapestry. From the gilded grooves of classical Roman inscriptions to the gold letters of modern plate-glass storefronts, gold has played a unique role in shaping the letter. Its preciousness gave extra glory to the Word of God, its rarity made it prized among collectors, and its luster let the scribe add light to the page in a way that no ink or color could outshine.

Long association, however, does not mean assimilation. Gold letters still require understanding and techniques that are different from black or colored letters. The understanding must come first. Gold is a metal. It is rare and therefore expensive. It is soft, so that while it is easily workable, it also is, if it is pure, susceptible to damage and wear. Because of its expense, many artists who use it—jewelers, sculptors, scribes, architects, furniture makers—have developed techniques for spreading a layer as thinly as possible on another material such as wood, silver, or plaster. Cooks of the Middle Ages even gilded the surfaces of some of their most festive roasts and sweetmeats. Objects with a gold layer of only a few molecules' thickness can still gleam like solid gold, giving the owner all the benefits of the real thing without the expense, vulnerability, and risk.

Scribes have found two main ways to spread gold over a letter's surface: in a powdered layer and in a solid layer. Powdered gold is easy to make, store, measure, and transport; it can be mixed with a variety of media like water, gum arabic, or shellac; and it can be applied to most surfaces with a brush, airbrush, or quill. Each particle of powder catches a little bit of light and reflects it, giving a soft or glittery shine from almost every viewing angle. Gold that is rolled out or beaten to a thin but solid layer, known as gold leaf, is more trouble to make and must be stored with special paper between layers to prevent it from adhering to itself. It can be applied to almost any surface that has been prepared with something slightly tacky, such as gum arabic, plaster-based gesso, or shellac. It is sometimes time-consuming and tricky to apply, but once in place it has great durability. After application, both kinds of gold may be burnished—rubbed smooth for extra shininess—but only gold leaf will shine as though it were real gold all through.

Gold letters contrast with a deep purple and scarlet background. Note how the shallow grooves made with a scribing tool to guide placement of the text letters have, over the years, begun to show. (From the Bible of Matthias Corvinus, Ms. Plut. 15.17, c. 3, courtesy of Biblioteca Medicea Laurenziana, Firenze.)

148

Designing letters for either gold paint or gold leaf is a little different from designing for inked or colored letters. Gold paint, or some of its better imitations made of other metals, reflects more light than the plain surface or the ink and color around it. This effect is more noticeable when the light is somewhat dim. Burnishing powdered-gold paint flattens some of the particles, so that more of them reflect light forward rather than scattering it off to the sides, as well as slightly smoothing the surface of the background material.

Gold leaf, in contrast, reflects light without scattering it, and the smoother the surface, the more directional the reflection. A flat, uninterrupted expanse of gold leaf either reflects all light to the viewer's eye or appears black. If the surface is not rigid, unattractive deformations of the intended letter contour can distract the eye. If the light comes from a point source and the gold is applied in small patches, a many-faceted, glittering effect is possible. Most traditional examples of gilded letters use gold this way.

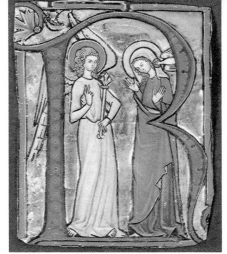

Gold leaf creates the background of this early-fourteenth-century Swiss capital. (With permission of The Metropolitan Museum of Art; purchase, Gift of J. Pierpont Morgan, by exchange, 1982. Copyright © 1982 by The Metropolitan Museum of Art.)

MATERIALS
powdered gold such as:
> gold paint concentrated in tablet form or dried in a thin layer (shell gold)
> small watercolor brush reserved for use with gold paint
> imitation gold powder paint or ink
> other genuine or imitation metal powders
> powdered-gold-paint markers such as Edding 751 Contour marker or Niji Metallic marker

solid gold layer such as:
> gold leaf or imitation gold foil

raising preparation
burnisher (polishing tool)

TECHNIQUE
Before you even begin to acquire the special materials and tools to work with gold, you should study it visually with the skills you already have. Choose an example of a gold letter from the work of another calligrapher and copy it, first drawing a picture of it in black and white and then painting a portrait of it with color. Many people are so accustomed to looking at gold that this exercise can shock them; what they have been seeing as gold is in fact black, white, or a mixture of unacknowledged hues. Even a matte, powdered-gold rendering of shiny, burnished gold leaf creates a completely different effect on the viewer.

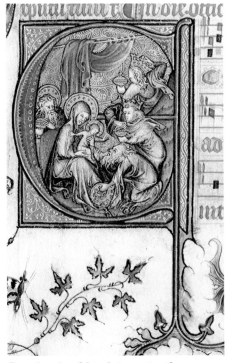

Powdered-gold paint creates the delicate tracery background and solid halos of this fourteenth-century French illuminated scene. (From a missal made for the Abbey of St. Denis, with permission of The Victoria and Albert Museum, Crown copyright.)

To experiment directly with gold, you must first decide whether you want to work with powder or leaf. Powdered gold comes in various degrees of authenticity, from 24 karat to iron pyrite, and in many degrees of fineness, from almost imperceptible grains to glitter. You can buy it dry or already mixed with water, gum, shellac, or glue.

Fasten coated sheet firmly over embossing mold.

Rub with embossing tool . . .

orangewood stick or wooden sculpture tool . . .

spoon or spoonhandle . . .

or your own fingernail.

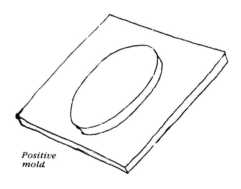

Negative mold cut from stiff paper or card.

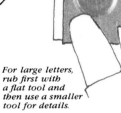

For large letters, rub first with a flat tool and then use a smaller tool for details.

Lay coated sheet over stencil. Rub with embossing tool.

If gold faces up, the image will be concave.

If gold faces down, image will be convex.

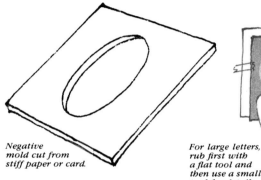

Positive mold.

Use cut-out parts of letter. Glue them into position. Let dry.

Fasten coated sheet over raised letter and rub with embossing tool.

Resulting letter will be slightly larger than the corresponding negative-embossed image.

Sharp edges occur in different places (arrows).

Lay coated sheet over a tissue, blotter, or paper towel.

Pressing down with a blunt tool, draw the desired letter.

Design can be convex if gold side faces down.

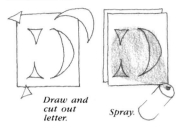

Draw and cut out letter.

Spray.

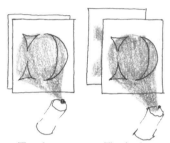

The closer the stencil is to the surface, the sharper the outline.

The farther the stencil is from the surface, the softer the outline.

Spray with adhesive or brush with slow-drying glue.

Remove stencil. Sprinkle metallic powder, glitter, or gold dust over tacky area.

Gold leaf, similarly, ranges from pure gold to Mylar, and can have an almost transparent thickness of a few molecules or the rigidity of foil.

Several steps will help you get the most out of powdered gold in your next lettering project. Your decision about both authenticity and fineness will depend on the distance from which the viewer will see your letter. The sparkle of glue and glitter that is too coarse close up may be perfect at ten paces, while the gleam of the finest gold powder may be lost beyond arm's length. Consider, too, what kind of light will illuminate your work and what climate it will have to weather.

Some kinds of powdered-gold paint can ber burnished slightly, either to make the whole letter shinier or to contrast shiny areas with matte ones. You can burnish from the front to shine the surface, or from the back to raise the contour, or you can do both. Try superimposing a lattice of crossed lines, or a network of dashes, or an allover texture of single dots on the flat texture of a matte background.

Gold leaf is traditionally applied to a raised preparation that is stickier than the surrounding area. This raised area should not be overly rounded or most of the rays that strike the letter will reflect at too wide an angle; an ideal amount of rounding will send all of the rays back to the viewer's eye. Gold leaf can also be seen from the back if the sticky substance is applied to glass. By etching the front and gilding the back of glass you can create unique effects of overlap and depth.

You may mix powder and leaf gold on the same page, as medieval illuminators frequently did. You may also experiment with gold alloys and with such other metals as silver, aluminum, and platinum leaf, and bronze, brass, and pyrite powders. Remember, however, that pigments next to the metal on the page and chemicals in the air may interact with it to change its color.

After you have learned the special ways of seeing and handling gold, you can begin to treat it as a color and watch how it behaves with other colors on the page. Apply a gold letter to various colors of background. Gold looks different on blue and on red, and different on scarlet red and crimson red. Notice how it looks on different textures, under different colors and amounts of light, next to dark and light hues

Gold can be outlined lightly or heavily.

Gold changes appearance on different colored backgrounds.

Gold is not one substance but comes from different alloys in a range of tones.

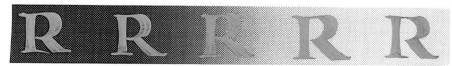

Gold can be set against a wide variety of background tones.

A METALLIC
ALPHABET

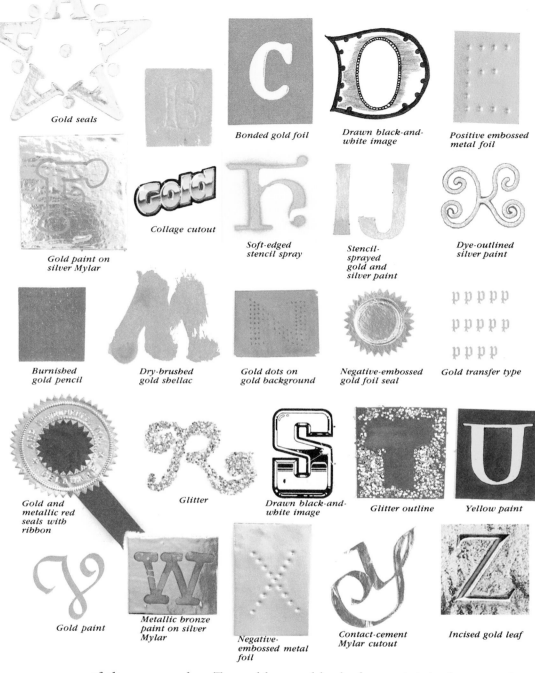

Gold seals

Bonded gold foil

Drawn black-and-white image

Positive embossed metal foil

Gold paint on silver Mylar

Collage cutout

Soft-edged stencil spray

Stencil-sprayed gold and silver paint

Dye-outlined silver paint

Burnished gold pencil

Dry-brushed gold shellac

Gold dots on gold background

Negative-embossed gold foil seal

Gold transfer type

Gold and metallic red seals with ribbon

Glitter

Drawn black-and-white image

Glitter outline

Yellow paint

Gold paint

Metallic bronze paint on silver Mylar

Negative-embossed metal foil

Contact-cement Mylar cutout

Incised gold leaf

of the same color. Try gold on gold—leaf on paint, leaf on powder, powder on paint. Don't fall back on traditional rules about using gold until you have explored the reasons it acts the way it does.

SUGGESTED READING

The Calligrapher's Handbook, edited by C. M. Lamb (New York: Taplinger, 1976).

The Materials and Techniques of Medieval Painting by Daniel V. Thompson (New York: Dover Publications, 1956).

On Divers Arts by Theophilus (New York: Dover Publications, 1963).

The Visconti Hours (New York: George Braziller, 1972).

 I 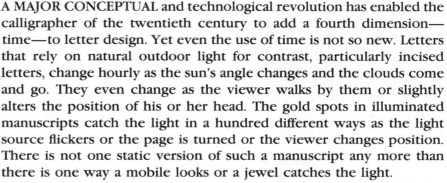 E

The Fourth Dimension

Art is Nature speeded up and
God slowed down.

Marc Chagall

This monumental numeral 9 transforms the Seagram Company's address into a New York street sculpture that rewards the passerby with a multitude of views.

A MAJOR CONCEPTUAL and technological revolution has enabled the calligrapher of the twentieth century to add a fourth dimension—time—to letter design. Yet even the use of time is not so new. Letters that rely on natural outdoor light for contrast, particularly incised letters, change hourly as the sun's angle changes and the clouds come and go. They even change as the viewer walks by them or slightly alters the position of his or her head. The gold spots in illuminated manuscripts catch the light in a hundred different ways as the light source flickers or the page is turned or the viewer changes position. There is not one static version of such a manuscript any more than there is one way a mobile looks or a jewel catches the light.

The bound volume itself is a supremely four-dimensional object. The pages unfold in sequence and all cannot possibly be viewed at one time. This fourth dimension can be a few seconds if you flip the pages, a few hours if you read the text, or several years, if you live in Dublin and drop by Trinity College Library every week to view a new page of the Book of Kells on display.

Not everyone agrees on what, exactly, time does to the other three dimensions. Some effects are quantifiable: a valentine carved on a tree changes and spreads as the tree grows old; the front of a sign vanishes when the viewer looks at the back. Other changes are more ineffable. As the artist Henri Matisse wrote, "Time extracts various values from a painter's work. When these values are exhausted the pictures are forgotten, and the more a picture has to give, the greater it is." A letter's up-to-date style can gradually transmute into quaint irrelevance over the course of a century. Even those effects that can be measured must be measured against something else, and time is no exception.

With the Greek alphabet, Western culture inherited the Greek philosophical concept, expressed by Protagoras in the fifth century B.C., that "Man is the measure of all things." Cubits, hands, and paces

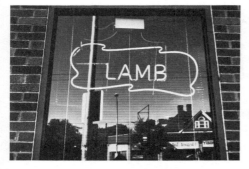

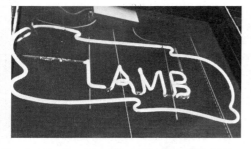

A monoline neon sign reveals different angles when viewed from different vantage points. The brain stores these views and enriches each one with a concept about how the form looks in composite.

quantified the measurements of buildings, horses, and land. The reach of a man's arms still governs the size of the frame that, dipped into a vat of wet pulp, holds paper sheets and the resulting book pages folded from them. "Time whereof the memory of man runneth not to the contrary" still delineates legal exceptions.

Traditional calligraphy, too, is permeated with time on a human scale. Accurate history and the ability to visualize eras long past were not part of the intellectual climate of the West until a few centuries ago. Scribes and artists dealt with only the fuzziest notions of the history of their craft. Each successive revival of pure Roman letters relied on the secondhand interpreted forms of the revival before; the moldering ruins and inscriptions of Roman buildings were not connected with the history of the age, but with mythical beings from another age. And medieval illuminators clothed Bible characters from two thousand years past in the familiar costumes of the Middle Ages.

Time, however, is not limited by the measures of the human dimension. It can change the letter itself, aging its color or eroding its contours imperceptibly over the life spans of many generations of viewers. Some pieces of calligraphy are designed with the aging process in mind. A few try to imitate it. Some seek other routes to permanence by translating their lettered images into more durable media. The permanence of their lettering has been a subject of great concern to scribes through the ages, challenging them to discover new materials and to refine their techniques.

Today, scribes confront the same concern for the passage of time with improved materials and also with new attitudes toward the life of the lettered object. Many of the contemporary scribe's tasks involve preparing an original for reproduction, an original which is only for reproduction and has no visual purpose on its own. The scribe or the client controls the permanence of what is printed not by doing something to the original, but by controlling the number of copies, the quality of the paper and ink, and the possibility of reprinting. The single handmade manuscript, produced with great labor and patience for the greater glory of God, does not define today's calligraphy as it did the calligraphy of a thousand years ago. The purposely ephemeral "weathergrams" of the calligrapher Lloyd Reynolds, for example, are designed to weather away outdoors in a short time. Calligraphic motions were choreographed recently to perform a multi-media evocation of the written idiom, called "Dancing Ink." Many other scribes today are inheriting, borrowing, and inventing other new kinds of calligraphic vehicles.

Twentieth-century art has gone through decades of intense materialism, in which people have bought art not because they like it but because they see it as a good investment. A respected business newspaper includes among its stock and bond quotations a weekly index to the current market value of a dozen different categories of art. Some artists have reacted against what they see as exploitation by creating

eight 8"

Time changes styles. Here, standard banker's scripts of a hundred years ago and of today.

works of art—events, arrangements, performances—that are intrinsically perishable and by their nature cannot be owned. (Andy Warhol went so far as to have a notary officiate at the "removal" of marketable artistic value from a painting he had done.)

Unlike collectors, visual artists share with musicians and writers a burning interest in what they are working on next and a comparative boredom with the work just past; this is a key element in their growth as artists. "A creative artist works on his next composition because he is not satisfied with his previous one," says Dimitri Shostakovich, and W. H. Auden wrote, "In the eyes of others a man is a poet if he has written one good poem. In his own he is only a poet at the moment when he is making his last revision to a new poem. The moment before, he was still only a potential poet; the moment after, he is a man who has ceased to write poetry—perhaps forever." Consideration of longevity is not central to these ideas.

Some artists integrate the idea of aging into their works of art from the very beginning, choosing materials not just on the basis of how they look at the time but how they will look in the future. Today, works of art from earlier eras have been reassessed in light of how their present appearance relates to their original appearance, and to what extent the artist anticipated this contrast. The portions of Leonardo da Vinci's *The Last Supper* that have been cleaned and restored surprise many viewers with their gaudy tones. A Rembrandt stripped of its familiar yellowed varnish seems strangely colorful after the somber hues that modern viewers have grown accustomed to. The unfaded margins of a Winslow Homer watercolor that have been protected from sunlight by a mat look garish beside the familiar luminous, washed-out colors that people have come to think of as the artist's intent.

A work of art has many dimensions; the passage of time is one of

Letter design and sentence syntax show clearly the sequence of composition in this graffito from the late 1960s. (From a photograph by Christopher S. Johnson, with permission of Stock, Boston.)

Letter strokes can hint at the time dimension of their writing. Absorbent paper allows more ink to soak in when the pen slows down or pauses. Extruded material piles up or widens if time passes while the pen pauses.

them. Sometimes calligraphers are more comfortable not confronting this dimension or not taking the trouble to discern what the artist of another era really intended. While the scribes of the Middle Ages strove for the crispest black letters on the smoothest white parchment, some of the calligraphy of the twentieth-century medieval revival emulates instead the appearance of those letters six hundred years later—sepia-brown, unevenly translucent letters on mottled yellow, heavily veined pages. Yet even the pre-aged sepia ink and imitation "olde" medieval parchment paper pay homage, in their own way, to the time dimension in a manuscript.

Time, like other dimensions of a letter, comes in different sizes. Time can be measured with a calendar or a stopwatch. Letters can change slower than a lifetime or faster than the eye can see. Film and video of the twentieth century simply speed up the process of perceived change, making it controllable by the artist and reproducible by the user. Instead of letters that convey a sense of growth, we actually see them growing. Instead of playful logo designs, we see the letters at play.

MATERIALS
stop-frame movie camera

paper stapled together to form flip-book

TECHNIQUE
The four-dimensional visual experience can be analyzed, practiced, and rendered just like the two- and three-dimensional ones. It has scale, rhythm, surprise, balance, texture, density, and movement.

If you want to work with the fourth dimension, you can most easily choose materials if you have decided about scale. In this section time is explored on two scales, the interval of more than one day and the less-than-ten-seconds sequence of movement.

Time can appear to have flowed on unbroken through a letter's life, or images added later can punctuate its history. Water damage, wormholes, fingerprints, and rough handling at the bindery leave their characteristic marks. These traditional impressions of real time can be forged for duplicitous purposes, mimicked for historic effect, exaggerated for parody, or translated into modern terms to put time under the artist's creative control for new effects. Medieval and Renaissance scholars, for example, often annotated the margins of the books they read, strengthening or challenging the author's line of thought. In the same way, contemporary graffiti artists visually heckle their more formally lettered kinfolk, and the organic growth of the two- or three-stage graffiti sequence has become a familiar format for public humor and debate. Fresh metaphors for the passage of time may come from humble as well as from great sources.

Changing the letter quickly means fooling the eye with the tech-

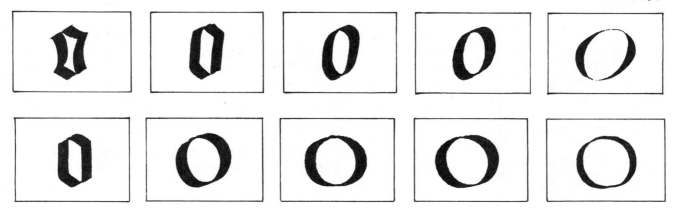

Time-lapse animation follows the eight-hundred-year metamorphosis of a letter, reflecting prevailing stylistic tastes. One frame equals eighty years.

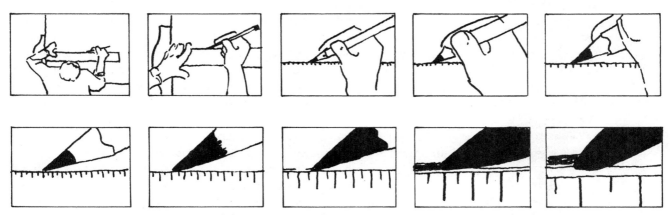

Real-time dimension is present in this zoom shot of the pencil position for ruling lines. Although each frame brings the viewer closer in, nothing "happens."

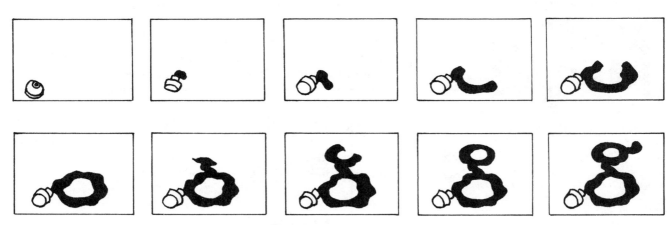

Animation can manipulate not only the images but the speed and even the direction of time. This real-time sequence can speed up, slow down, or reverse to put the letter back into the inkwell.

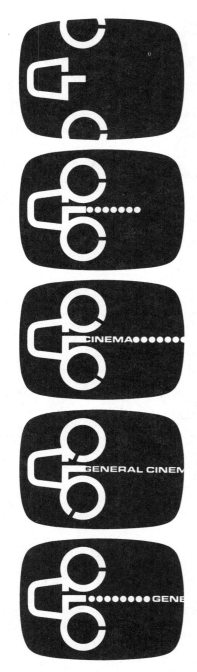

This sequence of stills from an animated logo shows the film company's initials coming together to form a stylized movie projector and then "projecting" a beam of light formed by the company's name. (Courtesy of General Cinema, Boston. Designer, Selame Design, Newton, Massachusetts.)

niques of animation—but the eye is anxious to be fooled. While a lineup of slightly differing images may convey to the careful viewer some vague sense of time, a sequence of images shown one after another will seem to move in a flickering way when between two and twenty images are viewed per second; the brain remembers and pieces together what is going on. If more than twenty images, or frames, per second are shown, the flicker disappears as the eye converts the separate pictures into a smooth sequence of motion.

The passage of time can be observed through the absence, as well as the presence, of change. The multiple-image silk-screen prints of Andy Warhol are in some ways identical in concept to his films of objects, in which the sequence of images, whether of Marilyn Monroe, a soup can, or the Empire State Building, conveys the passage of time *without* any visible change.

Light, in fact, chemically bleaches the cones it hits in the retina of the eye; the fraction of a second needed to return to normal chemistry produces the familiar "afterimage," which makes animated film possible. Although commercial motion-picture cameras run at twenty-four frames per second, animation sometimes is done at eight frames per second to cut down production costs. Then each frame is shot three times. On television thirty frames are shown per second. (When films are broadcast on television, an adapter repeats every fourth frame to compensate.)

If you have access to photographic equipment, you can experiment with letter animation. Even a small camera and standard 8mm film for home movies can, with a tripod and shutter release, teach all the fundamentals of letters on film. You can shoot an animated sequence in three kinds of time: "real time," showing a letter taking shape just as it would in real life; "time lapse," where what would take an hour in real life takes less time in the film; and "slow motion," slowing down on film some activity that takes place more quickly in real life. The examples shown here illustrate how calligraphy can translate to film.

The camera, however, is not essential to learning about animation. The twentieth-century photographer Margaret Bourke-White wrote, "A camera is an instrument for teaching how to see without a camera." A motion-picture camera's first lesson is in conceiving the material to be photographed. Sometimes that material will stand on its own. A traditional scribe using pen, ink, and paper can create a perfectly convincing letter in motion by putting it into a flip-book. The viewer can control the speed of the motion and even reverse the sequence, making time run backward—or seem to stop.

VI.

NEW CONFIGURATIONS

You will have written exceptionally well if,
by skillful arrangement of your words, you
have made an ordinary one seem original.

Horace

MAKING LETTERS is only the beginning; arranging them is the main thing. Since even a single letter can be arranged many ways, the possible designs for a monogram, a logo, a word, a sentence, an alphabet, or an extended text are infinite. The art of the calligrapher celebrates this interplay between seeing and reading.

Calligraphy extends far beyond the techniques for shaping individual letters. The art encompasses the whole page, reaching past the paper's edge to permeate the visual landscape.

Stage, Subject, and Speech

Intelligent Design

This early-seventeenth-century writer's desk and equipment is shown in great detail and inventive perspective. (From Traicté de l'antiquité . . . des maisons d'Hapsbourg *by A. Baltyn, with permission of The Victoria and Albert Museum, Crown copyright.)*

Graphic excellence is that which gives to the viewer the greatest number of ideas in the shortest time with the least ink in the smallest space.

Edward R. Tufte, *The Visual Display of Quantitative Information*

DESIGNING WITH CALLIGRAPHY means arranging letters so that the viewer gets a visual experience from them in addition to reading what they spell. There is no way the calligrapher can duck this responsibility, no neutral design—short of reciting the words aloud—which will not give the viewer this visual experience. Some scribes and typographers strive for a transparent viewing experience, in which the reader gets the most information with the least visual awareness of the design. Inevitably, however, what appears transparent in one place and time seems highly colored in another, and the transparent designs of today are the archaic curiosities of tomorrow. Vanilla flavor is still flavor.

The intelligent scribe can put as much into the visual content of a piece of calligraphy as the original author put into its literary style—whether or not the reader is conscious of its presence. The art of layout design combines three major elements: the nature of the page, the meaning of the text, and the number of letters. Letters can confront the viewer in many different settings and can be set off from their surroundings by a variety of frames. Two of the most familiar arenas for traditional calligraphers are the broadside poster, or single-framed sheet, and the two-page spread of the open bound book. Other genres combine letters with pictures on title pages and book jackets, in medieval tapestries, in the speech balloons of comic strips. Contemporary graphic life puts letters on protest placards, company vans, air-mail envelopes, and record labels. People eat letters from soup bowls, on birthday cakes, on candy. They live in letters, wash their hands with them, and wear them next to their skin—or even closer. Each format lets the letters speak in a certain way, drawing on a certain set of implicit assumptions that amplify meaning while they limit expression. The calligrapher must first choose the forum, before dealing with questions of meaning and visual content.

Most text has a nonvisual content, created by its author and discernable when it is read aloud, that constitutes its meaning apart from how it looks. This meaning may be clear or obscure, trite or

profound, familiar or strange, general or particular. The calligrapher deals with it and transmits a personal interpretation of it. This may be as straightforward as a simple graphic depiction of an object mentioned in the text or may extend to a subtle evocation of what the scribe feels is the atmosphere of the writing or the author's tone of voice. A skillful calligraphic design enhances the meaning of the text.

Calligraphy generally deals with a certain number of letters or letter strokes. A piece of calligraphy can be based on one swash, one letter, one word, one sentence, one sonnet, or one book, but it must be designed with the approximate length of the text in mind.

The designs in this section illustrate some of the ways that these three elements—forum, meaning, and text—interact with each other, and how the calligrapher can experiment with them.

MATERIALS

a piece of calligraphy to critique (your own, a historical example, or a class work for teaching purposes)

tracing paper overlay and pencil to draw, write comments, suggest improvements, and note strong points

(With permission of Humor Graphic, *Milan.)*

For centuries, letters on clothing have identified the opinions and affiliations of their wearers, decorated their belongings, or served as a convenient spot for an artist to add information to a picture. (From a Flemish tapestry, purchased from the Maria Antoinette Evans Fund, with permission of The Museum of Fine Arts, Boston.)

Letters spell out who's on whose team in twentieth-century America. (From Dugout, *a Saturday Evening Post cover by Norman Rockwell, with permission of Curtis Publishing, © 1948 by The Curtis Publishing Company.)*

TECHNIQUE

There is seldom one right answer to a design problem, and never the same answer to the next one. Thus the calligrapher should cultivate not only facility in inventing possible designs, but astuteness in judging them. This critical eye, willing to appraise its own work objectively, can be used as well in judging the designs of other calligraphers past and present, and is as essential to the calligrapher as a skillful hand.

Learning to see is not the sudden acquisition of a mysterious knack but a gradual cultivation of visual habits. And while individual tastes and preferences are useful guidelines, judgment goes beyond likes and dislikes. The technique you will explore is the technique of seeing. The critical eye can evaluate calligraphy by a number of spe-

cific criteria. A design should show that the calligrapher has made decisions about at least some of these points:

Purpose. What is the piece for? The forum should suit the length and meaning and should guide the viewer directly into the design without confusion about the scribe's intent. If there is ambiguity, it should be intentional. The design, too, should offer physical clues

Letters decorate this contemporary biker's clothes and skin. (From a photograph by Cary Wolinsky, with permission of Stock, Boston.)

about itself as an object: what distance to view it from, how long to spend looking at it, whether to touch it, how it is made, what to look for.

Legibility. How important is the reading of the words in the overall conception of the design? Will the viewer see the design first, read the text first, or alternate between them?

Opinion. Who is speaking? The calligrapher does not have to agree with the text (unless it is his own), just as an actor does not have to limit his roles to characters whose actions he condones. The artist makes it clear whose voice is whose.

While evaluating a design on the basis of the artist's decisions about how it will work, the critic can also judge whether those decisions have succeeded. The following criteria may be useful:

Originality. Has the designer copied other people's solutions? While imitation can sometimes be a form of homage, it more often results in dull, warmed-over designs and incongruous matching of form and content. (Stringently true copying, as an exercise in technique, should aim to reproduce exactly the appearance of the original and should never be passed off as one's own work.) Or has the artist instead indulged in startlingly unusual departures from familiar forms without apparent reason? Originality can be expressed in design, ma-

Proper nineteenth-century penmanship technique prescribed forms of expression, styles of pen decoration, and posture of the writer. (From Hill's Manual of Social and Business Forms *by Thomas E. Hill.)*

terials, choice of text, or choice of forum, or the balance between any of these.

Clarity of purpose. Every design has a purpose—to inform, to entertain, to purge, to offend, to decorate, to protest. Is that purpose apparent?

Success. Does the design accomplish what it sets out to do? If the purpose is clear, does the design sustain and fulfill those expectations? If the piece is meant to be read, it should be legible. If it is meant to be seen and not read, the viewer should not be frustrated by trying and failing to decipher it.

Integrity. Are the style, materials, tone of voice, level of workmanship, and sincerity consistent throughout the piece? The viewer needs to rely on the artist to maintain an even texture of performance throughout. An unskilled swash looks almost worse when it is juxtaposed with elegant lettering. Get it right or let it alone. The artist should be aware of his or her limitations.

Technical proficiency. Is the calligrapher able to execute the design at a level of workmanship appropriate to its purpose? Too good can be just as wrong as too bad; exquisite gold leaf on a billboard is just as out of place as felt marker on a retirement scroll. Does the calligrapher show a broad grasp of the essentials of the art? Well-formed letters are not enough; they must be well spaced and intelligently arranged. Sometimes technical proficiency comes more from the eye than the hand, and can be achieved less often by endless hours of careful drudgery than by the bold decision to simplify the piece through one more draft.

Errata. Everyone makes mistakes—typographic errors ("writos"), physical and psychological slips of the pen, optimistic and endearing misspellings, design miscalculations, disastrous omissions and equally disastrous intromissions, misjudgments of material, misattribution of

quotations, ragged edges, wobbles, snags, smudges, splatters, and smears. Every calligrapher, even the most eminent, can offer at least one horror story about some particularly spectacular blunder. There are many ways to handle errors. If errors are present in a piece, how has the artist acknowledged them, ignored them, camouflaged them, or turned them into assets? Does their treatment seem appropriate to the overall work?

Partnership. Does the calligrapher get a free ride off the author? Has the spirit as well as the letter of the copyright law been honored? A hand-lettered version of the words of a great author does not bestow greatness on the calligrapher any more than a photograph of a famous person makes a great photographer. The calligrapher can add a great deal of meaning to the author's work. But if he chooses not to, or if the nature of the project does not allow him to, this choice should be apparent in the piece. The author's wording and spelling should not be tampered with. Citations should be scrupulously appended to even the most familiar quotation, lest the next calligrapher to copy it mistakes the words for the calligrapher's own. The signature of the scribe should be unobtrusive and clearly differentiated from the author's citation. As in all art, the surest signature is the presence of a distinctive, confident, unmistakably unique design style.

Lettering decorates this Greek pot from the fifth century B.C. *(With permission of The Metropolitan Museum of Art, Rogers Fund, all rights reserved.)*

SUGGESTED READING

International Calligraphy Today (New York: Watson-Guptill, 1982).
The Visual Display of Quantitative Information by Edward R. Tufte (Cheshire, Conn.: Graphics Press, 1983).

Logo Outer and Inner Self

This silhouetted hand resembles dozens of specimens found on or near prehistoric cave paintings. Thought to be talismans or signature devices, they are generally left-hand outlines and sometimes show the fingers truncated as though they were curled under.

LOGOTYPES REPRESENT the most highly developed aspect of representative lettering, where the visual qualities of the letters themselves are meant to convey subjective information about the identity of the thing they name. The logo—the letter as emblem—is a statement made by a person or a group, sometimes with the aid of a designer, that establishes distinction from any other person or group that might have a similar name. It can be as simple as a signature or as formal as a trademark.

Historical precedents exist for all categories of logos, from the shadow handprint of the cave artist to the hieroglyphic cartouche of Egyptian royalty, the cylinder signet of Mesopotamia, the cipher of the English monarch, the watermark of the medieval papermaker, the monogram of the Victorian lady, and the fingerprint of the twentieth-century burglar.

Logos—one's own and those of other people—represent identity from two different angles, the expressive and the impressive. The expressive logo grows from people's signatures and reveals qualities of personality that are theirs alone. Signatures show the same indefinable stamp of individuality and character that is present in the rhythms of people's speech, their posture, their movements and gestures. The best way to develop this kind of logo is to search for the most distinctive and confident parts of a signature and accentuate them. Sometimes a change of pen shape, size, or angle is all it takes.

Graphologists have studied writing for centuries, hoping to find a systematic way to tell a person's character from a handwriting sample. Opinions differ widely about how reliable graphology is, how specific it can be, how ingrained a person's writing habits are. Even the historians of Chinese calligraphy profess to admire most the writing that resembles the writer, fat brush characters from a fat calligrapher, wiry strokes from a thin one. Consciously or subconsciously, the calligrapher can cultivate the expressive qualities that dedicated graphologists profess to see in the written signature.

The impressive logo, rather than revealing inner personality, describes a person more objectively from the outside. It impresses on the viewer those attributes the person has chosen to display. It corresponds to people's clothes, not their bodies. Many logos of this kind

Writing can express personality through a variety of graphic forms. Many twentieth-century cartoon artists make creative use of these idioms to hint at the speaker's personality, mood, tone of voice, age, or vocation.)

Graphic inventions in Pogo, the popular and long-running twentieth-century cartoon, evoke various characters' occupations and show them speaking in undertones or singing above the range of audibility (and visibility). (From Ten Ever-Lovin' Blue-Eyed Years with Pogo by Walt Kelly, Simon and Schuster, with permission of Mrs. Walt Kelly.)

The characters below parody the cartoonist's custom of using letter styles to portray tones of voice. (From The Boston Phoenix, with permission of the artist, David Sipress, © 1981 by The Boston Phoenix.)

Formal portraits on a fifteenth-century silver groat and a sixteenth-century silver medal contrast with the actual handwritten signatures of Henry VII and his granddaughter Elizabeth I. (With permission of the Trustees of The British Museum.)

Signatures carry abstract visual messages as well as spelling out information. (With permission of Harper & Row, Publishers, Inc. Puzzle #28 from What's the Big Idea? *by Don Rubin [J. B. Lippincott Company]. Copyright © 1979 by Don Rubin.)*

start with initials rather than names, and structure the interaction of two or three letters in very controlled ways. Often, too, an impressive logo is done by a designer; the impressive logo differs from the expressive just as a portrait differs from a self-portrait. The designer is able to synthesize traits from the outside that an individual, or an organization, might not be able to articulate from the inside.

MATERIALS
felt marker
500 sheets of inexpensive typing or copier paper
scissors and paste
binder or folder

TECHNIQUE
You may wish to start by designing your own logo, or one for someone who may have requested it. In either case, gather as much information as possible about the person or organization that needs the logo. Ask about the individual's past, tastes in furnishings, artistic interests, color

preferences, self-image, and goals. Find out about the organization's product, size, employee environment, philosophy, future plans, customers, physical plant, and existing graphics. Since you are seeking to evoke personality visually, the more specific your knowledge, the easier your design task will be. If your subject is your own personality, you will need to cultivate objectivity. (Many calligraphers find it difficult to design their own logos, holding off indefinitely until the perfect idea strikes them.)

After you have put together the descriptive characteristics of the subject of your logo design, isolate yourself for a few hours and, pen in hand, study the word or initials. Use what you have learned in earlier chapters of this book. Look for letters that impersonate objects. Search for interesting and original ligatures. Try the letters in every alphabet style you know. Swash them, change the serifs, or incorporate a drawing. Join parts of them together. Reverse the values of figure and ground, or experiment with various color choices. Work steadily and not too slowly, exploring a particular line of inquiry as far as it will go. Save everything, even if you make dozens of fruitless false starts. An hour or a day later, those dead ends may lead somewhere.

Cut out and paste together several pages of the dozen or so best designs. Don't throw the others away. Have good-quality machine copies or photostats made of the pages of proposed designs and collect them in a folder, cover, or simple binder. The cover functions as a frame, setting the collection of designs off from the surroundings. Look at them and react to them; then put them away. If no design has emerged as a clear choice, do more designs. If one design needs to be modified, modify that design. But try not to blunt your first impression

(Drawing by Lorenz, with permission of The New Yorker, © *1982 by The New Yorker Magazine, Inc.)*

"If you don't mind my saying so, Captain, I love your graphics."

A succession of proposed designs for a specialty company evolved in a more complicated and then, ultimately, a more simple direction. (Courtesy of and trademark of Illuminations, Inc.)

by looking at the designs constantly, casually, over the course of the day; a logo deals with a first impression made before the conscious mind starts analyzing it, and you will lose this fresh sight with too much exposure.

After a design is chosen, do a polished final version. (If your first drawings were very rough, if the final version is to be very laborious, or if further modifications have intervened, an intermediate semi-finished version is a good precaution.) Have the final artwork photostatted as a safety measure, and ask for a series of photostats of various larger and smaller sizes with which to try different layouts.

Learning to design logos is a long process, part of which is learning to look carefully at the logos around you that catch your eye. Try to see what in the undesigned word suggested the final design to the designer, what it was in the letters themselves that contained the seed of the ultimate solution.

SUGGESTED READING

American Trademark Designs by Barbara Baer Capitman (New York: Dover Publications, 1976).

Developing a Corporate Identity by Elinor Selame and Joe Selame (New York: Lebhar-Friedman, 1980).

Italic Handwriting by Tom Gourdie (New York: Pentalic, 1976).

Parts of Speech

Structure and Meaning

Ingenuity is the intellectual form of generosity.

Claude Lévi-Strauss, *Tristes Tropiques*

IN CHOOSING A TEXT, the calligrapher sets in motion the process of design. The text possesses visual attributes and contains verbal meaning. The calligrapher creates an intelligent layout by balancing the two.

The idea for a design can come from the text's shape or from its content, or from a combination of both. Some texts suggest a design so insistently that the calligrapher has little option but to follow their advice. The sonnet, the double dactyl, the haiku, and the limerick all dictate their own layout, and the scribe who tries to reorganize them into other line configurations will almost always face an uphill battle. Sometimes the customs of the forum itself also decree where the words should go. To serve the function for which they were intended, a letterhead, an honorary degree, or an invitation must cater to the reader's expectations. Finally, the length of certain words in the text and the scribe's unwillingness to break them with a hyphen may determine where the other words will go.

There may appear to be no visual reason to break the text, no

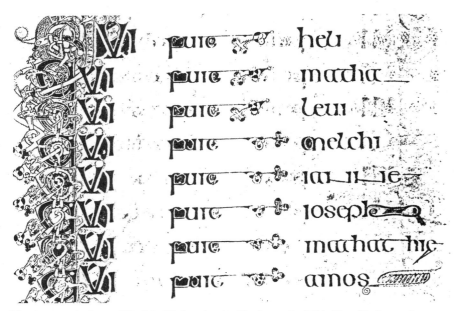

The repeated phrase "Qui fuit" dominates the layout of this New Testament genealogy. (From the Book of Kells, with permission of the Board of Trinity College, Dublin.)

171

NEVER COMPOSE ANYTHING
UNLESS
THE NOT COMPOSING OF IT
BECOMES
A POSITIVE NUISANCE
TO YOU.

Gustav Holst

The placement of these phrases and words echoes the careful grammar of old-fashioned sentence diagramming.

A contemporary advertisement for lampshades arranges its message to resemble a lamp, complete with a slightly bolder letter style for the shade so that it appears to be lit. (Courtesy of L. M. Berkelhammer. Designer, Robert Greenebaum, Greenebaum Graphic Design.)

rhymed endings or capitalized initials or prescribed format, and yet a verbal reading reveals phrasing that helps the reader enjoy and comprehend the text. Many texts benefit from this translation of content into form. The scribe can, by dividing the lines at the right places, modulate the pace of the viewer's reading. This helps the viewer understand the meaning of the text.

Another kind of layout results from imposing on the physical body of the lettered text a shape that represents something named or

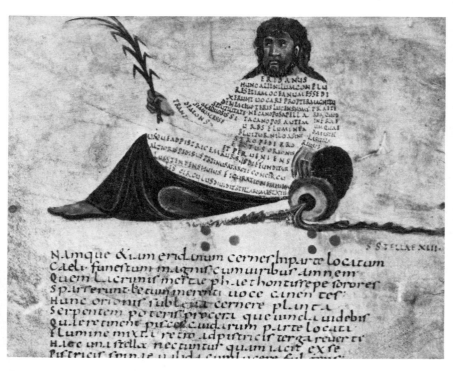

Ninth-century letters line up to form the constellation Eridanus. (Detail from the Harley Aratis, with permission of The British Library.)

suggested in the text. The correlation can be obvious (matching a ship silhouette with a quotation about sailing, or Christmas tree with a Christmas greeting) or it can be subtle (leveling a quotation about the prairie to suggest the flat horizon, or building words into mountains to lift the reader to higher altitudes). The shape can also be abstract, hinting at some general quality of the text, ponderous or elegant, balanced or asymmetrical, rather than suggesting something specific.

At the other end of the spectrum from the quotation that suggests to some degree its own visual treatment is the occasional all-purpose, comfortable text, short enough to be handled easily, long enough to be flexible, inhabited by no unwieldy words, and dominated by no formal structure. It suggests no particular visual imagery and offers a number of possible line arrangements. A malleable, forgiving text permits what every scribe desires—a free hand.

MATERIALS
marker
500 sheets of inexpensive typing paper
scissors and paste

TECHNIQUE
Designing a layout for a text starts as soon as you choose the quotation. Pay attention to how the quotation has already been presented, since this can help you discover if the author had a particular line format in mind. You may want to consult alternate sources to settle any questions about correct capitalization, punctuation, line indentation, and spacing, since typesetters and editors sometimes exercise a heavy hand in changing an author's intentions. Emily Dickinson's poetry, for example, is punctuated in manuscript with her unique, carefully worked-out system of long and short dashes, which did not survive the editing and publishing process; you may wish to restore them. In contrast, the unconventional capitalization, word spacing, and letterspacing of the poet e e cummings are his, not his editor's, and are vitally important to the meaning of his poems. Take the trouble to verify your references.

Look carefully at your text, and try to assign it to one of the four general categories; the line length may already be determined by a structured format, the verbal phrasing may strongly suggest line length, something mentioned in the text may suggest a specific line configuration, or the text may be hospitable to any number of designs.

The words of a sales award shape the diamond that was awarded.

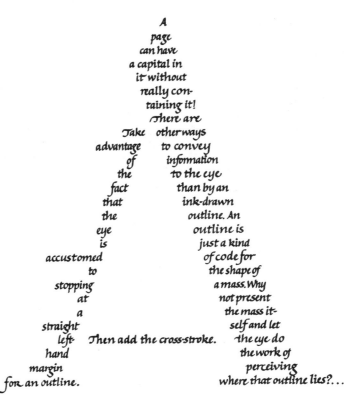

Instructional material can visually form the layout it verbally describes.

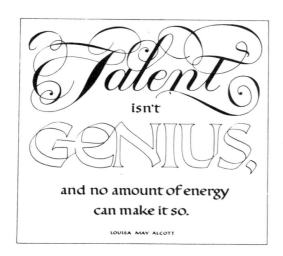

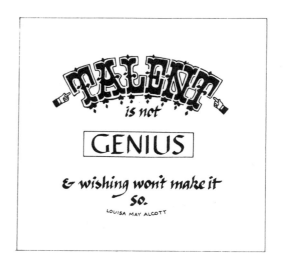

Sometimes a quotation strikes the same designer in a different way after a few years. Sometimes, too, a general layout idea can be tried out with different quotations.

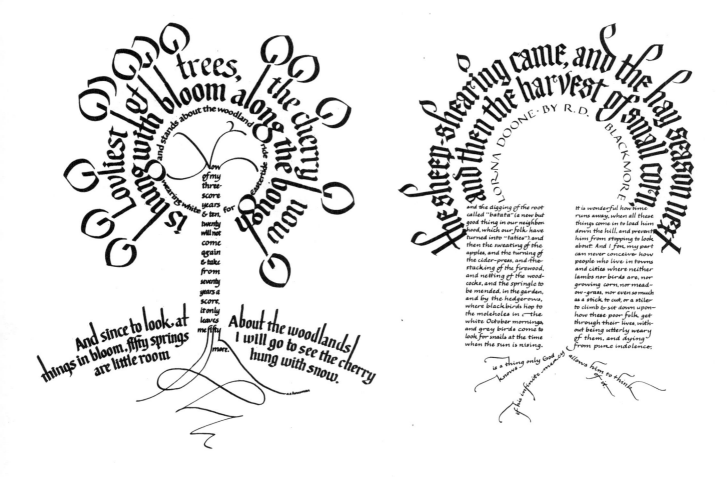

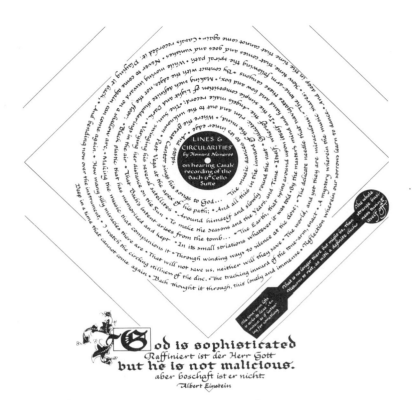

A poem about a musical experience follows the same spiral path that the words describe. (From "Lines and Circularities" in The Collected Poems of Howard Nemerov, *The University of Chicago Press, 1977, by permission of the poet.)*

God is sophisticated
Raffiniert ist der Herr Gott
but he is not malicious.
aber boschaft ist er nicht.
Albert Einstein

If a form already exists, test it to see how much you can manipulate it before it weakens. The structure of some poetry may be deceptive; treat it as prose and it takes on a new identity. Other poems need the visual reinforcement of their line structure to make sense.

If no prior line layout seems to exist, read the passage aloud expressively and think for a while about the meaning of each phrase. Most quotations of medium length—more than two words and less than a hundred—fall naturally into a one-, two-, or three-part structure. The one-part quotation is usually a headline, a declarative sentence, a title, or a slogan. The two-part quotation has a number of types: title and story, joke and punch line, statement and commentary, declaration and repetition, text and translation, assertion and rebuttal. The three-part quotation offers more complex possibilities: thesis, antithesis, synthesis; big, bigger, biggest; small, smaller, smallest; three-item list; elation, despair, resignation. Beyond the three-part format lie other layouts, such as title and list; exposition, development, recapitulation, and coda; planet and satellites; theme and variations; sound and echoes.

You may prefer dividing the lines to shape the block of text rather than to enhance the phrasing of thought. Contemporary psychological research suggests that reading and seeing take place in different parts of the brain (or even on different sides), so that one cannot take place while the other is happening. The longer the text, the easier it is to

Meaning can be turned upon itself by ironic juxtaposition. (From a design by Hellier Denselow, H. R. Beard Collection, with permission of The Victoria and Albert Museum, Crown copyright.)

You must learn day by day, year by year, to broaden your horizon. The more things you love, the more you are interested in, the more you enjoy, the more you are indignant about — THE MORE YOU HAVE LEFT WHEN ANYTHING HAPPENS.

Ethel Barrymore

Capitals can put the emphasis where it seems most appropriate to the scribe.

subordinate it to the shape, so that the reader sees the contour first and reads the text second; the shorter it is, the more likely the reader is to read it first and then pay attention to the shape. If you have trouble getting the text to fit the desired outline, you can augment the word spacing or letterspacing to justify the line, you can hyphenate a word, or you might recast all the line breaks in the hope of uncovering a more natural layout. Sometimes cutting out the words and moving them around freely will help you visualize what changes in line breaks will look like.

Designing with a flexible and nonspecific text offers a wealth of possibilities. You can draw on historical layouts, dress it up or down, range from representational to abstract, and experiment freely with variations on a number of basic ideas. This need not be a one-shot episode, either; you can return to a quote you enjoyed designing in the past. You will gain fresh insight not only into the design process but into your own growth as well, for the passage of time adds new skills and mellows the old ones.

(Drawing by CEM, © 1961 by The New Yorker Magazine, Inc.)

SUGGESTED READING

Calligrammes by Guillaume Apollinaire (Paris: Club du Meilleur Livre, 1955).

The Copyright Book by William S. Strong (Cambridge, Mass.: MIT Press, 1982).

"What Would You Do If You Had It to Do Over Again?" by Jack Anson Finke, *U & lc,* Vol. 5, No. 2 (June 1978).

Alphabet Abstract

Tools of the Trade

The plan is the generator . . . without the plan there can be neither grandeur of aim and expression, nor rhythm, nor mass, nor coherence.

Le Corbusier

Line spaces that equal letterspaces give this fifth-century B.C. Greek inscription an overall grid pattern reminiscent of the grids drawn to guide letter practice on a wax writing tablet. (With permission of the Trustees of The British Museum.)

MANY DESIGNS are based not on a quotation but on something that does not have any meaning to be expressed through layout. An alphabet, a quote in a foreign language, or an abstract letter design represent the purely visual part of the calligrapher's art. Abstract calligraphy lets the scribe explore the visual dynamics of letters on a page without reference to their content.

In choosing an abstract subject to be lettered, the calligrapher exercises control over the degree of abstraction. Every piece of calligraphy is, after all, seen as distinct from being read, to some extent. A lively, intriguing quotation, a plot-filled narrative, or a compelling poem will excite the reader's interest and relegate the abstract visual experience to secondary importance. An extremely familiar quotation, a slowly developing narrative, or a topic of only passing interest will keep the viewer's attention focused more on seeing than on reading. The meaning of the text can be further deemphasized if it is in a language foreign to the viewer or is a particularly impenetrable selection. Clues in the layout can signal to the viewer whether it is worthwhile striving to decipher the text.

Abstract calligraphy directs attention away from the meaning of the text and toward the appearance of the text. The calligrapher solves visual problems of surface texture, depth, and equilibrium. These solutions, instructive in themselves, are in turn useful for nonabstract calligraphy as well.

Letters create textures wherever they are grouped on a page. The spaces between letters, between words, and between lines of lettering can be controlled to produce a great variety of regular and irregular textures, each of which has its place in abstract calligraphy. The letters can lie evenly over the whole page, or change texture abruptly, or create repetitive patterns, or introduce random effects. The scribe can borrow textures from historical calligraphy, from other visual arts, from music and speech, or from nature.

Lines of letters can also form textures, mimicking natural, geometric, or imaginary patterns. The whorls of a fingerprint or a contour-plowed field, the convolutions of a maze or knotwork panel, all can be expressed with lines of lettering. Optical illusions can manipulate the eye's reactions.

These ninth-century decorated capitals follow a formal one-letter—one-space principal rather than the natural spacing of text letters. (From Latin 9428 folio 16, with permission of the Bibliothèque Nationale, Paris.)

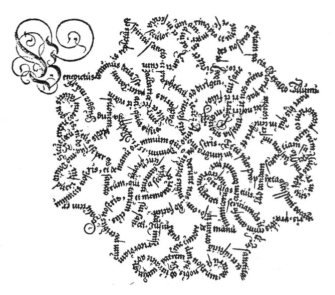

Lines of lettering in this sixteenth-century German woodcut create an intricate knot. (Woodcut by Wolfgang Fugger from Ein Nutzlich und Wolgegrundt Formular Manncherly Schöner Schrefften, *with permission of The Metropolitan Museum of Art, all rights reserved.)*

Popular song lyrics follow convuluted paths and shift through many colors to fill a page of Celtic design. (Calligraphy of Beatles lyrics by the author, courtesy of The Cooper-Hewitt Museum, The Smithsonian Institution's National Museum of Design.)

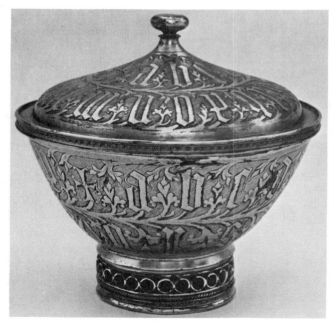

The straight lines of a Gothic alphabet decorate this silver bowl. (The Studley Bowl, with permission of The Victoria and Albert Museum, Crown copyright.)

Calligraphic layouts, like letters themselves, can create illusions of depth. Letters can be grouped to suggest the vanishing point of two parallel lines on the horizon, the progressively denser texture of a receding pattern, or the softening focus of a distant object. They can even persuade the eye to accept the paradoxes of ambiguous depth.

Early-twentieth-century correspondence shows a habit customary to the nineteenth: turning to cross one set of written lines with another, presumably to save paper and postage. (From a letter from Louise Endicott to Henry Adams, 1912, courtesy of The Massachusetts Historical Society.)

Careful execution of decorative split-serif letters and naive spacing of the alphabet and the embroiderer's name characterize this early-nineteenth-century child's sampler.

A sample page of sixteenth-century swashed Italic capitals can interest the calligrapher as a source of individual letters or as an alphabet design. (From a manuscript by Francesco Moro, with permission of The Victoria and Albert Museum, Crown copyright.)

MATERIALS
ruler
T square, triangle (set square)
sharp #3 pencils
French curves, Flexicurve
compass

TECHNIQUES
One of the joys and challenges of the art of calligraphy is that the greatest rewards come from an approach that is both careful and carefree. If you can cultivate both precision and spontaneity, you will have the style that best expresses your inner vision. Some new tools and techniques will facilitate your exploration of abstract layout and exercise skills that will be valuable to your readable calligraphy, too.

The classic exercise in abstract calligraphy is the alphabet design, which treats just the twenty-six letters as the "text" or just one letter repeated as often as the calligrapher needs. You can practice your layout skills in either of these ways.

Since abstract calligraphy is not meant primarily to be read, take the abstraction one step further to help simplify your layout process. Depending on the length of the text, the style of the alphabet, and the

size of the letter, you can reduce any text to a fast, representative, completely nonalphabetic scrawl. Then, when you try out visual ideas, you will have a kind of shorthand form to experiment in, one that will let you see quickly whether an idea works. At its best, a layout is visible speculation—drawn thinking—and any excess toil that slows down a fluent sketch of these first ideas should be eliminated.

Try different graphic shorthand styles to see which one approximates the alphabet you have chosen and facilitates the layout you have in mind. You can represent separate letters with a one-stroke O or a rounded box. Extended coils can stand for small groups of words; if

Two alphabets occupy each other's spaces.

Alphabets line up to form a number of abstract designs.

you go faster or want to evoke a more angular alphabet, the loops disappear to turn the coil into a sawtooth wave. Finally, to render a design quickly or to avoid giving the flavor of any particular style, use two parallel lines.

Once you have grasped a good idea for an abstract layout, progressively more careful renderings will make it clearer to you. Plan on at least one shakedown cruise, where you letter quickly and roughly to see if the letters fit the shorthand in the layout. If your text is to be read as well as seen, you will want to be sure that it fits into the spaces

An alphabet can form a design, or it can frame a design.

Letters drawn by a seven-year-old each become a lively creature. (Courtesy of Andrew Sage.)

provided and that the layout does not militate against the reading process.

As your layout gets less sketchy and more explicit, you may find that careful drawing alone will not accomplish the images you intend. You may need a more precise vision of something, or you may need specialized tools. Precise vision can come from studying a real object, a photograph, or a sketch; don't hesitate to use any prop that helps make your general idea particular. Besides making your layout more succinct and communicative, drawing trains your eye to observe carefully.

Cultivate the same pragmatic attitude when you seek new tools. There are a number of ways to draw a spiral, for instance, each with their special tool and component of toil. You have a choice. Specialized drafting implements can help you draw the exact angles,

curves, and circles that your layouts need. Study catalogues, borrow from other fields, observe your colleagues, and try out every tool you can. Sometimes the layout suggests the tool, but sometimes knowing that the tool exists may stimulate you to try a design you would not have otherwise considered.

Celtic alphabets trace Celtic key designs.

SUGGESTED READING

Borders for Calligraphy by Margaret Shepherd (New York: Macmillan, 1980), pp. 19–28.

Dance of the Pen by Arthur Baker (New York: Art Direction Book Company, 1978).

Pen Calligraphy: Course One by John Cataldo (Worcester, Mass.: Davis Publications, 1979).

A Search for Structure by Cyril Stanley Smith (Cambridge, Mass.: MIT Press, 1981).

The Works of Edward Ruscha (San Francisco: San Francisco Museum of Modern Art, 1982).

Nontext Context

Illegible Things That Behave Like Letters

The word is the image of the thing.

Simonides, fifth century B.C.

THE CALLIGRAPHIC IDIOM is so engaging to the eye that it allows noncalligraphers of all kinds to speak its language. While letters can be stretched to express other arrangements than conventional horizontal lines of words on a page, nonletters can, conversely, perform in the visual roles first created, defined, and filled only by letters. Things other than letters can be written and arranged like letters. Over the centuries so many artists have painted, carved, printed, and drawn calligraphically that by now almost every category of calligraphic expression finds its counterpart in another visual art.

Calligraphy of every order of magnitude can inspire a corresponding art form, from the iconization that transforms a single initial into an

*The idiom of the lined and lettered page informs many works of Paul Klee. (*Arrival of the Jugglers, *with permission of The Phillips Collection, Washington, D.C.)*

*Letter-like symbols animate this mostly monochromatic combination of collage, ink, and gouache. (*Fortress 10 *by Martin Naylor, with permission of The Victoria and Albert Museum, Crown copyright.)*

*Numeral-like forms capture internal and external shapes of varying colors. (*Rolling Landscape *[1938] by Paul Klee, with permission of The Solomon R. Guggenheim Museum, New York. Photograph by Robert E. Mates.)*

object of worship, through the careful positioning that throws new light on a small collection of simple shapes, to the massing that turns a mob of nearly identical characters into organized ranks. At every level, the familiar vehicles of letter design can carry a variety of other cargo.

Many artists have worked on the idiom of letter, line, and page. The emblematic *art brut* figures of Joan Miró seem as though, some day in the future, they might evolve into alphabets. Martin Naylor's

Train tracks make an ethereal tracery of calligraphic monolines. (Courtesy of Wausau Insurance Company, Milwaukee, Wisconsin.)

A seemingly weightless but solid line of ink floats across a translucent but rigid one. (Courtesy of the artist, Luigi Pericle.)

This contemporary tapestry design suggests the limitless pattern-making potential of the simplest square stroke. (From a computer-aided design for a woven tapestry, courtesy of the artist, Anna Dunwell, Boston. Permutation © 1981 by Anna Dunwell.)

powerful characters and Philip Bouwsma's expressive ones similarly suggest the undecipherable alphabet systems of an alien race. Landscapes of the imagination by Wassily Kandinsky and Paul Klee rest on letter-like alignment, and the structure of the page appears built out of the essence of letters and letter spaces in the works of Klee, Bradley Walker Tomlin, and Piet Mondrian.

Art can imitate the nonletter parts of calligraphy, too. No calligrapher's education is complete without seeing the work of that master of the swash, Jackson Pollock.

(Succession by Wassily Kandinsky, with permission of The Phillips Collection, Washington, D.C.)

Calligraphy infuses not only the fine arts but the subtle ones. Cartoonist-calligrapher Saul Steinberg, for instance, draws a wide variety of images as though they were letters. Many graphic artists employ nonletters in letter roles to produce an enjoyable double take.

Even the three-dimensional arts apply the concepts of lettering to the creation of nonletters. To the sensitive eye, designers from every field seem to work calligraphically, whether they realize it or not. Reading and seeing are so integral to human life that their rhythms resonate through all the arts.

SUGGESTED READING

American Art Since 1945 by Dore Ashton (New York: Oxford University Press, 1982).

Lettering by Modern Artists (New York: Museum of Modern Art, 1964).

The Meanings of Modern Art by John Russell (New York: The Museum of Modern Art, 1981).

thank your friends for me for
all their good advice about how to
work your typewriter but what i have
always claimed is that manners and methods
are no great matter compared
with thoughts in poetry you cant hide
gems of thought so they wont flash
on the world on the other hand if you press
agent poor stuff that wont make it live
my ego will express itself in spite of
all mechanical obstacles having something
to say is the thing being sincere
counts for more than forms of expression thanks
for the doughnuts

archy

Don Marquis, *Archy's Life of Mehitibel*

Acknowledgments

Extra thanks are due
to Alison Lewis, Gordon Shepherd,
Michael Ochs, and Stanley Kugell for suggestions on the text;
to Elizabeth Moore for several of the illustrations;
to Sallie Gouverneur, without whom
this book would not have gotten started;
to Glorya Hale, without whom it would not have gotten finished;
and to Jack and Marilyn Brandt.
And to David, to whom this book is dedicated.

Bibliography

Books

Alphabet at Work by William Gardner (New York: St. Martin's Press, 1982).

Art and Visual Perception by Rudolf Arnheim (Berkeley: University of California, 1974).

Drawing on the Right Side of the Brain by Betty Edwards (Los Angeles: Tarcher, 1979).

Left Brain, Right Brain by Sally P. Springer and Georg Deutsch (San Francisco: W. H. Freeman, 1981).

Lettering and Lettering Display by William Mann (New York: Van Nostrand Reinhold, 1974).

Lettering as Art by Villu Toots, exhibit catalog (Estonia: ENSV Kunstifond, 1980).

Modern Scribes and Lettering Artists (New York: Taplinger, 1980).

Scribes and Sources by O. S. Osley (Boston: Godine, 1980).

Type and Typefaces by Ben Lieberman (New York: Myriade Press, 1978).

Words and Buildings by Jock Kinneir (London: Architectural Press, 1980).

Periodicals

The Ampersand (Pacific Center for the Book Arts, P.O. Box 6209, San Francisco, California 94101).

Calligranews (Calligrafree, P.O. Box 96, Brookville, Ohio 45309).

Calligraphy Idea Exchange (Kent Road, Huntingdon Valley, Pennsylvania 19006).

Fine Print (P.O. Box 7741, San Francisco, California 94120).

Graphis (Graphic Press, 107 Dufourstrasse 107, CH-8008 Zurich, Switzerland).

Humor Graphic (Via Arzaga n. 28, 20146 Milano, Italy).

Italix (Haywood House, P.O. Box 3402, Alliance, Ohio 44601).

Newsletter of the Pacific Center for the Book Arts (P.O. Box 6209, San Francisco, California 94101).

Newsletter of the Society of Scribes (P.O. Box 933, New York, New York 10150).

Newsletter of the Society of Scribes and Illuminators, (c/o The Federation of British Crafts Societies, 43 Earlham Street, London WC2, England).

Print (355 Lexington Avenue, New York, New York 10017).

Science News (Science Services, Inc., 1719 N Street, N.W., Washington, D.C. 20036).

Scientific American (415 Madison Avenue, New York, New York 10017).

U & lc (International Typeface Corporation, 2 Dag Hammarskjold Plaza, New York, New York 10017).

Visible Language (Box 1972, CMA, Cleveland, Ohio 44106).

Index